LEGAL GUIDE
FOR THE
VISUAL ARTIST

LEGAL GUIDE
FOR THE
VISUAL ARTIST

Tad Crawford

HAWTHORN BOOKS, INC.
Publishers/NEW YORK

Grateful acknowledgment is made to the following for permission to reprint copyrighted materials:

Associated Councils of the Arts, New York, for the article "The Commissioning Contract for Video Artists" by Harvey Horowitz, © 1975 by Advocates for the Arts.

Gemini G.E.L., Los Angeles, for their print documentation form, © 1974 by Gemini G.E.L.

Illustrators Guild, New York, for their confirmation of engagement form, © 1976 by the Illustrators Guild.

New York Law Journal, for the article "A Proposal for the Arts" by Tad Crawford, © 1976 by New York Law Publishing Co.

Bay Area Lawyers for the Arts, San Francisco, for the artist-gallery agreement reprinted from *A Guide to the New California Artist-Dealer Relations Law*, © 1975 by the Bay Area Lawyers for the Arts.

American Artist, for the article "The Hobby Loss Challenge" by Tad Crawford, © 1976 by Billboard Publications, Inc.

LEGAL GUIDE FOR THE VISUAL ARTIST

Library of Congress Catalog Card Number: 76-15431

ISBN: 0-8015-4471-8

1 2 3 4 5 6 7 8 9 10

Lovingly,
to my wife, Phyllis,
and my family

CONTENTS

Business art is the step that comes after Art. I started as a commercial art-ist, and I want to finish as a business artist. After I did the thing called "art," or whatever it's called, I went into business art. I wanted to be an Art Businessman or a Business Artist. Being good in business is the most fascinating kind of art. During the hippie era people put down the idea of business—they'd say, "Money is bad," and "Working is bad," but mak-ing money is art and working is art and good business is the best art.

—ANDY WARHOL
pop artist
from *The Philosophy of Andy Warhol:*
From A to B and Back Again

The immediate cause of the sense of infinite corruption, degradation and humiliation that is the normal lot of the American artist today is the art world. . . . One has only to observe what happens to the sense of friend-ship, love, fraternity and comradeship among artists as they are "picked up" by the art world to see, instantly, that the rewards of such "success" are death and degradation. The art world is a poison in the community of artists and must be removed by obliteration. This happens the instant artists withdraw from it.

—CARL ANDRE
minimal artist
from *Open Hearing*

ACKNOWLEDGMENTS

Special thanks, for encouragement and assistance, to Bill Beckley; Jeffrey Cooper, Esq; Prof. Jack Crawford, Jr.; Eileen Farley; James L. Garrity, Esq.; Simon Gluckman, C.P.A.; Rubin L. Gorewitz, C.P.A.; Paul Jacobs, Esq.; Elsie Mills; Prof. Joseph M. Perillo; the School of Visual Arts; the School of Visual Arts Alumni Association; Roger Welch; and Carl Zanger, Esq.

1

ART AND LAW

After the Second World War the art world's center shifted from Paris to New York City. The dominant art movements—abstract expressionism, pop art, minimal art, and conceptual art—originated with American artists. The prices for art, even during the lifetimes of the artists, rose phenomenally. American art schools began producing more and more graduates—over 30,000 per year by the middle of the 1970s. Merely the commercial aspects of postwar American art would have necessitated a growth of the law relating to art and artists, but a newfound concern with the rights of artists as well offered unexplored potentials for legal innovation. Today every artist—a term used in this book to encompass fine artists, graphic artists, and photographers—must be capable of resolving complex financial and legal problems.

Action in the legal sphere may appear to be an anomaly for the artist involved with creative work. Perhaps, as Carl Andre suggests, the artist should seek to withdraw from the art world and the dangers of success. There is increasing recognition that art is of a different nature from other commodities. This lies at the heart of much of the movement for artists' rights, along with the feeling that artists are not fairly treated by society. Yet for today the artist must at least partially focus on art as commerce, what Andy Warhol calls being "a business artist."

"Art law," although drawn from many areas of the law, is developing more and more into a distinct entity. *Legal Guide for the Visual Artist* seeks to introduce the artist to the legal problems of both art in commerce and artists' rights. It is structured chronologically (as closely as possible) about the sequence of art law issues which begin to affect the

artist as soon as work is created. Because some lawyers may use this book as an introduction to this field of law, notes to reference sources are provided. The artist, however, should feel comfortable reading the text with only occasional reference to the notes.

Lawyers for the Arts

The very definition of an area of the law as "art law" is an encouraging sign for the expertise lawyers will bring to the artist's problems. The literature and educational programs for lawyers have vastly increased in the last five years. Law schools are beginning to offer art law courses and bar associations are paying greater attention to art and the artist. The selected bibliography shows how recent the growth of art law books for lawyers has been.

Equally encouraging are the lawyers across the country volunteering to help needy artists. Up-to-date information on the volunteer lawyers closest to a specific location can be obtained from one of the following established groups:

CALIFORNIA
Hamish Sandison, Executive Director
Bay Area Lawyers for the Arts
25 Taylor Street
San Francisco, California 94102
(415) 775-7200

ILLINOIS
Tom Leavens, Executive Director
Lawyers for the Creative Arts
111 North Wabash Avenue
Chicago, Illinois 60602
(312) 263-6989

NEW YORK
James Fishman, Executive Director
Volunteer Lawyers for the Arts
36 West 44th Street
New York, New York 10036
(212) 575-1150

But perhaps even newer forms of legal representation will evolve to aid the artist. One model would be a prepaid legal services plan exclusively for artists. An annual premium would guarantee legal services up to a certain value without additional charges. Such a plan could be staffed by lawyers versed in art law to achieve maximum efficiency with minimum cost. These plans have worked well for labor unions and might work equally well for groups of artists.[1]

Artists Groups

There are too many artists groups across the country to even begin to mention each by name, but some of the groups with special interest in law and artists' rights are listed on pp. 211 to 214. These groups have different focal points. Many offer newsletters and other information services of value to their members. A few provide legal services, while others lobby for legislation favorable to artists. Health, life, and even automobile insurance are being offered more frequently at group rates. Perhaps retirement plans can be offered as well. The problem of credit—and credit cards—for artists hasn't been resolved, but it is hoped some of these groups will soon create a credit union for artists. Such a credit union would hold the deposits of its members, paying interest, and at the same time would make loans available at reasonable interest rates to members who wished to borrow. Each state has a state credit union league (such as The New York League, 1211 Western Avenue, Albany, New York 12203), which provides information to groups or individuals about starting a credit union.

Some of the artists groups seek to establish minimum rates for pricing art sold by members. A number of the groups have codes of ethics, which dictate standards for both business and art practices in the profession. The Illustrators Guild Code of Ethics, for example, appears at p. 71 as part of their Confirmation of Engagement Form.

In addition, organizations with many nonartist members, such as the Associated Council for the Arts, the Business Committee for the Arts, and the National Committee on Cultural Resources, have been active in articulating the importance of the arts to the nation and in evolving new methods of funding for the arts.[2] These organizations are discussed in more detail at pp. 214–215.

Artists and Art Law

The dynamic quality of American art is mirrored in the development of art law. Legal considerations exist from the moment an artist conceives a work. While no handbook can solve the unique problems of each artist, the artist's increased awareness of the general legal issues pertaining to art will aid in avoiding risks and gaining benefits that might otherwise pass unnoticed. The knowledge of when it is advisable to consult with a lawyer can be a great asset by itself. Certainly the artist should never feel intimidated, helpless, or victimized. A greater familiarity with art law should help the artist, and that is the purpose of *Legal Guide for the Visual Artist.*

2

COPYRIGHT

Artists should place copyright notice—for example, © Jane Artist 1977 —on their art work prior to exhibition or sale.[1] The artist need not even register the copyright until such time as an infringement takes place. By availing themselves of copyright protection, artists gain the power to prevent unauthorized copying, selling, distributing, publishing, or making of other versions of their work in different media. The economic and artistic effect of not being protected by copyright is illustrated by what happened with Robert Indiana's design using the word *love*. This uncopyrighted work received wide exploitation commercially—for example, in the form of jewelry selling for $23.99—but Robert Indiana received no remuneration. Since that time Robert Indiana has adopted the practice of copyrighting his work.

This chapter will explain how the artist obtains and benefits from copyright protection available under the common law and the Copyright Act of 1909, which will remain in force through January 1, 1978. The next chapter will examine the Copyright Revision Act of 1976, finally enacted into law after fifteen years of debate. The Copyright Revision Act of 1976 will apply to all copyright matters arising after its effective date of January 1, 1978, and is best understood by seeing its relationship to the common law and the Copyright Act of 1909. The rest of this chapter, therefore, concentrates on the common law and the Copyright Act of 1909.

The artist will find it helpful, in reading the copyright chapters, to have an up-to-date Copyright Information Kit, which can be obtained free, upon request, from the Copyright Office, Library of Congress,

Washington, D.C. 20559. The Copyright Information Kit contains copyright application forms and circulars explaining numerous aspects of obtaining copyrights and the role of the Copyright Office.

What Is Copyrightable

Only copyrightable art work can benefit from copyright protection. The two requirements for copyrightable work are creativity and originality.

Creativity doesn't require brilliance or an artistic breakthrough. The artist must merely create work which has some minimal artistic qualities. For example, even a child's awkwardly executed drawing would be sufficiently artistic to be copyrightable.

Originality simply means that the artist's work is not copied from the work of another person. If two artists, by an unlikely chance, happened independently to create identical works, both works would be copyrightable. But if one artist copied from the other, the copied work would not be copyrightable. Two artists who used the same subject, such as the same person for a portrait by each artist, could of course each copyright the resulting work.

The artist can use uncopyrightable elements in a work which is copyrightable. Squares, circles, and similar basic geometric forms are not copyrightable. But if an artist uses such forms creatively, perhaps in a collage, the work will be copyrightable. An artist who adds new elements to the artist's previously copyrighted work can copyright the new elements. Also, if a work is in the public domain (which means the work is not protected by copyright and may be freely copied by anyone), the artist can create a copyrightable work by adding original and artistic new elements to such a work copied from the public domain. Marcel Duchamp's *L.H.O.O.Q.*, a photograph of the Mona Lisa with the addition of a moustache and beard, would have been copyrightable. But had Duchamp copyrighted the work, he would only have been able to prevent copying of the moustache and beard, not the Mona Lisa, which would remain in the public domain.

A utilitarian object, such as a lamp, can be copyrightable if it is also artistic. But if the design of a utilitarian object is based on its function, such as a stove or a toaster or a similar household item, the object will not be copyrightable even if it happens to be attractive in appearance.

An idea is not copyrightable, but the creative expression of the idea which forms an independent work is copyrightable. For example, the idea to use a particular subject is not copyrightable. It is the artist's special realization of the subject which is copyrightable. The disclosure of an idea, however, can be protected by a contract (preferably written, with a clear description of the benefit each party to the contract is receiving) requiring payment if any use is made of the idea.[2] Titles, names, and short phrases are not generally copyrightable because they lack a sufficient amount of creative expression. Works which are obscene, an ambiguous term at best, will also not be copyrightable.

There are two types of copyright, common law copyright and federal statutory copyright (referred to as "statutory" copyright). Both types can aid the artist in protecting work.

Common Law Copyright

Common law copyright comes into existence upon the creation of the work (without any action on the part of the artist) and lasts until the work is published or registered with the copyright office. Publication can be simply defined as making a work available to the general public, but the real complexity of the concept is explained more fully later in the chapter. If a work were never to be published, common law copyright would last indefinitely.

Because the sale of an art work may transfer the common law copyright to the purchaser, New York and California have enacted statutes reserving the common law copyright to the artist unless a written agreement transfers the common law copyright to the purchaser. The New York statute covers sales of paintings, sculptures, drawings, and graphic works.[3] The broader California statute covers commissions as well as sales of fine art (defined to include mosaics, photography, crafts, and mixed media) and also includes the categories covered under the New York statute.[4] These statutes try to protect the artist from unfair commercial exploitation but do not prohibit all reproductions (such as, for example, fair use reproductions discussed later in the chapter). Artists in other states should be aware that common law copyright may pass with the physical art work upon sale. The best protection is to both contractually reserve all reproduction rights upon sale and place statutory

copyright notice on the work (statutory copyright can only be transferred in writing).

Statutory Copyright

The statutory copyright is obtained by simply publishing the work with the appropriate statutory copyright notice in a conspicuous and accessible place on the work. This notice consists of "Copyright" or "Copr." or ©, the name of the copyright owner, and the publication date (for example, © Jane Artist 1977). The position of the copyright notice on works of art should ideally be on the front of a two-dimensional art work so that it can be seen by the viewer. However, if the notice is permanently affixed on the back of the art work, this will also be valid.[5] In such cases, it would be advisable to have copyright notice on the title cards appearing with the exhibited work. Notice on a three-dimensional work may be placed on the base or pedestal.[6]

For the artist, the copyright protection of greatest interest exists in classes "G" for a work of art, model, or design for a work of art; "H" for reproductions of a work of art; "J" for a photograph; and "K" for a print or pictorial illustration. The Copyright Office's Circular 70, *Copyright Information about Pictorial, Graphic, and Sculptural Works*, describes these classes more fully. Also helpful are Circular 40J, *Copyright for Photographs;* Circular 40K, *Copyright for Prints and Pictorial Illustrations;* and Circular 40C, *Cartoons and Comic Strips.* An optional short form of copyright notice applies to each of these classes and requires only the symbol © accompanied by the initials, monogram, mark, or symbol of the copyright owner (for example, © JA), as long as the owner's name is permanently affixed on an accessible portion of the work.[7]

Statutory copyright can also be obtained for certain works prior to publication, as is explained later in the chapter.

Exclusive Rights

The exclusive rights of the copyright owner, with respect to the work, include the rights to copy, sell, distribute, publish, and make other versions of the work in different media. For a model or design for a work of

art, the exclusive rights include the right to complete, execute, and finish the work.[8] A person who uses any of these exclusive rights without permission of the copyright owner is an infringer. The penalties for infringement are discussed later in the chapter.

Who May Copyright

Common law copyright protects all artists regardless of citizensip or domicile.[9]

Statutory copyright protection is limited, however, to citizens of the United States and foreign nationals residing permanently in the United States. Other foreign artists must avail themselves of the provisions of international copyright conventions and presidential proclamations to gain statutory copyright protection in the United States.[10]

Duration of Copyright

The common law copyright lasts until a publication occurs—regardless of what length of time may pass. The statutory copyright lasts for an initial twenty-eight year term commencing on registration or publication, whichever is earlier, and a twenty-eight year renewal term.[11] Also, statutory copyrights which would have expired at the end of the renewal term on or after September 19, 1962, have been extended, due to the deliberations over copyright revision, and their term is specified under the Copyright Revision Act of 1976.

Manufacturing Requirement

The manufacturing clause requires that, to obtain statutory copyright, lithographs and photoengravings, as well as books and periodicals of domestic origin, be manufactured in the United States.[12] Exceptions are created for a lithograph or photoengraving which is of foreign origin, which is protected under the Universal Copyright Convention discussed below (but not if the artist is a U.S. citizen or domiciliary), or which illustrates a scientific work or work of art located in a foreign country. Violation of the manufacturing requirement may cause a forfeiture of

copyright. If a book or periodical is first published abroad in English, ad interim copyright lasting five years can be obtained by deposit of a copy with the Copyright Office within six months of such publication.[13] If a publication satisfying the manufacturing requirement takes place in the United States within the five years, the statutory copyright is extended to the full term.[14]

International Protection

If the artist anticipates that work may be exploitable abroad, care should be taken to use appropriate copyright notice. The Universal Copyright Convention—covering most European countries—requires the symbol ©, the name of the copyright proprietor, and the year of first publication.[15] Thus, the short form notice © JA would be insufficient to gain protection under the Universal Copyright Convention. For the Buenos Aires Convention—covering many Western Hemisphere countries—the phrase "All rights reserved" should be added to the notice. Protection under the Berne Copyright Convention, to which the United States is not a signatory, can be gained by simultaneously publishing a work in the United States and a country which is a member of that convention.

Publication

The term *publication* has been used to indicate the time when common law copyright ends and statutory copyright begins, assuming proper statutory notice has been placed on the published work. In fact, however, it is not clear that publication has an identical meaning for common law and statutory purposes. Thus a publication with proper notice, which would be sufficient to gain statutory copyright protection, might still not be a publication which would end common law copyright protection if proper notice were not present.

For both common law and statutory purposes, publication generally occurs when copies of the work are offered for sale, sold, or publicly distributed by the copyright owner or under his or her authority. However, art works are frequently first exhibited or offered for sale not through copies but by use of an original work or works. The consensus is that the exhibition of an uncopyrighted art work will not be a publica-

tion if copying of the work, usually by photography, is prohibited and if this prohibition is enforced at the exhibition.[16] On the other hand, such an exhibition will be a publication if copies can be freely made or disseminated.[17] Authority is also divided over whether the sale of an original uncopyrighted art work is a publication which will bring an end to common law copyright protection.[18] Despite this, both New York and California have enacted the statutes discussed earlier, which provide that the sale of an uncopyrighted art work shall not transfer the right of reproduction to the buyer unless a written agreement is signed by the artist or his agent expressly transferring such right of reproduction.

Unpublished Works

There are, in fact, two types of statutory copyright protection, one for unpublished work and the other for published work. The types of work which can be protected under the statute when unpublished are those registerable in class "G" (a work of art or a model or design for a work of art) and in class "J" (a photograph). For class "G" one copy of the work or, alternatively, one photograph or other identifying reproduction, and for class "J" one copy of the photograph must be sent with an appropriate application form and a fee of $6 to the Register of Copyrights, Library of Congress, Washington, D.C. 20559 for copyright protection. No copyright notice is necessary to secure protection for an unpublished work. If the work is subsequently published, the appropriate copyright notice must appear on the published work bearing the year of the unpublished work's registration. If the published work contains new copyrightable material, then it would be best to include both the year of the unpublished registration and the year of publication. The Copyright Office, in Circular 40J, *Copyright for Photographs,* sets out a method for photographers to copyright unpublished photographs in bulk and save on the copyright fees.

Registration

The registration of unpublished works is necessary to gain statutory copyright protection, but such protection can be gained for published works merely by publication with the appropriate copyright notice.[19]

Failure to register does not invalidate copyright protection for a work published with copyright notice, but registration must be complied with prior to commencing any action based on a copyright infringement or renewing copyright protection.[20] Also, the issuance of the certificate of registration by the Copyright Office is prima facie evidence of the validity of the facts set forth in the certificate.[21]

Registration for published works is accomplished in classes "G," "H," "J," and "K" by deposit of two complete copies of the work as it was published with copyright notice, by filing of an application form for the appropriate class, and by payment of a fee of $6 to the Register of Copyrights. However, an optional deposit of photographs or other reproductions is possible in certain cases for works "impractical to deposit . . . because of their size, weight, fragility, or monetary value." The Copyright Office will not, unfortunately, accept photographs of lithographs and other fine prints but insists on receiving two copies of the work itself. The Copyright Office's Chart 70, *Registration of Copyright Claims for Pictorial, Graphic and Sculptural Works,* and Circular 70A, *Optional Deposit,* are both helpful in determining the registration requirements.

Circular 30, *Postage-Free Mailing Privilege,* explains how the copyright application form and copies for deposit can be mailed without charge. The registration fee, however, must be sent in a separate envelope with regular postage.

Defective Notice

Because statutory copyright for published works is obtained by publication with copyright notice, defective notice can cause copyright protection to be lost. If, for example, a year later than the year of first publication is placed in the notice, copyright protection is lost. There are exceptions, however. For example, the use in the notice of a year prior to that of first publication will merely reduce the copyright term but not invalidate the copyright. Also, if copyright notice is omitted from a relatively small number of copies, the copyright will continue to be valid, although an innocent infringer will not be liable for the infringement.[22]

Collective Works

The present rule is that the exclusive rights encompassed by copyright are indivisible.[23] Ths doctrine of indivisibility requires the transfer of the

entire bundle of rights with the assignment of a copyright. If less than all the rights are to be assigned, the arrangement will be merely a license and not an assignment of copyright ownership.

The doctrine of indivisibility of copyright can cause contributors to collective works such as magazines to accidentally dedicate their contribution to the public domain. The copyright at the front of a collection cannot protect a contribution if the contributor has retained the copyright in the contribution. This is because notice must be in the name of the copyright owner. However, the owner of the collection is merely a licensee. This unfortunate rule, for example, put into the public domain one uncopyrighted art work used as a magazine advertisement for an artist's exhibition and another uncopyrighted art work used to illustrate an article about an artist.[24] The artist whose work will be published in a magazine should insist that copyright notice in the artist's name appear on or next to the contributed work, unless the copyright has been transferred to the magazine. The artist can consult Circular 42A, *Copyright for Contributions to Periodicals.*

Works for Hire

The rule is established that, in the absence of other contractual arrangements, an employer will own the copyright for work created by an employee artist in the course of employment.[25] Less clear, however, has been the ownership of copyright in a commissioned work. If no payments have been made to the artist, the artist will be the copyright owner. If partial payments have been made (unless a written agreement specifies copyright ownership), it will be difficult to determine ownership of the copyright.[26] Where both the work and payments have been completed, the person who commissioned the work will own the copyright unless an agreement has been made to the contrary. This lack of clarity points to the value of using written agreements such as the Commission Agreement for Design of Art Work and the Work of Art Commission Agreement reproduced at pp. 73–76. Photographers should consider ownership of negatives a separate issue from ownership of copyright, as discussed at pp. 72–73.

Transfer of Copyright

An agreement to transfer a common law copyright can be oral—except in New York and California, as discussed earlier. However, assignment of a statutory copyright must be written in a form similar to the example provided below.[27] Moreover, the assignment of a statutory copyright should be recorded in writing with the Register of Copyrights within three months after execution if within the United States or within six months after execution if outside the United States.[28] The failure to file will render the assignment "void as against any subsequent purchases or mortgages for valuable consideration, without notice, whose assignment has been duly recorded."[29] If any doubt exists as to whether a transaction is an assignment of the entire copyright, recordation of the relevant contract should be made with the copyright office to be completely safe. Statutory copyright, subject to certain automatic reversionary interests for the renewal term which benefit the deceased artist's surviving spouse and children,[30] passes by the laws of intestacy in the absence of a will.[31]

ASSIGNMENT OF COPYRIGHT

Assignment, made this ____ day of _____, 19____, by _____ (the "Artist"), residing at _____, to _____ (the "Purchaser"), residing at _____.

WHEREAS, the Artist has created an original art work titled _____ _____, and described as _____, and is the sole proprietor of the copyright in such work, and

WHEREAS, the Purchaser wishes to acquire the entire interest of the Artist in said work.

NOW, THEREFORE, in consideration of $_____, the receipt of which is hereby acknowledged, the Artist hereby assigns and transfers to the Purchaser, his heirs, executors, administrators, and assigns, all of the Artist's right, title, and interest in the said work and the copyright thereof throughout the world, including any statutory copyright together with the right to secure renewals and extensions of such statutory copyright throughout the world, for the full term of said copyright or statutory copyright and any renewal or extension thereof which is or may be granted throughout the world.

IN WITNESS WHEREOF, the Artist has executed this instrument as of the day and year set forth above.

Artist

(It would be advisable for the Artist to sign before a Notary Public.)

Fair Use and Permissions

The *fair use* of a limited part of a copyrighted work or works may be allowed without the permission of the copyright owner for purposes of review, critical commentary, news articles, and similar restricted uses which do not compete with the work. Whether such a use is a fair use or a copyright infringement, however, depends upon the circumstances of the particular use. It would be wise, therefore, to obtain permission to use a copyrighted work if any doubt exists as to whether an intended use will indeed be a fair use. The Reference Division of the Copyright Office will search its own records for a small fee to determine who is the copyright owner of a given work, as explained in Circular 22, *How to Investigate the Copyright Status of a Work.* This assumes, of course, that the work has been registered for statutory protection, which may often not be the case for the visual arts.

A sample permission form, which the artist can adapt to the different uses to which the copyrighted work may be put, appears below.

COPYRIGHT PERMISSION FORM

Dear Sir/Madam:

I am preparing a book titled _____
to be published by _____. May I please have your permission to include the following material (Specify the material. For a published work, include the original place of publication, date, and page numbers.) in my book and in future revisions and editions thereof, including nonexclusive world rights in all languages. These rights will in no way restrict republication of your material in any other form by you or others authorized by you. Should you not control these rights in their entirety, would you kindly let me know whom else I must write.

Unless you indicate otherwise, I will use the following credit line (Specify credit line.) and copyright notice (Specify the form of the copyright notice which will protect the material you are asking to use.)

I would greatly appreciate your consent to this request. For your convenience a release form is provided below and a copy of this letter is enclosed for your files.

Sincerely yours.

Jane Artist

I (We) grant permission for the use requested above.

Date

Infringement

The plaintiff in an infringement suit must prove that the plaintiff owned the copyright and that the work was copied by the infringer. Infringement of common law copyright is remedied under state law by damages which, generally, are based on the market value of the work or, as a possible alternative measure, the profits of the defendant. If malice can be shown in the infringement of a common law copyright, punitive damages can be awarded.

The statutory damages are specified as "such damages as the copyright proprietor may have suffered due to the infringement, as well as all the profits which the infringer shall have made from such infringement."[32] There is uncertainty as to whether the damages and profits are to be awarded in the alternative or added together. There is also provision for in-lieu damages, generally between $250 and $5,000 per infringement at the court's discretion, which the copyright owner may choose in cases in which the damages and profits standard would be difficult to meet.[33] Other sanctions against infringers include injunctions, impounding and destruction of infringing copies and plates, criminal penalties, mandatory court costs, and a discretionary award of reasonable attorney's fees.[34]

Patents

Art works protected by copyright can sometimes also be protected by patent.[35] While a copyright can be obtained for original work, a patent requires a far more difficult test of invention.[36] A utility patent, which

might be relevant for some conceptual works, can be obtained for a work which is useful, new, and unobvious to persons skilled in the discipline. The more common patent protection for art works would be a design patent. Such a patent is granted on an article of manufacture, for example, a statue used as a lamp base, which has a design that is new, original, ornamental, and unobvious.[37] A utility patent has a nonrenewable term of 7 years,[38] while an applicant for a design patent has the option of nonrenewable terms of 3½, 7, or 14 years.[39] Patent protection prevents others from exploiting the patented article regardless of whether the copying necessary for copyright infringement can be shown. However, a patent can be both lengthy and expensive to obtain, while copyright protection attaches simply upon publication with notice. The artist considering patent protection should consult with a lawyer knowledgeable in the area of patents.

Artists and Copyright

Copyright is a valuable protection for artists determined to exert maximum aesthetic and economic control over their art work. It is a right easily and inexpensively obtained but of long duration and significant effect. The artist who wishes to benefit from copyright protection prior to January 1, 1978, must be familiar with the common law and Copyright Act of 1909 discussed in this chapter. After January 1, 1978, the artist will gain copyright protection under the Copyright Revision Act of 1976, which is described and explained in the next chapter.

3

THE COPYRIGHT REVISION ACT OF 1976

Sixty-five years of technological evolution in the media required changes in the copyright laws. After fifteen years of deliberation, copyright revision was at last achieved in the Copyright Revision Act of 1976 (referred to as the "act"), the effective date of which is January 1, 1978. A new Copyright Information Kit should be obtained from the Copyright Office after the effective date of the act in order for the artist to have the most current copyright information.

The act makes many significant changes in the copyright law.[1] All works fixed in a tangible form will be protected by statutory copyright, which will come into existence as soon as the work is created. Therefore, publication with copyright notice is no longer necessary to gain statutory copyright protection. However, copyright protection can be lost if publication, as defined under the act, takes place without copyright notice on the work. The provisions regarding the form of copyright notice are modified, and defective notice can, in some cases, be remedied. Registration is possible in all classes of work regardless of whether publication has occurred. And the duration of copyright protection is increased to the life of the artist plus fifty years.

This chapter explains in greater detail the provisions of the act.

What Is Copyrightable

The act continues the requirement of originality, stating, "Copyright protection subsists . . . in original works of authorship fixed in any tan-

gible medium of expression, now known or later developed. . . ." The definition of "works of authorship" includes "pictorial, graphic, and sculptural works," which, in turn, are stated to "include two-dimensional and three-dimensional works of fine, graphic, and applied art, photographs, prints and art reproductions, maps, globes, charts, technical drawings, diagrams and models."

Common Law Copyright

The act eliminates common law and state copyright protection for any works covered under the act, which are those works "fixed in any tangible medium." Thus, a small class of art works which are not fixed in a tangible medium, such as some performance art, might still be protectable under common law or state statutes. Also, the act does not affect types of legal actions unrelated to copyright, such as invasion of privacy or defamation, nor does it affect copyright suits based on matters arising before the effective date of the act.

Statutory Copyright

The act does not change the basic requirement of statutory copyright notice shown in the preceding chapter (© Jane Artist 1978), but the short form notice has been changed and its use restricted. The act allows for "an abbreviation by which the name can be recognized, or a generally known alternative designation of the owner," but the year must still be included. If Jane Artist signed her work JA, valid notice could be © JA 1978. The notices in which the year may be omitted are restricted "to where a pictorial, graphic, or sculptural work, with accompanying text matter, if any, is reproduced in or on greeting cards, postcards, stationery, jewelry, dolls, toys, or any useful articles. . . ." The year date will no longer be generally omittable from the works which now compose classes "G," "H," "J," and "K." Finally, the position of notice must be such "as to give reasonable notice of the claim of copyright." The Register of Copyrights will prescribe, prior to the act's effective date, nonexhaustive regulations as to what constitutes "reasonable notice." Presumably, notice affixed to the back of a two-dimensional art work will continue to be a valid placement of the notice.

Exclusive Rights

The act grants substantially the same rights as existed previously, but adds the right "to display the copyrighted work publicly." However, a purchaser is given the right to exhibit the work to an audience present at the location of the work without obtaining the artist's consent.

Who May Copyright

The act protects unpublished works "without regard to the nationality or domicile of the author." Published works will be protected if the artist is a national or domiciliary of the United States, if the artist is a national or domiciliary of a nation covered by a copyright treaty or presidential proclamation, if the work is published in a nation which is a party to the Universal Copyright Convention of 1952, or if the work is published by the United Nations or the Organization of American States.

Duration of Copyright

The act ends common law copyright with its possibility of perpetual protection, except for such common law protection as may exist for works not fixed in tangible form. Federal copyright protection will no longer be two twenty-eight-year terms, but the life of the artist plus fifty years.

In the case of a work created jointly, the term shall be the life of the last surviving artist plus 50 years. For works created anonymously, under a pseudonym, or as a work for hire, the term shall be either 75 years from first publication of the work or 100 years from the work's creation, whichever period is shorter. If the name of the artist who has created a work anonymously or used a pseudonym is recorded in the Copyright Office, the term shall run for the life of the artist plus 50 years. Because the date of an artist's death is important for determining the copyright term, the Copyright Office will maintain records as to the date of death of artists who have copyrighted work. However, a presumption will exist that the copyright term has elapsed if 75 years from publication or 100 years from creation of a work have passed and the Copyright Of-

fice records do not disclose any information indicating the copyright term might still be in effect.

Rules are given to determine the terms of copyrights in existence on the effective date of the act.

Works which are protected by common law copyright on January 1, 1978, the effective date of the act, will be protected as if they had been created on that date. An artist who created a work in 1977, but never published the work or filed for copyright, would automatically have the work protected under the act as of January 1, 1978. The term of protection would be the artist's life plus fifty years. In no case, however, would the copyright expire before December 31, 2002. Also, if the work were published on or before December 31, 2002, the term would automatically extend at least until December 31, 2027.

Works registered for statutory protection prior to January 1, 1978, shall have a term of twenty-eight years, but can be renewed for another term of forty-seven years. Works already in their copyright renewal term (that is, the second twenty-eight-year term) on January 1, 1978, shall be extended to create a term of seventy-five years from the date copyright originally was obtained. Also, copyrights which would have had their renewal term expire after 1962, except for the special extensions of their renewal terms during consideration of copyright revision, will have a term of seventy-five years from the date copyright was originally obtained.

The act provides that all copyright terms shall run to the end of the year in which they would expire. This will greatly simplify determining the duration of a copyright, since all terms will end on December 31 of the appropriate year.

Manufacturing Requirement

The act completely eliminates the manufacturing requirement as of July 1, 1982. Prior to that date, the act greatly reduces the requirement which is applicable only to "copies of a work consisting preponderantly of nondramatic material that is in the English language and is protected under this title. . . ." Thus, pictorial or graphic works are no longer subject to the manufacturing requirement. A book containing both illustrations and "nondramatic literary material that is in the English language"

would be subject to the manufacturing requirement only if the literary material were more important than the illustrations. In such case, however, the literary material would have to be "manufactured in the United States or Canada"—such manufacture in Canada being another relaxation of the manufacturing requirement—but the illustrations would not have to be. Moreover, works by foreign artists, or by American and foreign artists, or by American nationals domiciled abroad for one year, are exempt from the manufacturing requirement except in the case of works for hire for United States employers.

International Protection

The requirements for international copyright protection will remain the same, although the passage of the act makes it more likely the United States will also be able to join the Berne Copyright Convention and gain additional international protection for United States citizens.

Publication

Because the act creates copyright protection as soon as a work is fixed in tangible form, the concept of publication has diminished importance. But publication without notice (subject to the provisions discussed later regarding defective notice) can cause the copyright on the work to enter the public domain. It might, therefore, have been hoped that the act would definitively answer the question of what is a publication. The act defines the original art work as a copy, since "copies" include "the material object . . . in which the work is first fixed." Publication is then defined as "the distribution of copies . . . of a work to the public by sale or other transfer of ownership, or by rental, lease, or lending. The offering to distribute copies . . . to a group of persons for purposes of further distribution . . . or public display, constitutes publication." The definition of publication specifically states, "A public performance or display of a work does not of itself constitute publication." To display a work "publicly" is defined to mean to "display it at a place open to the public or at any place where a substantial number of persons outside of a normal circle of a family and its social acquaintances is gathered. . . ."

If the artist were to display a work at the artist's own open exhibition

without offering the work for sale, then certainly no publication would have occurred. But if the work were exhibited for sale by a gallery, this exhibition would appear to be an "offering to distribute copies . . . to a group of persons for purposes of . . . public display," which is a publication. If the work were lent by the artist to a museum for exhibition, this would appear to be "the distribution of copies . . . of a work to the public by . . . lending," which is a publication.

However, not only does the issue of exhibition constituting publication remain, but the sale of an art work may also be a publication. The act provides that "the distribution of copies . . . of a work to the public by sale" is a publication. This, however, might lead to the result that a sale would place the copyright in the public domain if no notice appeared on the work.

The legislative history of the act indicates that Congress did not intend such disruptive results from exhibition or sale of original art work. Representative Kastenmeier specifically stated prior to the act's passage in the House, "It is not the committee's intention that [an art work existing in only one copy] would be regarded as 'published' when the single existing copy is sold or offered for sale in the traditional way—for example, through an art dealer, gallery, or auction house. On the other hand, where the work has been made for reproduction in multiple copies—as in the case of fine prints such as lithographs—or where multiple reproductions of the prototype work are offered for purchase by the public—as in the case of casting from a statue or reproductions made from a photograph of a painting—publication would take place at the point when reproduced copies are publicly distributed or when, even if only one copy exists at that point, reproductions are offered for purchase by multiple members of the public." With this clarification in mind, the best rule to follow is placing copyright notice on the work at the earliest possible time.

Registration

The act will permit the registration for copyright protection of all unpublished as well as published works. Registration for both unpublished and published works will be permissive and not a condition for protection by copyright. The issuance of a certificate of registration, either before or five years after first publication, is *"prima facie* evidence of the

validity of the copyright and of the facts stated in the certificate." The court in its discretion will determine the weight to be given a certificate issued more than five years after first publication. Registration is required to commence a suit for infringement. Also, in-lieu damages and attorney's fees will not be awarded if an infringement of an unpublished or published work occurs prior to registration (unless a published work has been registered within three months of publication). The registration fee will be increased from $6 to $10.

The deposit requirements for registration are one complete copy of the work for an unpublished work and two complete copies of the best edition for a published work. However, the act provides for an exemption or alternate form of deposit "where the individual author is the owner of copyright in a pictorial, graphic, or sculptural work and (i) less than five copies of the work have been published, or (ii) the work has been published in a limited edition consisting of numbered copies, the monetary value of which would make the mandatory deposit of two copies of the best edition of the work burdensome, unfair, or unreasonable." Thus, originals of fine prints should no longer have to be deposited.

Defective Notice

The act provides that the omission of copyright notice—or the omission of a name or date or the use of a date more than one year later than the actual date of publication—will not invalidate a copyright if (1) notice has been omitted from a relatively small number of copies, (2) registration has been previously made or is made within five years of the publication without notice and a reasonable effort is made to add notice to all copies, or (3) the omission of notice violates a written requirement by the copyright owner that such notice appear on all copies. If a year earlier than the actual publication date appears on the notice, the copyright is still valid and the copyright term is computed from the earlier date.

Collective Works

The act protects contributors to collective works (except for advertisers) "where the person named in a single notice applicable to a collec-

tive work as a whole is not the owner of copyright in a separate contribution that does not bear its own notice." Or, more generally, the act protects any copyright owner when an incorrect name appears in the notice. In such a case the contributor's copyright will remain valid, the person named in the notice will have to account to the contributor for receipts, and infringers will be highly restricted as to defenses.

The artist should, however, place copyright notice on the contribution, since this may limit the publisher of the collective work to a one-time use of the contribution. This provision of the act has not been definitely interpreted but, if the contribution has no notice, the act does clearly determine what use can be made of the contributed work by the owner of the copyright in the collective work: "In the absence of an express transfer of the copyright or of any rights under it, the owner of copyright in the collective work is presumed to have acquired only the privilege of reproducing and distributing the contribution as part of that particular collective work, any revision of that collective work, and any later collective work in the same series." The best practice to follow, of course, is always to make a written agreement detailing exactly what rights are being transferred to the owner of the collective work.

Works for Hire

The act resolves copyright ownership of works for hire favorably to artists. In the case of an employee working regularly for an employer, the employer will own the copyright in work created by the employee pursuant to the employment. Of course, the employer and employee could make a valid written agreement under which the employee would own the copyright. On the other hand, an employer would not own the copyright in "a work specially ordered or commissioned for use as a contribution to a collective work . . . [unless] the parties expressly agree in a written instrument signed by them that the work shall be considered a work made for hire." The failure to expressly agree in writing that such a contribution is a work for hire would, therefore, leave the artist the owner of the copyright. In the case of other commissioned work, for example, a painting of flowers, the work-for-hire rule would not apply since the definition of work for hire is restrictive. The artist would be the owner of the copyright.

Transfer of Copyright

The act specifically provides that copyright is divisible from the physical art work and can be separately transferred.

The act also emphatically rejects the doctrine of indivisibility by providing that any of the exclusive rights in a copyright can be transferred individually. A transfer of copyright ownership is defined as a transfer "of a copyright or of any of the exclusive rights comprised in a copyright, whether or not it is limited in time or place of effect, but not including a non-exclusive license." For example, the artist might transfer the right to make copies to one person and the right to make derivative works to another person. The exclusive rights can also be subdivided. So, for example, rights to make different kinds of derivative works could be transferred to different persons. Any such transfer of a copyright or an exclusive right in a copyright must be in writing. The time for recording transfers is shortened to within one month of the execution if within the United States or within two months of the execution if outside the United States. Failure to so record a transfer can cause a later conflicting transfer to prevail over an earlier transfer.

Due to the greater length of the new terms, transfers and licenses which were granted by the artist can be terminated during a five-year period beginning at the end of thirty-five years after the execution of the grant or, if the grant includes the right of publication, during a five-year period beginning at the end of thirty-five years from the date of publication or forty years from the date of execution, whichever term ends earlier. This right of termination does not apply to works for hire or grants made by will. Also, transfers and licenses granted by the artist, certain family members, or the artist's executors in works registered for copyright protection prior to January 1, 1978, can be terminated during a five-year period commencing on the later of January 1, 1978, or the end of fifty-six years after the copyright was obtained. Again, this termination right does not apply to works for hire or grants made by will. The right of termination is exercised by the artist or other person who made the grant, or by the artist's surviving family in an order prescribed by the act.

A copyright can be transferred by will or, if the artist dies without a will, can be transferred by the laws of intestacy.

Fair Use

The act provides statutory recognition of fair use by stating that copying "for purposes such as criticism, comment, news reporting, teaching (including multiple copies for classroom use), scholarship, or research, is not an infringement of copyright." To determine whether a use is a fair use depends on four enumerated factors: "(1) the purpose and character of the use, including whether such use is of a commercial nature or is for nonprofit educational purposes; (2) the nature of the copyrighted work; (3) the amount and substantiality of the portion used . . . and (4) the effect of the use upon the potential market for or value of the copyrighted work." Display of a work "by instructors or pupils in the course of face-to-face teaching activities of a nonprofit educational institution" is not an infringement.

Compulsory Licensing

The act provides for the compulsory licensing (that is, use without the permission of the artist) of "published nondramatic musical works and published pictorial, graphic, and sculptural works" by a public broadcasting entity for transmission over noncommercial educational broadcast stations. A copyright royalty tribunal will set rates for royalties to be paid to artists whose work is used by compulsory license. Also, the tribunal will establish rules under which the public broadcasting entities must keep records of compulsory licensings and give reasonable notice to artists entitled to receive royalties. An agreement between a public broadcasting entity and a copyright owner may, however, be substituted in place of compulsory licensing. Also, compulsory licensing does not apply to "the production of a transmission program drawn to any substantial extent from a published compilation of pictorial, graphic, or sculptural works, or the unauthorized use of any portion of an audiovisual work."

Infringement

The owner of a copyright or any of the exclusive right in a copyright may recover damages for "the actual damages suffered by him or her as a

result of the infringement, and any profits of the infringer that are attributable to the infringement and are not taken into account in computing the actual damages." The act provides for injunctions, impounding and disposition of infringing articles, higher in-lieu damages, criminal penalties, discretionary court costs, and reasonable attorney's fees.

Patents

Both copyright and patent protection can still be obtained for art works meeting the standards described in the preceding chapter.

Design Protection

Title II proposed for the act—"Protection of Ornamental Designs of Useful Articles"—was *not* enacted. The artist should be aware of this proposal, however, since it may well be introduced in Congress again. Design protection would provide a valuable new type of protection for articles which might be in the overlap area of copyright and patent protection. This protection would extend to "the author or other proprietor of an original ornamental design of a useful article." "Useful article" is defined as "an article which in normal use has an intrinsic utilitarian function that is not merely to portray the appearance of the article or to convey information." Design is equated with appearance, being " 'ornamental' if it is intended to make the article attractive or distinct in appearance," and, " 'original' if it is the independent creation of an author who did not copy it from another source." To be ornamental and original are the basic requirements to gain copyright protection. But for an article merely to be useful is a far lower standard than that applying to patent protection.

The result would be a new type of protection which would commence "upon the date of publication of the registration" by the administrator (probably the Register of Copyrights) and would last for a five-year term which could be extended for an additional five-year renewal period. Design notice would have to be present in the form "Protected Design" or "Prot'd Des." or Ⓓ; the year when the design was first made public; and the name, abbreviation, alternative designation, or, in some cases, distinctive identification of the proprietor. After registration, the year

and proprietor may be replaced by the registration number. The notice must be "so located and applied as to give reasonable notice of design protection while the useful article embodying the design is passing through its normal channels of commerce." Registration would be mandatory within six months of making public the design or design protection would be lost.

4

RIGHTS OF THE ARTIST

The artist in the United States is not legislatively granted the moral rights in the artist's work which many countries give to artists. The moral rights inalienably belong to the artist even after work has been sold. The moral rights suggested, for example, under the Berne Copyright Convention, to which the United States is not a signatory, provide that "the author shall have the right to claim authorship of the work and to object to any distortion, mutilation or other modification of, or other derogatory action in relation to said work, which would be prejudicial to his honor or reputation." [1] Also, artists in foreign countries often have an economic right in the work after sale. Known as the *droit de suite* in France, this right requires that part of the proceeds from certain sales of art work be paid back to the artist. A right to such proceeds exists in some form in Belgium, Italy, Poland, Uruguay, Turkey, West Germany, Portugal, Tunisia, Chile, and Luxembourg. [2]

The artist in the United States, however, can use certain legal doctrines (which the cases have developed) to approximate the moral rights of artists sometimes granted abroad. Also, attempts are being made by both private contracts and proposed legislation to create a *droit de suite* or art proceeds right for artists in the United States. [3] To put these developments in a clearer perspective, moral rights and the *droit de suite* under French law will first be described, [4] after which the United States law will be compared to the French law.

Right of Disclosure

The French right of disclosure gives the artist the sole power to determine when a work is completed and ready to be disclosed to the public. This has led to some interesting decisions in French courts. In the *Whistler* case in 1900, the artist was dissatisfied with a portrait he had done upon commission. Lord Eden, who had commissioned the portrait, was satisfied and demanded delivery of the work. Application of the right of disclosure gave Whistler the right not to deliver the work until such time as he considered the work completed, despite the fact that the work had been publicly exhibited. The *Camoin* case in 1931 involved a painter who had slashed and discarded several canvases. The slashed canvases were found and restored by another person who sought to sell the works. The painter intervened, based upon his right of disclosure, and the French court seized and destroyed the canvases in accordance with the artist's original intent.

The *Rouault* case in 1947 was a dispute between the artist and the heirs of the artist's dealer. The artist had left 806 unfinished canvases in a studio at the gallery of the dealer. Rouault, who had a key to the room and would occasionally work on the paintings, had agreed to turn over all his work as created to the dealer. The dealer died and the heirs of the dealer claimed to own the 806 works. The court held that Rouault owned the works, because the right of disclosure required the artist himself determine the work to be completed before any disclosure of the work to the public by sale could occur. Any agreement to the contrary would be invalid. Finally, the *Bonnard* case ultimately resolved that paintings only become community property upon completion to the artist's satisfaction. The estate of an artist's wife would, therefore, have no right in works the artist had chosen not to disclose. The right of disclosure, like the other moral rights, was enacted as legislation in France on March 11, 1957.

Right of Paternity

The French right of paternity gives the artist a perpetual and unassignable right to have the artist's name and authorship acknowledged with regard to any of the artist's works. The artist, including collaborators, must receive appropriate authorship credit even on advertisements,

reproductions, and similar uses. An agreement under which an artist is required to use a pseudonym will not be valid since the artist's right of paternity would be violated. Also, the artist may prevent the use of his name in association with a work not created by the artist.[5]

Right of Integrity

The French right of integrity is basically the right, after a work has been disclosed, to prevent any alterations or distortions of the work without consent of the artist. For example, the *Buffet* case in 1962 involved a decorated refrigerator which the painter maintained could not be sold other than as a whole. The French court supported this view on the ground that the right of integrity would be violated by permitting the refrigerator to be sold in parts. Very complex issues as to the right of integrity can arise when works are being adapted from one medium to another. The court is often called upon to determine whether the adaptation is faithful to the spirit of the original. The artist cannot use the right of integrity to object to exhibitions of the artist's work unless such exhibitions display altered work or in some way reflect upon the professional standing of the artist.[6]

Enforcement of Moral Rights

Since the moral rights are perpetual, the question arises who will enforce such rights after the artist's death. The right of disclosure is enforced by the artist's executors, descendants, spouse, other heirs, and general legatees, and finally by the courts. The rights of paternity and integrity can be transmitted to heirs or third parties under the artist's will for enforcement.

Droit de Suite

In 1920 France created the *droit de suite,* a right of artists to share in the proceeds from sales of their work. The legislation was prompted in part by a Forain drawing showing two children dressed in rags looking

into an expensive auction salesroom and saying, "Look! They're selling one of daddy's paintings."[7]

The measure, later incorporated in the copyright provisions under the law of March 11, 1957, was a response to the stereotyped image of the artist living in penury while works created earlier sold for higher and higher prices. The *droit de suite* lasts for a term of the life of the artist plus another fifty years, during which the proceeds benefit the artist's spouse and heirs. The *droit de suite* applies to original works when sold either at public auction or through a dealer, although the extension of the *droit de suite* to dealers by the law of March 11, 1957, appears not to have been followed or enforced.[8] The *droit de suite* is collected when the price is over 10,000 francs (approximately $2,500). The rate is 3 percent upon the total sales price, not merely the profit of the seller. Artists utilize *S.P.A.D.E.M. (Société de la Propriété Artistique, des Dessins et Modèles)*, an organization like ASCAP, to collect proceeds due under the *droit de suite. S.P.A.D.E.M.*, by reciprocal agreements with similar organizations, also receives proceeds due its artists from sales of work in Belgium and West Germany. The *droit de suite* is payable to a foreign artist if a French artist could collect a similar payment in the country of the foreign artist. Despite some commentary to suggest that United States artists should be able to collect the *droit de suite* in France because the United States has signed the Universal Copyright Convention, it appears that United States artists are not entitled to the *droit de suite* because the United States offers no such right to foreign artists.[9] Foreign artists can collect the French *droit de suite* in any case if such artists have resided in France for five years, not necessarily consecutively, and have contributed to the French life of the arts.[10] This survey covers only the French law, of course, and the laws of other countries with rights similar to the *droit de suite* can vary significantly.

Rights in the United States

No federal legislation has been promulgated to create either moral rights or an art resale proceeds right in the United States. But artists in the United States do have other means to attempt to protect their work and reputation.[11] Common law copyright, for example, would create somewhat similar rights for an artist in the United States as the right of

disclosure creates in France. To understand more clearly the doctrines creating protection for the United States artist, each such doctrine is considered separately. Often, however, the artist will use several of the doctrines in a single case since the protections can overlap.

Unfair Competition

A recent court decision states that "the essence of an unfair competition claim is that the defendant assembled a product which bears so striking a resemblance to the plaintiff's product that the public will be confused as to the identity of the products. . . . The test is whether persons exercising 'reasonable intelligence and discrimination' would be taken in by the similarity." [12] The application of the doctrine of unfair competition can be even broader than this definition indicates. In proper factual situations, the doctrine can prevent the artist being presented as the creator of works the artist in fact did not create; prevent the artist being presented as the creator of distorted versions of the artist's own works; prevent another person from claiming to have created works in fact created by the artist; protect titles which, although not usually copyrightable, may become so well recognized that use of the title again (such as *Gone With The Wind*) would create confusion of the new work with the original work; and generally prevent the competitors of an artist from confusing the public to benefit unfairly from the reputation for quality of the artist's work.

An example of the application of the doctrine of unfair competition involved the "Mutt and Jeff" comic strip, which the cartoonist first sold to a San Francisco newspaper and then to a New York City newspaper. When the cartoonist signed an exclusive agreement with the San Francisco newspaper, the newspaper in New York City hired other cartoonists for a competitive "Mutt and Jeff" strip. However, the court stated, "No person should be permitted to pass off as his own the thoughts and works of another," and granted an injunction to prevent the New York City newspaper fron continuing to produce a "Mutt and Jeff" comic strip.[13]

The artist should realize, however, that the doctrine of unfair competition does not entitle the artist to authorship credit when the artist has transferred a copyright without reserving the right to such credit. For example, the artist Vargas entered into an agreement with *Esquire* to create

"Vargas girls," but the contract had no provision for authorship credit for the artist. *Esquire* chose to publish the work under the name "Esquire girls" and Vargas had no right to be credited as the artist upon publication. Despite his argument that the phrase "Vargas girls" implied he would receive credit, he would have been entitled to such credit only if the contract expressly so stated.[14] Also, in the United States, there is no question that a contract is valid even if an artist agrees either to work under a pseudonym or not to receive authorship credit.

The doctrine of unfair competition cannot, basically, replace a contract expressly protecting the artist's rights. An artist who worked for hire in creating a church mural had no right to prevent the destruction of the mural, because the contract reserved no rights to the artist in such an event.[15] The artist may well wish a contractual provision requiring the artist's approval for any changes, including destruction, with regard to the work. But, at the least, the contract must provide for authorship credit if the artist is to argue that distortions or alterations are prevented by the doctrine of unfair competition. The doctrine would not be flexible enough to extend to distortions or alterations of a work created anonymously and sold without any reservations.

Trademarks

A trademark is a distinctive motto, symbol, emblem, device, or mark which a manufacturer places on a product to distinguish in the public mind that product from the products of rival manufacturers.[16] Trademarks are usually registered with the Patent Office for federal protection and with the appropriate state office for state protection, although even an unregistered mark can have protection under the common law. An artist who is exploiting work commercially—for example, posters, jewelry, or clothing—might wish to seek trademark protection for a distinctive logo or motto. Also, the artist would wish to be certain that any chosen trademark did not infringe an already registered trademark in commercial use. A trademark can be licensed, as long as the artist giving the license ensures that the quality of goods created by the licensee will be of the same quality that the public associates with the trademark. Trademarks are entitled to protection in foreign countries under treaties executed by the United States. The effect of having a trademark is like unfair competition in that others are prevented from us-

ing the trademark where confusion to the public would result. While trademarks are used for products, or in some cases for services, the artist should at least be aware of the existence of this type of protection.

Right to Privacy

The right to privacy is the right to be free from unwanted and un-necessary publicity or interference which could injure the personal feel-ings of the artist or present the artist in a false light before the public. This right is recognized in varying forms by almost every state. New York's Civil Rights Law Section 50, for example, prohibits using "for advertising purposes, or for the purposes of trade, the name, portrait or picture of any living person without having first obtained the written consent of such person." Under Section 51, however, this right is specifically not applicable to use of "the name, portrait or picture of any . . . artist in connection with his . . . artistic productions which he has sold or disposed of with such name, portrait or picture used in con-nection therewith." The right to privacy is personal, which means that only the living artist may use it—not assignees or heirs. The right to privacy diminishes as the artist gains stature as a public figure, par-ticularly as to those areas of the artist's life in which the public has a legitimate interest.[17] The New York statute also speaks of "advertising purposes" or "purposes of trade" but exhibitions of work, especially if by a private collector or a museum, would not appear to be for such uses. An artist could recover for invasion of privacy where an unauthorized use of the artist's name accompanied sale of pillows designed in imitation of the artist's work.[18] But after the artist's sale of all rights in a cartoon, a magazine was able to use the artist's name in manufacturing and selling dolls based on the cartoon without an invasion of the artist's privacy.[19] While theoretically the right to privacy might be used to protect the artist against distortions of the artist's work, the practical effect of the right to privacy in this area would seem quite limited.

Protection against Defamation

Defamation is an attack on the reputation of another person. Both libel and slander are forms of defamation, libel being expressed by print,

writing, pictures, or signs, and slander being expressed by spoken words.[20] For an artist to bring an action for defamation, the defamatory material must have reached the public. Also, the defamatory material must be false, since the truth of the alleged defamatory material will be a defense to a lawsuit based on defamation.

The artist should be aware of an important distinction made between defamation and criticism. An artist who places work before the public invites criticism of the work. That criticism, no matter how hostile or fantastic or extravagant, is not by itself defamatory. However, if untrue statements are made disparaging the work, or if the artist is attacked personally in a way unconnected with the work, the critic may well have crossed the border into the area of defamation.[21]

The effect of showing or publishing an artist's work in a distorted form while attributing the work to the artist would be damaging to the artist's reputation. Protection against defamation is, therefore, a method which an artist can use to prevent violations of the integrity of the artist's work.

Right to Publicity

The right to publicity is a relatively new right independent of the right of privacy. The right of publicity states that a person with a public reputation has a right to benefit from the commercial value associated with that person's name or picture. Sports figures, for example, have the right to financial benefits from use of their names and pictures on baseball cards or in a baseball game.[22] But the right to publicity will be of little value to the artist who is not famous.

The right to publicity does not prevent advertising uses of a well-known person's name and picture if such uses are incidental to a legitimate news article. Joe Namath was the subject of many newsworthy articles on football in *Sports Illustrated*. However, when *Sports Illustrated* used photographs from the articles to illustrate advertising, Namath contended that his right to publicity had been violated. The court concluded that the use of the name and photographs of Namath were only uses incidental to establishing the quality and news content of *Sports Illustrated*. To allow damages might well violate the First Amendment guarantees of freedom of speech and press, so Namath lost the case.

Also, valuable as this right of publicity may be to well-known artists, the right will at present neither protect artists from being denied author-

ship credit where a contract is silent as to such credit nor protect art works from distorting changes.

Art Proceeds Right

The French *droit de suite* has at least been discussed for the United States under the designation of an art proceeds right. Such a right would require the payment back to the artist of a certain percentage of either proceeds or profits from subsequent sales of the artist's work. California has taken the lead in this area by enacting a 5 percent resale proceeds right for artists.[23] Whenever an original painting, sculpture, or drawing is sold in California or sold anywhere by a seller who resides in California, the artist shall be paid 5 percent of the gross sale price within ninety days of the sale. For this provision to apply, however, the sale must be for a profit, the price must be more than $1,000, and the sale must take place during the artist's life. If the seller cannot locate the artist within ninety days to make payment, the proceeds are deposited with the California Arts Council. After seven years, if the council has been unable to locate the artist, the proceeds are used for the council's arts programs. The law is effective as of January 1, 1977, and applies to works sold after that date regardless of when the works were created or first sold. If the seller does not make payment, the artist has the right to bring suit for damages within three years after the date of sale or one year after discovery of the sale, whichever period is longer. It is speculated that certain provisions of this law may be an unconstitutional burden on interstate commerce, which implies that a fully effective art proceeds right for artists will ultimately have to be the product of federal legislation.

The other approach to an art proceeds right has been by private contract. If an artist and collector agree for a payment back to the artist upon subsequent resales, the artist would be able to gain by private bargaining what French artists possess by national legislation. But the Projansky contract, which provides for such an art proceeds right as well as attempting to create moral rights for United States artists, is not yet widely used. The Projansky contract appears on p. 62.

Artists in the United States

The enlightened approach often found abroad, which creates for artists both moral rights and a *droit de suite,* has yet to be adopted in the United States. Although many different doctrines protect the artist in the United States, there are still substantial risks that the artist may either go unacknowledged as a creator or have no recourse to prevent the alteration or destruction of the artist's work. Only by contracts, such as the innovative Projansky contract, can the artist in the United States attempt to create protections and rewards similar to the moral rights and *droit de suite* established by law in many foreign nations.

5

THE CONTENT OF ART WORKS

The First Amendment of the United States Constitution provides guarantees of freedom of expression which apply to artists and their work, but such guarantees are not unlimited.[1] Copyright, patent, trademark, the doctrine of unfair competition, the rights to privacy and publicity, and protection from defamation safeguard not only the artist but the artist's competitors as well. Significantly, other private citizens also have rights protecting them from invasion of privacy or defamation, which the artist will have to consider when creating work. Additionally, the public at large through law enforcement agencies may seek to suppress works which are considered either obscene or a desecration of a governmental symbol.

Defamation

Defamation, as discussed in the preceding chapter, is an attack upon a person's reputation by print, writing, pictures or signs, or spoken words. The defamatory material must reach the public, since damage to reputation is a necessity in an action for defamation. While the truth of an alleged defamation would be a defense to such an action, the burden of proving truthfulness is on the person who asserts truth as a defense.[2] Generally, everyone who participates in publishing or exhibiting defamatory material will be liable to the defamed person.[3]

The artist who attacks a person's reputation, for example, by representing a person as involved in unethical or criminal conduct, as

physically deformed in an unnatural or obscene way, or as lacking manners or intelligence may face a libel suit. The person defamed need not be mentioned by name, so long as the depiction will be recognizable to those acquainted with the person's reputation.[4] The depiction may not in itself be defamatory, but may become so because of accompanying written material. For example, a newspaper published a photograph of a man and woman with a caption indicating their intention to marry. The man, however, was already married and his wife successfully sued for the damage to her reputation from the implications of the false caption.[5]

The First Amendment, however, limits the extent to which actions for defamation can successfully be pursued. The right of a public figure, in particular, to sue for libel is limited to false statements made with actual malice or reckless disregard of the truth.[6] The term *public figure* is itself subject to definition. For example, a woman successfully sued a magazine for unfavorably misreporting the grounds of her divorce decree. Although the woman was often mentioned in society columns and actually gave news conferences because of the widespread reporting of her divorce proceedings, the Supreme Court reasoned she was not a public figure because she had no major role in society's affairs and had not voluntarily joined in a public controversy with an intention to influence the outcome.[7] Similarly, when a magazine accused a prominent lawyer of having framed a policeman as part of a Communist conspiracy to discredit the police, the attorney was determined not to be a public figure. The Supreme Court stated, "The communications media are entitled to act on the assumption that public officials and public figures have voluntarily exposed themselves to increased risk of injury from defamatory falsehoods concerning them. No such assumption is justified with respect to a private individual."[8]

The Supreme Court determined that the states should have discretion to determine the standard of liability for defamation where a private individual is involved in a matter of public interest, so long as the states require some negligence or fault on the part of the person accused of the defamation. Thus, where a matter of public interest is involved, a public figure will have to show actual malice or reckless disregard for the truth to recover for defamation while a private individual will only have to show negligence. Where a private person is defamed on a matter not of public interest, there is no requirement even to show an intent to defame. Recovery in such a case is allowed on the basis of the defamation alone and malice or reckless disregard for the truth are only relevant in fixing the extra damages known as punitive damages.[9]

Privacy

The right to privacy, as discussed in relation to the artist, is the right to live free from unwanted or unnecessary publicity or interference which would injure a person's feelings or present a person in a false light before the public. Again, the First Amendment operates to reduce the right of privacy from which public figures may seek to benefit. A dramatic example is the litigation involving Ronald Galella, a photographer, and Jacqueline Onassis. Galella's role as a *paparazzo* pursuing Jacqueline Onassis for photographs created substantial and unwanted interference in her life. The Federal Court of Appeals described Galella jumping into the path of John Kennedy's bicycle to take a picture. "Galella on other occasions interrupted Caroline at tennis, and invaded the children's private schools. At one time he came uncomfortably close in a power boat to Mrs. Onassis swimming. He often jumped and postured around while taking pictures of her party. . . . He followed a practice of bribing apartment house, restaurant and nightclub doormen as well as romancing a family servant to keep him advised of the movements of the family."[10] The court indicated that such activities could not be tolerated, whether as an invasion of privacy or as harassment. But the final order of the court, mindful of Galella's First Amendment rights, merely restricted the photographer from approaching within twenty-five feet of Jacqueline Onassis, blocking her movement in public places, or harassing or endangering her.

The artist will often, however, deal with a person who is not a public figure. The right of privacy—such as that granted under the New York Civil Rights Law Sections 50 and 51, prohibiting the advertising or trade use of an individual's name, portrait, or picture without consent—would apply in full force. Yet a factual account or portrayal of a matter of current newsworthy or legitimate public interest will not be an invasion of privacy. For example, a professional musician who spontaneously performed before 400,000 people at the Woodstock Festival in 1969 could not object to the distribution without his consent of a film of his performance. This was because the Woodstock festival was an occurrence of great public interest and remained newsworthy long after the end of the festival.[11] Also, Section 51 specifically permits a photographer to display portraits at the photographer's place of business unless the person portrayed objects in writing. Beyond this, the artist should generally either

obtain a release or seek a lawyer's advice where pictures or portraits may ultimately be used for either advertising or trade purposes.

The artist must also consider whether portrayals of buildings may require releases. Normally a public building does not have any right to privacy and no release need be obtained from the owner. Similarly, a private building used as a background in a public place or thoroughfare would not require a release. But a private building or a public building where admission is charged might require a release, particularly since a subsequent advertising use might come within the doctrine of unfair competition.[12]

An appropriate form of a personal release is set forth at p. 44. A release should provide for the date, the consideration, the subject matter, the extent of the release, the persons other than the artist who may benefit from the release, the signature of the individual giving the release, and the guardian's consent if the person giving the release is a minor. The artist who is provided with a release, perhaps by an agency, should request indemnification against lawsuits based on invasion of privacy if the release appears inadequate.

Obscenity

The laws regulating obscenity have been the focus of much controversy and concern. What the artist creates for aesthetic reasons may not be perceived in the same way by viewers in the general public. Yet the most recent decision by the United States Supreme Court states that the guidelines to determine what is obscene must be "(a) whether 'the average person, applying contemporary community standards' would find that the work, taken as a whole, appeals to the prurient interest . . . (b) whether the work depicts or describes, in a patently offensive way, sexual conduct specifically defined by the applicable state law; and (c) whether the work, taken as a whole, lacks serious literary, artistic, political, or scientific value."[13] These guidelines hardly seem to offer more guidance than the subjective reaction of the ordinary citizen as to what may be obscene. Also, the guidelines specifically refer to community standards and state laws. This means that standards for judging what is obscene will vary not only from state to state depending on the state laws, but aso from community to community depending on the local standards.

RELEASE

In consideration of $_____ paid me by _____
simultaneously herewith and other valuable considerations, receipt of which
is hereby acknowledged, I hereby give _____, his assigns,
licensees, legal representatives, and heirs the absolute and irrevocable right to
use my name, picture, portrait, and photograph in all forms and media and in
all manners, including but not limited to exhibition, display, illustration,
advertising, trade, promotion, editorial, and art uses without violation of my
rights of privacy or any other personal or proprietary rights I may possess. Said
work and all components thereof shall constitute the sole property of
_____ and may be copyrighted in his own name or any
other name he may choose.

I am of legal age.* I have read and fully understand the contents of this
release.

_____ _____

(Date) (Signed)

(Witness)

*Delete this sentence if the party giving the release is a minor. In such case the
parent or guardian must consent by signing the guardian's consent below.

CONSENT

I represent that I am the parent (or guardian) of the above-named minor and
have authority to execute the above release. I hereby consent to the foregoing
on behalf of the above-named minor.

_____ _____

(Date) (Signed)

(Witness)

The artist can hardly be certain, therefore, when and where a work, upon exhibition or publication, may be found to be obscene.[14] At the least, if the artist keeps the work in the privacy of the studio, no violation of the obscenity laws will occur. But the obscenity laws, if applicable, can cover such uses of the work as possession for sale or exhibition, sale, distribution, exhibition, and mailing and importation through customs. The manner in which the material is offered to the public may be important in a determination of obscenity. If there is an emphasis solely on the sexual aspects of the works, this factor will make more likely a determination that the work is obscene. If minors have access to the material, an even higher standard than that applicable to pornography may be applied by the states without violating the First Amendment.

The First Amendment, however, offers important procedural safeguards to the artist whose work risks being alleged obscene.[15] Law enforcement agencies cannot simply seize such materials upon their belief the materials are obscene. The exhibitor of work must be given notice of a hearing to determine whether the work may be seized as obscene. At the hearing the exhibitor can be represented by a lawyer to argue that the works are not obscene. The judge must consider all relevant evidence, such as the works, the manner of publicizing the exhibit, and the degree to which the general public may view the works. Law enforcement officers who testify the works are obscene must actually have attended the exhibition. Only after such a hearing can the works be seized or the exhibition prohibited.

The artist or exhibitor may find that law enforcement agents have chosen to seize work without a prior adversary hearing. In such a case the law enforcement officials should not be resisted in any way, but merely advised that they are acting in violation of the First Amendment procedural safeguards and may be liable for damages for their actions. In no event should consent be given to the conduct of the law enforcement officials, since consent might be a waiver of the procedural safeguards necessitated by the First Amendment.

Obscenity is a complex legal area. The artist who either fears an obscenity issue may arise or faces such an issue must consult a lawyer for assistance in proving the work is not obscene and should not be suppressed.

Flag Desecration

The United States Code provides: "Whoever knowingly casts contempt upon any flag of the United States by publicly mutilating, defacing, defiling, burning, or trampling upon it shall be fined not more than $1,000 or imprisoned for not more than one year, or both." The definition of United States flag includes "any picture or representation . . . made of any substance or represented on any substance . . . by which the average person seeing the same without deliberation may believe the same to represent the flag . . . of the United States of America."[16] The states have enacted statutes which protect both state and federal flags. The First Amendment does offer protection to artists who use the flag in creating their work, particularly where the purpose of the work is political protest as opposed to a commercial use. For example, in 1966, an artist named Marc Morrel exhibited in the Radich Gallery in New York City "an object resembling a gun caisson wrapped in a flag, a flag stuffed into the shape of a six-foot human form hanging by the neck from a yellow noose, and a seven-foot 'cross with a bishop's mitre on the head-piece, the arms wrapped in ecclesiastical flags and an erect penis wrapped in an American flag protruding from the vertical standard,' "[17] as well as other works which used a Vietcong flag, a Russian flag, a Nazi swastika, and a gas mask. The gallery owner, Stephen Radich, was charged with desecration of the flag and began a seven-year odyssey through the courts. Radich was finally vindicated on the basis of a two-part judicial test. First, the court determined whether the activity, in this case the exhibition, had such elements of communication as to be protected by the First Amendment. If so, as with Morrel's work, the court then decided whether the state had interests which were more compelling than the individual's. The interests of New York State—such as preservation of the flag as a symbol, avoiding breaches of the peace, and protecting the feelings of passerby—were found less important than the interest of the artist and gallery owner in freely expressing the political protest conveyed by the exhibition.[18]

The divergent state laws and complexity of the area of flag desecration will make consultation with a lawyer a necessity for the artist who wishes to determine whether the First Amendment will provide adequate protection for given works of art using a motif of the state or federal flag.

Coins, Bills, and Stamps

The artist may also wish to use either United States currency or stamps as part of a work. Certain uses, however, are prohibited by federal statutes. For example, advertising on either real or imitation currency is forbidden and punishable by fines up to $500.[19] Mutilation of currency with an intent to make such currency unfit to be reissued is punishable by fines up to $100 or six months in jail, or both.[20] Also, anyone who makes or possesses a likeness of a United States coin for use in any manner is subject to fines up to $100, but the likeness must be such as to create some possibility that the coin could be mistaken as minted by the United States.[21]

The federal laws on counterfeiting do, however, make specific provisions to allow coins, bills, and stamps to be printed and published "for philatelic, numismatic, educational, historical, or newsworthy purposes in articles, books, journals, newspapers, or albums."[22] Advertising uses are restricted to legitimate coin or stamp dealers in trade publications. The illustrations of coins or bills must be black and white and either less than ¾ or more than 1½ times the size of the original. The size requirements apply to stamps which are in color, but not to black-and-white or canceled colored stamps. The negatives and plates must be destroyed after being used for the illustrations. Also, coins, bills, and stamps may be used in films, microfilm, and slides as long as no prints or reproductions are made without the permission of the secretary of the treasury for purposes other than the educational, newsworthy, and similar purposes discussed above.

6

CONTRACTS: AN INTRODUCTION

A contract is an agreement creating legally enforceable obligations between two or more parties.[1] The artist is constantly entering into contracts with collectors, dealers, agents, exhibitors, publishers, landlords, and others. While a lawyer should usually be consulted when the artist is given a contract to sign, the artist's knowledge of the different negotiable points in each contract can assist a lawyer in reaching the contract best suited to the artist's individual needs. This chapter develops a background of the law relating to contracts in order that subsequent chapters on specific types of contracts can be more helpful.

Governing Laws

Every state except Louisiana has enacted the Uniform Commercial Code, a statute which provides laws to govern the sale of goods. For example, the Uniform Commercial Code applies when an artist contracts to sell a finished work or to specially create a work for a purchaser. The Uniform Commercial Code does not apply, however, where the artist's services are employed in a project such as the creation of a mural.[2] Such a contract for services is governed by the case law of the various states, although general principles of the case law can be described.

Offer and Acceptance

An offer is a proposal to enter into a contract. It is a promise which invites acceptance in the form of a return promise or, less usually, an ac-

ceptance by performance based on the terms of the offer. If a collector says to an artist, "I want to buy your painting, *Doves of Peace*, for \$250," an offer has been made. The collector has promised in definite terms which can be accepted by the artist's return promise to sell the painting. If the collector says, "This painting would look wonderful in my office," or, "This painting will be worth a fortune soon," or, "I want to borrow this painting to try for a few weeks," no offers have been made. If the collector says, "You paint my portrait and we'll agree later about the price," or, "You paint my portrait and I'll pay you as I see fit," no offers have been made because a material term—the price—has been omitted.[3] However, if the collector says, "Paint my portrait and I will pay you \$250 if satisfied," a valid offer has been made. The artist should beware of such an offer, because the collector may be able to reject the finished portrait. The courts generally rule that a satisfaction clause means that a dissatisfied collector may reject the work, even if the collector reasonably should have been satisfied.[4] But the artist certainly does not want to deal with vagueness of this nature and should either avoid satisfaction clauses or require step-by-step approval from the collector as do the Commission Agreement for Design of Art Work and the Work of Art Commission Agreement reproduced at pp. 73–76.

It is interesting that the exhibition of a painting with a price is not an offer. The reason for this is that advertising to the public at large does not create an offer. If a collector is willing to meet the asking price, it is the collector who makes the offer which the artist may then accept or refuse.[5]

The person making an offer can usually revoke the offer at any time prior to acceptance. Another way in which an offer can be terminated is by limiting the time for acceptance. An example of this would be, "I will purchase your painting for \$250 if you will sell it to me within the next ten days." This offer would terminate at the end of ten days. If no such time limit is set, the assumption is made that the offer ends after a reasonable amount of time has passed. An offer is also terminated by a counteroffer. For example, if the collector offers \$250 for a painting and the artist demands \$500, the original offer of \$250 is no longer effective.

Acceptance is usually accomplished by agreeing to the offer. If the collector offers to pay \$250 for a portrait, the artist can accept by stating, "I agree to paint your portrait for \$250." The less usual method of acceptance would be by conduct indicating acceptance of the offer. The artist could simply begin painting the portrait, which would be an implied acceptance of the collector's offer. The best way, however, is to accept

by giving a promise in return instead of merely performing according to the terms of the offer.

The end result of the process of offer and acceptance is a meeting of the minds, a mutual understanding between the parties to the contract.

Consideration

Every contract, to be valid, must be based on consideration, which is the giving of value by each party to the other. The consideration each party to a contract receives is what induces entry into the contract. Where the collector promises to pay $250 for a portrait which the artist promises to paint, each party has received value from the other. The consideration must be bargained for at the time the contract is entered into. If a collector says, "I'm enjoying my portrait you painted so much, I'm going to pay you an extra $250 even though I don't have to," the collector is not obliged to pay. The artist has already painted the portrait and been paid in full, so the promise to pay an additional $250 is not supported by consideration.

The one situation where consideration is not required occurs when a person relies on a promise in such a way that the promise must be enforced to avoid injustice. If a collector makes a promise which he reasonably should know an artist will rely upon, such as offering $250 as a gift for the artist to buy art supplies, the collector cannot refuse to pay the money after the artist has in fact relied on the promise and purchased the supplies.

Competency of the Parties

The law will not enforce a contract if the parties are not competent. The rationale is that there can be no meeting of the minds or mutual understanding in such a situation. A contract entered into by an insane person is not enforceable. Similarly, contracts entered into by minors will, depending on the law of the specific state, be either unenforceable or enforceable only at the choice of the minor. The age of reaching majority has traditionally been twenty-one, but many states such as New York and California have now lowered the age of majority to eighteen years of age.[6]

Legality of Purpose

A contract for a purpose which is illegal or against public policy is not binding. Thus a contract to smuggle pre-Columbian art into the United States would not be valid because a federal statute prohibits such importation without the permission of the country where the art is found.[7] Similarly, a contract between an unethical art dealer and an art forger to create and sell old masters could not be enforced by either party in court.

Written and Oral Contracts

A common fallacy is that all contracts must be written to be enforced. While this is not always true, it is certainly wise to insist on having contracts in writing. The terms of a contract may come into dispute several years after the creation of the contract. At that time reliance on memory to provide the terms of the contract can leave much to be desired, especially if no witnesses were present and the parties disagree as to what was said.

A written contract need not even be a formal document. An exchange of letters can create a binding contract. Often a letter agreement is signed by one party, and the other party completes the contract by also signing at the bottom of the letter beneath the words *consented and agreed to.* Both parties may not have signed an agreement, but a memorandum signed by the party against whom enforcement is sought can be found to constitute a valid contract. Even where the parties merely show, from their conduct, an intention to agree, a contract—called an implied contract—can come into existence. But when part of a contract is in writing, the artist should not rely on an oral agreement to the effect that compliance with all the written provisions will not be insisted upon. Courts are reluctant to allow oral evidence to vary the terms of a written contract, except in cases where the written contract is procured by fraud or under mistake or is too indefinite to be understood without the additional oral statements.

The Uniform Commercial Code requires written evidence whenever goods of a value of more than $500 are to be sold.[8] This simple rule, however, is subject to several important exceptions. If the contract provides for goods to be specially created for the purchasers—photographs

of a specific place, for example—an oral contract for more than $500 will be valid if the artist has made a substantial start on the work. If the artist receives and accepts payment or if the purchaser receives and accepts the work, the oral contract will be valid despite being for more than $500. Also, merchants who have made an oral contract for more than $500 will have a valid contract if one merchant then writes a note binding against that merchant and the other merchant doesn't give written objection to the contents of the note within ten days of receipt. *Merchant* is a special term under the Uniform Commercial Code, defined to mean a person who deals in goods of a certain kind or has special skill or knowledge as to the goods or practices involved in the transaction. A gallery or publisher would be a merchant, and at least some artists may also come within the definition.[9]

There are provisions, however, in statutes other than the Uniform Commercial Code which also require certain contracts to be in writing. For example, the original Statute of Frauds enacted in 1677 in England required contracts which could not be performed within one year to be in writing. This is still the law in almost every state.[10] Unlike the Uniform Commercial Code, which only requires written evidence for sales of goods, this provision applies to contracts for services as well and requires that the writing contain all of the essential terms of the contract. If an artist agrees to sell a collector two paintings each year for three years at $50 per painting, the contract cannot be performed within one year and must be in writing to be valid. Similarly for services, if a muralist is hired by a church to paint a mural during the next fifteen months, that contract will take longer than a year to perform and must be in writing. If completion of the mural were only to take eleven months but the church's payments would be over a two-year period, the contract would again not be performable within one year and would have to be in writing to be valid.

The wisest course is to use only written contracts, but, particularly where the contract is for the sale of goods worth more than $500 or will take more than one year to perform, the artist should generally insist on a written contract.

Warranties

Caveat emptor—let the purchaser beware—expressed the traditional attitude of the courts toward the protection of purchasers of goods. More

and more, especially under the Uniform Commercial Code, warranties are created with contracts of sale for the purchaser's protection. Warranties are express or implied facts upon which the purchaser can rely. Warranties can be created orally, even if the contract must be written, and can be made during negotiations, when entering into a contract, or, in some cases, after the contract is effective.

One implied warranty guarantees that the seller—for example, an artist—has title or the right to convey title in the art work to the purchaser.[11] Another implied warranty is that the art work will be fit for the particular purpose for which sold, if the artist is aware of the particular purpose and the purchaser relies on the artist's skill or judgment in furnishing the work.[12] If, for example, a sculpture, particularly purchased for a fountain, cracked because of the effect of water on the materials composing the sculpture, this warranty would be breached. This warranty would not apply where goods are put to a customary use, presumably including most forms of exhibition in the case of art works.

An express warranty is created when the artist asserts either facts or promises relating to the work or describes the work in such a way that the purchaser relies on the facts, promises, or description as a basis for making the purchase.[13] Describing the work as being constructed of certain materials, for example, would be an express warranty if the purchaser considered that a basis for purchasing the work. However, sales talk or opinions as to the value or merit of the work by the artist will not create warranties. If, for example, the artist speculates that the work will be worth a fortune in a few years, the purchaser cannot rely upon such an opinion and no warranty is created.

One express warranty which the artist may wish to make is that a work is either unique (one of a kind) or original (one of a limited number). This is particularly true where the work could be easily duplicated, such as photographs, found objects, collages, much pop art, and the manufactured geometric shapes created by some of the minimal artists. While the beauty of the work would not seem diminished by identical pieces, the value for most collectors would be greatly impaired. Painters benefit from the myth that all paintings are unique, but artists whose work can be duplicated must inspire faith in the purchaser that a unique work is unique and that an original work exists in no more than a given number of copies. For example, a photographic work might exist in color or in black and white, as well as having versions with a greater or smaller number of photographs. Although the artist and the purchaser

may differ as to what uniqueness is in an art work, the artist can avoid the purchaser's having any cause for complaint by placing a warranty like the following on the back of the work:

> NOTICE
>
> This art work, titled <u>Doves of Peace,</u> and briefly described as <u>doves flying against a background of clouds,</u> is an original work consisting of <u>6</u> numbered panels of <u>30″ × 40″</u> in dimension with no more than <u>3</u> other identical originals and no more than <u>4</u> other originals in black and white consisting of <u>3</u> panels of the dimension of <u>15″ × 20″</u>.

The artist would place this notice on the back of each panel, but sign only panel 1 to avoid the possibility of the work being split up. The notice can easily be adapted to suit the details of different art works. The purchaser will be pleased by this reassurance as to the scarcity of the work, and the artist will benefit from the increased trust created by such a demonstration of integrity. If the work were unique, the notice could simply be shortened to state the work's uniqueness.[14] The artist who creates one work with several different parts, such as a sculpture in three separate pieces, might want the purchaser to expressly warrant that the pieces would always be exhibited and sold as a single work.

Assignments of Contracts

Sometimes one party to a contract can substitute another person to take over the burdens or rewards of the contract. This is not true, however, for contracts which are based upon the special skills of one party to the contract. Where such personal ability is crucial to the contract—for example, in a contract for the creation of an art work—the artist may not delegate the contractual duties for performance by another artist.[15] But even though the artist is unable to delegate the performance of the artist's duties, the artist will still be able to assign to another person the artist's right to receive money due or to become due under the contract.[16] A well-drafted contract will state the intention of the parties as to the assignment of rights or delegation of duties under the contract.

Nonperformance Excused

There are a variety of situations where the artist's failure to perform contractual obligations will be excused. The most obvious case is that the death of the artist is not a breach of contract which would permit a lawsuit against the artist's estate. Similarly, because the artist's work is personal, unforeseen disabling physical or mental illness will excuse performance by the artist. Also, payment by the party contracting with the artist will be excused if the continued existence of a particular person is necessary to the contract being performed—for example, if a portrait was commissioned but the person to be portrayed died prior to commencement of the work.

Grounds other than the personal nature of the artist's work will also permit the artist to refuse to perform. If the other party waives the artist's performance or if both parties have agreed to rescind the contract, no performance will be necessary. If the artist is prevented by the other party from performing, perhaps by a person refusing to sit for a portrait, performance will be excused and the artist will have an action for breach of contract.[17] Similarly, no performance is required where performance would be impossible, as in the case of a muralist who cannot paint a mural because the building has burned. Also, performance is excused if it would be illegal due to a law passed after the parties entered into the contract.

Insurance and Risks of Loss

The artist may wish to insure work in order to receive insurance proceeds in the event of its loss or destruction.[18] The artist should seek an agent who is familiar with insuring art works. Such insurance may cover only works in the artist's studio or may extend to cover works in transit. Valuation can be difficult with art works, and the artist might even have to incur the extra expenses of an appraisal. Also, once the artist has insurance, exact records as to the art work subject to the insurance become crucial in order to document claims. If the artist's premises or work may be dangerous, the artist might also want liability coverage to pay for accidents on the premises or caused by the work.

If the artist has no insurance and the work is damaged or stolen while in the artist's studio, the artist will simply have lost the work. But if the artist has sold the work, when does the risk of loss pass to the purchaser? The general rule is that if a work must be shipped, the risk of loss passes to a purchaser upon delivery. Thus the artist would normally bear the risk of loss while the work was being shipped to a purchaser.[19] However, if the purchaser buys the work at the artist's studio and leaves the work to be picked up later, risk of loss will have passed to the purchaser. This is because a sale, by a nonmerchant seller under the Uniform Commercial Code, passes the risk of loss to the purchaser after such notification as would allow the purchaser to reasonably pick up the work. For example, where a bronze sculpture was sold along with the contents of a house, it was not reasonable to expect the purchaser to take possession of the sculpture within twenty-four hours of being given the keys. The risk of loss remained on the seller, but might have shifted to the purchaser if the purchaser had a longer period in which to pick up the sculpture.[20] The contract of sale offers the artist an opportunity either to shift any risk of loss to the purchaser or to provide for insurance on the works sold.

Remedies for Breach of Contract

A party who refuses to perform a contract can be liable to pay damages. There must, however, be some detriment or loss caused by a breach of contract before the recovery of damages will be allowed. The damages will generally be the amount of the reasonably foreseeable losses (including out-of-pocket costs and lost profits) caused by the breach.[21] Also, the injured party must usually take steps to minimize damages.

The artist may wonder what happens when performance under a contract is either nearly completed or is completed but varies slightly from what was agreed upon. Unless the contract specifies that strict compliance is necessary if the artist is to be paid for performing the contract, the artist will usually be able to recover the contract price less the costs necessary to pay for the defects in performance. For example, where an artist created stained-glass windows in substantial compliance with the designs except that less light came through the windows than one of the parties had apparently intended, the court stated, "Where an artist is

directed to produce a work of art in accordance with an approved design, the details of which are left to the artist, and the artist executes his commission in a substantial and satisfactory way, the mere fact that, when completed, it lacks some element of utility desired by the buyer and not specifically contracted for, constitutes no breach of the artist's contract."[22]

The question, however, of what constitutes substantial performance is an area where litigation is likely. The reason for this is another rule: that part performance under a contract will not allow recovery based on the price specified in the contract for full performance. Moreover, such part performance will not, in most states, even be paid for on the basis of reasonable value unless the part performance is of substantial benefit to the other party who accepts and retains the benefits of such performance. This rule would not apply, of course, if one party prevented the other from performing. Also, where one part of a contract can be separated from another part, such as a number of payments for a number of different sets of photographs, recovery will usually be permitted for the partial contract price specified for each partial performance.[23]

In some situations damages may not be adequate to compensate for the loss caused by a breach of contract. If a famous artist is retained to paint a portrait of unique emotional value, the artist's refusal to honor the contract might be difficult to value in money damages. But since involuntary servitude is prohibited, the artist cannot be forced to create the portrait.[24] On the other hand, if a painting with unique value is already in existence, a purchaser might well be able to require specific performance of a contract of sale. This would mean that a court would order the seller, whether an artist or a dealer or a collector, to transfer to the purchaser the specific painting for which the purchaser had contracted.[25] Specific performance can only be used, however, where the payment of money would not be sufficient remedy.

Statutes of Limitation

A statute of limitation sets forth the time within which an injured party must bring suit to have the injury remedied. After the limitation period has passed, no lawsuit can be maintained. The limitation period for actions based on contracts for the sale of goods under the Uniform Commercial Code is four years from the time of breach, while the limita-

tion period for breach of a contract for services varies from state to state (for example, six years in New York).[26] The artist contemplating legal action is well advised to seek redress promptly so that no question will arise regarding statutes of limitation.

Bailments

A bailment is a situation where one person gives his or her lawfully owned property to be held by another person. For example, an artist might lend a work to a museum, leave a painting for framing, drop off a portfolio at an advertising agency, or leave film to be developed at a film lab. In all of these relationships, where both parties benefit from the bailment, the person who takes the artist's property must exercise reasonable care in safeguarding the work.[27] If that person is negligent and the work is damaged or lost, the artist will recover damages. Even if the work has no easily ascertainable market value, damages would still be awarded based on the intrinsic value of the work to the artist.[28]

However, the reasonable standard of care required in a bailment can be changed by contract. Often, for example, film labs will require an artist to sign a receipt which limits the liability of the lab to the cost of replacing film which is ruined. This is so despite the great value which may exist in the images recorded on the film.[29] Similarly, a museum, a framemaker, an advertising agency, and so on might seek to limit liability, perhaps to the extent of requiring the artist to sign a contract under which the artist would assume all risks of injury to the work. The artist should seek just the opposite—that is, to have the other party agree to act as an insurer of the work. This would mean that the other party would be liable if the work were damaged for any reason, even though reasonable care might have been exercised in safeguarding the work.

ASMP, for example, has developed a delivery memo for its members to have signed by the recipient of photographic positives or transparencies.[30] The contract provides for the recipient to have the liability of an insurer as to submitted materials while either in the recipient's possession or in transit. Other provisions require the recipient: to object to the terms of the delivery memo within ten days; to pay a fee for the recipient's keeping materials beyond fourteen days; not to use the materials without an invoice transferring rights in the work; to pay a minimum of $1,500 per transparency in the event of loss or damage; not to project any

transparencies; and to submit to arbitration. The setting of damages in advance is a frequent practice to avoid the necessity of extensive proofs to establish proper damages at trial. The courts will normally enforce such provisions for damages, known as liquidated damages, as long as damages would be difficult to establish and the amount specified is not unreasonable or a penalty.

Other artists might well wish to follow the lead of ASMP whenever work leaves their hands. Certainly, however, the artist entering into a bailment relationship should avoid a contract which lowers the reasonable care usually required to safeguard the artist's work.

7

SALES OF ART WORKS

The last chapter developed a background of contractual law in order to prepare for a discussion of the particular contracts into which an artist may enter. The artist's sale of art work directly to a purchaser—whether of already completed work or of commissioned work—will be explored in this chapter.

Basic Contractual Terms

If a purchaser decides to purchase a work, the artist should at least insist on a simple written contract in a form such as the Standard Bill of Sale, p. 61, developed by Artist's Equity. The bill of sale sets forth the place, date, purchaser's name, description of the work, price of the work, terms of the payment, and reservation of reproduction rights by the artist, and it is signed by both parties. These terms could also be set forth in a brief letter to the purchaser. The artist would sign the letter and the purchaser would sign beneath the words *consented and agreed to*. The artist might wish, in such a letter, to include an acknowledgment of the receipt of the work by the purchaser and receipt of the payment by the artist if such payment has been received.

ARTISTS EQUITY — STANDARD BILL OF SALE

Place _____ Date _____

(Fill out in duplicate)

Sold to: (Name) _____

(Address) _____

Description of work: Price:

Terms of payment:

Reproduction rights reserved

(Signed) _____ _____

Purchaser Artist or Authorized Dealer

Projansky Contract

The Projansky contract, or The Artist's Reserved Rights Transfer and Sale Agreement, was drafted in 1971 by New York City lawyer Bob Projansky to rectify the artist's lack of control over and profit from art work after sale. This innovative contract seeks to create, by contract, rights which are somewhat similar to the moral right of integrity and the *droit de suite* under French law. In reading over the provisions of the easier-to-use second edition of the Projansky contract, reproduced at p. 62, the artist should remember that not all of the proposed provisions need to be used for every sale and some sales will require provisions not present in the contract. The actual terms will vary, depending on the bargaining power of the parties, but the Projansky contract will aid the artist in developing an awareness of what can be demanded.

AGREEMENT OF ORIGINAL TRANSFER OF WORK OF ART

fill in names,
addresses of
parties

Artist: _____ address: _____

Purchaser: _____ address: _____

WHEREAS Artist has created that certain Work of Art ("the Work"):

fill in data
identifying the
Work

Title: _____ dimensions: _____

media: _____ year: _____ and

WHEREAS the parties want the Artist to have certain rights in the future economics and integrity of the Work,
The parties mutually agree as follows:

fill in
agreed value

1. **SALE**: Artist hereby sells the Work to Purchaser at the agreed value of $ _____

2. **RETRANSFER**: If Purchaser in any way whatsoever sells, gives or trades the Work, or if it is inherited from Purchaser, or if a third party pays compensation for its destruction, Purchaser (or the representative of his estate) must within 30 days

 (a) Pay Artist 15% of the "gross art profit", if any, on the transfer; and

 (b) Get the new owner to ratify this contract by signing a properly filled-out "Transfer Agreement and Record" (TAR); and

 (c) Deliver the signed TAR to the Artist.

 (d) "Gross art profit" for this contract means only: "Agreed value" on a TAR less the "agreed value" on the last prior TAR, or (if there hasn't been a prior resale) less the agreed value in Paragraph 1 of this contract.

 (e) "Agreed value" to be filled in on each TAR shall be the actual sale price if the Work is sold for money or the fair market value at the time if transferred any other way.

3. **NON-DELIVERY**: If the TAR isn't delivered in 30 days, Artist may compute "gross art profit" and Artist's 15% as if it had, using the fair market value at the time of the transfer or at the time Artist discovers the transfer.

4. **NOTICE OF EXHIBITION**: Before committing the Work to a show, Purchaser must give Artist notice of intent to do so, telling Artist all the details of the show that Purchaser then knows.

5. **PROVENANCE**: Upon request Artist will furnish Purchaser and his successors a written history and provenance of the Work, based on TAR's and Artist's best information as to shows.

6. **ARTISTS EXHIBITION**: Artist may show the Work for up to 60 days once every 5 years at a non-profit institution at no expense to Purchaser, upon written notice no later than 120 days before opening and upon satisfactory proof of insurance and prepaid transportation.

7. **NON-DESTRUCTION**: Purchaser will not permit any intentional destruction, damage or modification of the Work.

8. **RESTORATION**: If the Work is damaged, Purchaser will consult Artist before any restoration and must give Artist first opportunity to restore it, if practicable.

9. **RENTS**: If the Work is rented, Purchaser must pay Artist 50% of the rents within 30 days of receipt.

10. **REPRODUCTION**: Artist reserves all rights to reproduce the Work.

11. **NOTICE**: A Notice, in the form below, must be permanently affixed to the Work, warning that ownership, etc., are subject to this contract. If, however, a document represents the Work or is part of the Work, the Notice must instead be a permanent part of that document.

12. **TRANSFEREES BOUND**: If anyone becomes the owner of the Work with notice of this contract, that person shall be bound to all its terms as if he had signed a TAR when he acquired the Work.

13. **EXPIRATION**: This contract binds the parties, their heirs and all their successors in interest, and all Purchaser's obligations are attached to the Work and go with ownership of the Work, all for the life of the Artist and Artist's surviving spouse plus 21 years, except the obligations of Paragraphs 4, 6 and 8 shall last only for Artist's lifetime.

14. **ATTORNEYS' FEES**: In any proceeding to enforce any part of this contract, the aggrieved party shall be entitled to reasonable attorneys' fees in addition to any available remedy.

fill in date
both sign

Date: _____

Artist

Purchaser

TRANSFER AGREEMENT AND RECORD

fill in data
identifying
the Work

Title: _____ dimensions: _____

media: _____ year: _____

fill in date

Ownership of the above Work of Art has been transferred between the undersigned persons, and the new owner hereby expressly ratifies, assumes and agrees to be bound by the terms of the Contract dated _____ between:

fill in names,
addresses of
parties

Artist: _____ address: _____ and

Purchaser: _____ address: _____

Agreed value (as defined in said contract) at the time of this transfer: $ _____

do not FILL
in anything
between
these lines

Old owner: _____ address: _____

New owner: _____ address: _____

Date of this transfer: _____

fill in date
fill in names
of parties
and Artist's
address on
both
Notices

SPECIMEN NOTICE

Ownership, transfer, exhibition and reproduction of this Work of Art are subject to a certain Contract dated _____ between:

Artist: _____

Address: _____ and

Purchaser: _____

Artist has a copy.

cut out, affix to Work

NOTICE

Ownership, transfer, exhibition and reproduction of this Work of Art are subject to a certain Contract dated _____ between:

Artist: _____

Address: _____ and

Purchaser: _____

Artist has a copy.

Basic Terms

The Projansky contract, like the bill of sale from Artists Equity, starts by setting forth the names and addresses of the parties. The *whereas* clauses explain the motives of the parties and prepare a rationale for the duties and rights under contract. The first *whereas* clause states that the artist has created a work of art which is described by title, dimensions, medium, and year. The next *whereas* clause, the fundamental goal of the Projansky contract, states that "the parties want the Artist to have certain rights in the future economics and integrity of the Work." The first edition of the Projansky contract set forth a more detailed basis of such rights: (1) that the value of the art work sold would be affected by subsequent works created by the artist; (2) that the value of the work would, in fact, increase; (3) that the artist should share in any such increase in value; and (4) that the artist's intention in creating the work should be recognized by giving the artist a certain control over the work.

The Artist's Economic Benefits

The Projansky contract requires that each work have a permanently affixed notice showing that future transfers are subject to the contract (Article 11; Specimen Notice and Notice). Exchanges, gifts, inheritances, receipt of insurance proceeds, and similar transfer transactions relating to the work are covered by the contract as well as sales (Article 2). Depending on the nature of the transaction, either price or value is entered under Article 1 and used to calculate gross art profit, which is simply the excess of the present transfer value or price over the previous transfer value or price (Article 2(d)). The purchaser agrees to have anyone who purchases the work sign a Transfer Agreement and Record (abbreviated as TAR, as required by Article 2(b) and shown with the contract) and each subsequent purchaser is bound by all the terms of the original agreement (Article 12). Each time the work is sold, the seller within thirty days must file a current TAR signed by the new purchaser (Article 2(b) (c)) and pay 15 percent of gross art profit to the artist (Article 2(a)). The artist also reserves all reproduction rights in the work (Article 10) and has a right to receive 50 percent of any rentals received by the purchaser (Article 9). The term of the economic benefits would be for

the lives of the artist and spouse, plus an additional twenty-one years (Article 13).

The provisions can be illustrated by an example. In 1978 the artist sells a work for $1,000, subject to the Projansky contract. In 1980 the work is resold for $1,500. The owner who sells in 1980 must, within thirty days, file a current TAR and pay 15 percent of $500 to the artist. If, in 1978, the artist had parted ownership with the work through gift or barter, the Projansky contract could still be used. Similarly, if in 1980 the owner transfers the work by a method other than sale, the 15 percent of gross art profit would still have to be paid to the artist. If the party who purchases in 1980 for $1,500 resells in 1982 for $2,500, the artist will be entitled to receive 15 percent of $1,000 and a new TAR must be filed with the artist.

The Artist's Control

The artist also gains substantial control over the work after sale under the Projansky contract. Of course, reproduction rights are reserved to the artist (Article 10), which offers aesthetic control as well as economic benefits. The purchaser must give written notice to the artist of any intended exhibition (Article 4). The first edition of the contract had a much stronger provision which allowed the artist to either give advice or veto any proposed public exhibition. Upon showing satisfactory proof of insurance and prepaid transportation, the artist is entitled to borrow the work back from the purchaser for one sixty-day period every five years for exhibition at a nonprofit institution. The purchaser agrees not to "permit any intentional destruction, damage or modification of the Work," (Article 7), rights which the artist would not have in the absence of a specific contractual provision. If the work is damaged, the purchaser must consult with the artist prior to making repairs and, if possible, use the artist to do the repairs (Article 8). The term of the contract is limited to the life of the artist as to notice of the purchaser's exhibitions, the artist's right to possession once every five years, and the artist's right regarding restorations. Lastly, any party forced to bring suit for a breach of the contract may demand reasonable lawyer's fees as well as other remedies (Article 14).

Benefits to the Purchaser

The Projansky contract might seem to favor only the artist, raising the question of whether any but the most successful artist would have the bargaining power to force a purchaser to use the contract. However, there are benefits to the purchasers, the most important of which is the right to receive the artist's written certification of the work's provenance and history (Article 5). Also, the purchasers can feel more assured that they are treating the work as the artist would wish.

Arguments against the Projansky Contract

The merits of the Projansky contract have been warmly debated, although the contract has not come into wide use.[1] Some argue that use of copyright by artists would provide much of the economic benefit sought by the Projansky contract. A difficult problem for the artist would be enforcement of the provisions requiring the filing of a current TAR and the payment of 15 percent of gross art profit. Also, art works as an investment are not easily saleable, and a purchaser might be quite reluctant to accept a work which could only be resold if the new purchaser agreed to the substantial obligations of the Projansky contract. The purchaser may additionally be deterred by the prospect of work burdened by the Projansky contract passing through the purchaser's estate. Also, there must be an increase in the value of the work for the artist to benefit economically. For many artists, who are fortunate simply to sell their work, this increase may not occur. The contract, therefore, will benefit artists whose work does not increase in value only by giving such artists some control over the work at the expense of negotiating a more complex contract. Since the artist will not have to pay purchasers if the work decreases in value, the contract is argued to be unfair. In any case, appreciation of a work may be caused by inflation, in which case the appreciated value is merely an illusion. But still the 15 percent must be paid back to the artist. Some collectors even argue that increases in the value of the artist's work are due to the collector giving the work prestige by the collector's ownership of the work. And if the artist's work sells for such high prices, why can't the artist create more pieces for sale at the new price levels?

Arguments for the Projansky Contract

The best argument for the Projansky contract may simply be that it is an equitable proposal. Artists should receive part of the appreciation in value of work and maintain certain controls over work after sale. The purchaser who refuses to purchase a work under such conditions fails to respect the integrity of either the artist or the artist's work. Copyright laws are most beneficial for works which are intended for mass production and sale, not for unique or original works which may well not be reproduced during the artist's lifetime. Also, since the payment back to the artist need only be made if the work appreciates in value, the purchaser will necessarily have made a profit each time such a payment must be made. And frequently an artist's early works represent the crucial period during which the artist's sensibility developed. Such works will always have a special aesthetic value to both the artist and the public. Often that aesthetic value will be translated into a substantial discrepancy between the prices such works bring compared to prices for later work. This would certainly be the case, for example, with an artist like de Chirico whose early surrealist work was crucial to an entire movement while his later work received no acclaim.

A Compromise

The use of the Projansky contract will depend on bargaining power. Any artist who can persuade a purchaser to use the contract would certainly be justified in doing so. Even greater restrictions could be required by the artist—for example, that the work not be resold by the purchaser for a certain period of time. However, many artists will wish to modify the Projansky contract in ways which are more favorable to the purchaser. Bob Projansky suggests, for example, placing a higher value for the work in Article 1 so the gross art profit is initially less. Another alternative Projansky proposes is to have the 15 percent of gross art profit be used as a credit against the purchase of additional works from the artist. But it is possible to go beyond Projansky's proposals for modification. For example, the 15 percent of gross art profit could be changed to a lower figure. Or the contract might require that only the first purchaser, but not subsequent purchasers, be bound to pay the 15 percent of appre-

ciated value. This is proposed by the Jurrist contract, a variant of the Projansky contract drafted by lawyer Charles Jurrist, which also includes a warranty by the artist as to the uniqueness or originality of the work.[2] The artist might be willing to go even further and completely omit any requirement for payment of a part of appreciated value, but keep the requirements giving the artist privileges of control after the work is sold.

The issues raised by the Projansky contract penetrate to a deeper level than mere contractual negotiations. In fact, the very concept that art can be treated as a commodity at all like other commodities is brought into question. Each artist will find a personal answer to either the fairness or the practicality of the Projansky contract, but there can be no doubt of the value of this innovative contract in bringing such issues to the attention of both artists and the public.

Commissioned Design and Art Agreements

The Commission Agreement for Design of Art Work (referred to as the "design agreement") and the Work of Art Commission Agreement (referred to as the "commission agreement"), shown at pp. 73–76, are the creation of artists P. Richard Szeitz and Patricia McGowan Szeitz of the Upper Midwest Artists Association based on their experiences with the commission process and clients as well as the advice of lawyers with whom they consulted. They suggest that the contracts be used with the Projansky contract (commission agreement, Article 1), but the design agreement and commission agreement alone provide a good starting point for the artist who has been approached to create a commissioned work.

The crucial terms of a contract for a commissioned work must attempt to ensure that the purchaser will be satisfied with the finished work, while letting the artist be certain that the work in progress is, in fact, satisfactory. Of course, the artist should never agree to satisfy the purchaser, except perhaps to agree to create a work which reasonably should satisfy the purchaser, but, on the other hand, satisfaction must be the artist's goal. The more opportunities provided for consultation and approval in the process of creation, the better the likelihood of success in this regard. The design, whether a separate contract or a separate provision of the commission contract, provides the first opportunity to see

whether the artist and purchaser mutually understand one another with regard to the intention and execution of the work. If, however, step-by-step consultation still leaves the purchaser unsatisfied, both the design agreement, in which the purchaser "acknowledges familiarity with the style and quality of the work of the Artist," and the commission agreement, which permits the artist to make changes while going forward with "his best aesthetic judgement," indicate that the purchaser has no right to anything more than a work which should reasonably be satisfactory in view of the artist's particular style.

The design agreement contains the artist's agreement to design the work in preparation for creating it. The approximate budget, size of the finished work, materials, construction, scope of the artist's work, and responsibilities of the purchaser, such as posing or providing work space, are all specified (Article 1). The design fee must be paid upon signing the design agreement (Article 2). A completion date for the design is specified and the purchaser must notify the artist within ten days of any proposed changes in the design (Article 2(a)). If more than a certain number of designs must be done, the artist is entitled to receive additional compensation on an hourly basis (Article 2(b)). In the event the purchaser decides not to have the work created, the artist retains the design fee and all rights in the designs remain the property of the artist (Article 2(c); Article 3). The purchaser is not allowed to make a public display or commercial use of the designs without the artist's consent and a payment to the artist of no less than 10 percent of any revenues (Article 3). Having specified the rights of the parties at the earliest stage of their relationship, the design agreement then looks to the satisfactory completion of the designs and the continuation of work under the commission agreement (Article 2(d)).

The commission agreement gives the details regarding the work and includes a definite price. In order to be certain the parties are in agreement as to the satisfactory progress of the work, a sequence of three progress payments is used. The first payment is made upon signing the commission agreement, the second when the work is two-thirds completed, as shown by photographs or the purchaser's inspection, and the final payment (with any sales tax) upon completion of the work. Although the commission agreement (Articles 1 and 5) provides for use of the Projansky contract (Agreement of Original Transfer of Work of Art), the artist may not wish to use the Projansky contract for certain commissions. Also, it would be better to incorporate any provisions which the artist does want from the Projansky contract into the commission agree-

ment at the time of signing rather than to refer by name to a contract with which the purchaser may not be familiar.

A date is provided for final delivery of the work, but the artist will not be liable for damages in the event of delays (Article 2). If the artist cannot finish the work within sixty days of the delivery date, the artist must return all progress payments to the purchaser but retains all rights to "the concept, design and the Work itself" (Article 2(a)). The purchaser might well insist either that specific reasons, such as illness or act of God, be given to excuse delays or that the purchaser have an option to accept the partially completed work rather than merely to receive back the payments to date. Also, it might be wise to specify where the work is to be received, any installation which may be necessary, and who will pay for insurance and the costs of transportation. Since the artist is excused from any penalties other than return of payments if the work isn't completed, the purchaser might also object that it is harsh to charge interest on unpaid progress payments and at the same time to give the purchaser no rights in the work until the final payment is made (Article 3).

Article 4 bears on the satisfaction problem. Here the purchaser may refuse to continue payments without any liability for damages, but the artist retains all payments and all rights to the work. Since the artist has done the work, it would be unfair to return the payments. Also, if the purchaser isn't satisfied with the work, there is no purpose in giving the incomplete work to the purchaser. Of course, the purchaser might argue for a return of the payments in such a situation, but that is a matter of the relative bargaining strengths of the parties.

The agreements—or a single design and commission agreement if the artist prefers—can be simpler or more sophisticated depending on the work. If the work will be of very long duration, more than three progress payments would be reasonable. The purchaser may require the artist to maintain insurance on the work in progress so that the work can be replaced at no cost to the purchaser in the event of damage or theft. Also, a provision should definitely be included governing the effect of the death of either the artist or the purchaser while the work is in progress. If the artist dies, a fair provision might be to have the work, in whatever stage of progress, belong to the purchaser, while the payments to the date of death remain in the artist's estate. The same provision would be reasonable where the death of the purchaser makes further performance impossible—for example, a portrait. Otherwise the estate of the purchaser should be required to perform as if the purchaser were living.[3]

These are not all the possible terms of an agreement for a commis-

Confirmation of Engagement Form

(Your Letterhead/or your Name & Address)

1 Date _____

2 Client _____

3 Address _____

4 Commissioned by _____

5 Job # _____

6 Client's Job # _____

7 Number of Illustrations _____

8 Due Date for Sketches if Required _____

9 Due Date _____

10 First reproduction rights only (Fee) _____

11 Other reproduction rights (Fee) _____

12 Other uses and/or rights acquired (Fee) _____

13 Job Description

This engagement is subject to the terms of the Illustrators Guild Code of Fair Practice which appears on the back of this form. All terms apply unless objected to in writing within ten (10) days.

*Original art may be purchased or it remains the property of the artist and must be returned.

Illustrator _____ Client _____

The Illustrators Guild Code of Ethics

1. Orders to illustrators or their agents shall be transacted by way of a written agreement or standard contract which shall state the fee, special compensation when required, due date, name credit, reproduction rights, and a description of the work and the use or uses for which it is intended.

2. The initial fee entitles the employer to first reproduction rights only. Further reproduction or other rights, shall require additional compensation to be agreed upon.

3. All changes not due to the fault of the artist or representative shall require a supplementary confirmation in written form and artist shall receive additional compensation therefor.

4. There shall be no additional compensation for revisions made necessary by errors on the part of the artist or his representative.

5. Alterations to artwork shall not be made without consulting the initial artist, and the artist shall be allowed the first option to make all alterations when possible.

6. Work in progress, cancelled by employer shall be delivered, when required, to the employer and compensated according to the time and effort together with all expenses incurred. Work temporarily stopped by employer shall be considered cancelled after 60 days.

7. Payment is due to the artist and/or his representative no later than 30 days from the date of completion of work. Where extended assignments are involved, partial or advanced payment shall be required.

8. Nonconformance with agreed upon specifications or failure by the artist to deliver the contracted work when due, without prior consent by employer shall be considered a breach of contract and shall release employer form obligation.

9. No artist shall render free services on speculation.

10. There shall be no rebates, discounts, gifts, or payments to employers (including agents or employees of employer) by artists or their representatives.

11. If comprehensives or any preliminary work is published, full fee shall be paid therefor.

12. No artist shall be employed solely to do preliminary drawings or comprehensives with the intention that another artist will be assigned to do the finished work, without the consent of the initial artist at the time of employment.

13. There shall be no plagiarism of any creative artwork.

14. Name credit shall be given the artist for all editorial work. Name credit on advertising work shall be by agreement between the artist and employer.

15. Any agreement between an artist and representative shall be in writing and may take any form agreed to provided that it does not violate the Code of Fair Practice.

16. Samples of an artist's work furnished to an agent or submitted to a prospective employer shall remain the property of the artist and shall not be duplicated without his consent.

17. No samples of an artist shall be shown by a representative anonymously or without express agreement and authorization by the artist.

18. The Joint Ethics Committee shall have the function of discussing, investigating and making recommendations as to the solutions of problems arising out of the construction, interpretation and administration of this Code and as to the abuses or grievances which arise affecting the relationship between illustrators and employers.

sioned work, but knowledge of the more important terms and general approach will enable the artist to negotiate fair and effective agreements where commissions are concerned.

Confirmation of Engagement Form

The Illustrators Guild has developed an excellent Confirmation of Engagement Form (referred to as the "form") for use in confirming job assignments, especially for illustrations or photographs.

The form describes the nature and extent of the work along with a specification of due dates and rights conveyed. These rights, such as first reproduction rights, are more detailed than in the usual sale of a work of fine art where the artist should retain the copyright. This is because fine art is usually not for publication, while the photographs or illustrations are. A detailed discussion of publication rights and contracts is contained in Chapter 11, but an important provision of the form is that only first reproduction rights are sold (Article 2) and the original art work remains the artist's property. Changes, revisions, and alterations are provided for by the form (Articles 3, 4, 5). Canceled work is paid for on the basis of work to date (Article 6), while the artist's failure to deliver work when due releases the employer from obligation (Article 8). Such failure is stated to be a breach of contract and could subject the artist to a suit for damages. Name credit for the artist is specifically provided for all editorial work and for advertising work by agreement (Article 14). Also, the Joint Ethics Committee is empowered to act as a mediator in trying to solve problems arising under the form (Article 18). Such mediation, or an arbitration provision, if the parties are willing, can be a valuable way of solving misunderstandings without the need for expensive litigation.

Ownership of Negatives

Photographers will want to know about an unusual feature of the law relating to negatives. If the photographer works independently, of course, all rights in the works will belong to the photographer: If the photographer works for hire, the person hiring the photographer will own the copyright (but compare the differences between the old and new copyright laws, as discussed at p.13 and p.25). This will mean that the

photographer cannot sell or distribute any copies of those photographs without the permission of the copyright owner. But the photographer will own the negatives, unless the photographer agrees otherwise. The photographer becomes, in essence, a warehouse, storing negatives to meet later requests for photographs from those who originally hired the photographer.[4]

This rule may have ramifications for fine artists who employ photographers to make a photographic record of work. For example, the photographer Paul Juley was hired by portrait artist Everett Raymond Kinstler to photograph Kinstler's paintings. After Juley's death, an issue arose as to ownership of the negatives which Juley had retained. Kinstler said Juley had orally agreed that the negatives belonged to Kinstler and Juley kept the negatives only for convenience. Juley, however, had bequeathed the negatives with the rest of his work to the Smithsonian Institution. Kinstler, presumably barred by the rules of evidence from giving self-serving testimony regarding a contract with a man no longer living, found that the general rule applied giving ownership of negatives to the photographer. So the negatives today belong to the Smithsonian Institution. Part of the moral here is, again, to use written agreements.[5]

COMMISSION AGREEMENT FOR DESIGN OF ART WORK

The Collector _____,
residing at _____,
acknowledges sufficient familiarity with the style and quality of the work of the Artist _____, residing at _____.
The parties have made and entered into this agreement on this _____ of
_____, 19___.

1. DESCRIPTION. The Artist in consideration of the covenants and agreements herein contained, agrees to design _____
(hereinafter "Work") as preparation for its creation by the Artist for an approximate production budget of between $_____ and $_____.

a. Approximate size of finished Work:

b. Material & construction:

c. Scope of the Artist's work:

d. Collector is responsible for:

2. DESIGN AGREEMENT. The receipt of good and valuable consideration of $_____ on this day for the design work to be provided by Artist after signing of this agreement is hereby mutually acknowledged.

a. Artist agrees to provide reasonable study, sketch or maquette of the Work to the Collector on or about _____ (date). Upon receipt of design, the Collector shall notify Artist within ten (10) days of any proposed changes in design.

b. Artist will provide a maximum of _____ designs or revisions for this Work. Additional designs or revisions shall cost an additional design fee of $_____ per hour.

c. If Collector decides to not proceed with creation of the Work, all designs must be returned to Artist, Artist shall retain the design fee, and this agreement shall be terminated.

d. If Collector determines to proceed with creation of the Work pursuant to a selected design, the WORK OF ART COMMISSION AGREEMENT must be completed and signed by both parties, and the first one-third progress payment will be paid at that time.

3. COPYRIGHT. It is agreed that all designs are instruments of service and shall remain in the possession of and the property of the Artist, and thereby Artist retains the exclusive right to use and create Works according to the designs. Collector agrees to make no public display or commercial use of the designs, or any copy or facsimile thereof, without the Artist's consent. It is agreed that if consent is granted for commercial use, the Artist shall be entitled to a minimum of ten percent (10%) of any and all consideration paid or exchanged for such commercial use.

IN WITNESS WHEREOF the parties have hereunto set their hands.

By _____ By _____

Artist Collector

WORK OF ART COMMISSION AGREEMENT

On this _____ day of _____, 19_____,
_____ (Collector) has selected the design and given the
final approval for _____ (Artist) to proceed with the crea-
tion of this Work of Art:

Title:
Materials:
Approximate size upon completion:
Price:
Description of the Art Work:

Scope of the Artist's work:

Collector is responsible for:

1. PROGRESS SCHEDULE AND PAYMENTS. Collector agrees to pay to Art-
ist one-third (1/3) of the price of the Work ($_____) at this time or
within ten (10) days.

Collector agrees to pay an additional one-third (1/3) of the cost of the Work
($ _____) when the Work is approximately two-thirds (2/3) com-
pleted. Documentation of the progress of the Work may be made by
photographs of the Work or by the personal inspection of the Collector at the
discretion of the Artist.

Upon nearing completion of the Work the Artist will give the Collector five
(5) days advance notice of specific date of delivery so that Collector will be
ready to receive the Work, make the final payment ($_____), and sign
the AGREEMENT OF ORIGINAL TRANSFER OF WORK OF ART. Any Sales
Tax that may be required by law will be paid at this time ($_____).

a. It is hereby understood and agreed that it may not be possible to create
the Work exactly as depicted in the design, and the Artist shall only be bound
to use his best aesthetic judgment to create the Work according to the style
and intent of the design. The Artist is hereby free to make design modifica-
tions as the Work progresses.

2. FINAL DELIVERY. The parties agree that final delivery of the Work will
be made on or about _____. The Artist will make every
effort to honor and meet this deadline. It is agreed, however, that this delivery

date is an estimate only and that Artist shall not be responsible for any general, special or consequential damages for failing to deliver by this date. The Artist will immediately notify Collector of any delay occurring or anticipated.

a. In the event the Artist is unable to finish the Work within sixty (60) days of the estimated delivery date, or is unable to produce the Work for any reason, the Artist shall be liable for no special, general or consequential damages, but the Artist shall return all payments received. The Artist shall retain all rights to the concept, design, and the Work itself.

3. DELAYED PAYMENTS. In the event Collector fails to make the progress payments when due, interest at the rate of three-fourths percent (3/4%) per month shall be assessed against the unpaid balance due. In addition, the Artist has the right to retain all previous payments plus all rights to the Work until full payment is made. It is understood that delay of any payment may proportionately extend the time required to complete the Work.

4. TERMINATION OF AGREEMENT. If Collector does not find the Work as it progresses fulfilling his expectations or needs and therefore wishes to terminate the agreement, Collector shall immediately notify the Artist of the termination. The Artist shall thereupon be entitled to retain all payments which Artist has received or was entitled to receive pursuant to this agreement prior to such notification. Further, the Artist shall retain all rights to the concept, design and Work itself, including the right to complete, exhibit and sell the Work.

5. TRANSFER OF WORK OF ART. It is hereby stated and acknowledged that Artist retains all rights and title to the Work until final payment has been received and the AGREEMENT OF ORIGINAL TRANSFER OF WORK OF ART has been duly completed and signed by the parties.

6. ATTORNEYS' FEES. In any proceeding to enforce any part of this contract, the aggrieved party shall be entitled to reasonable attorneys' fees in addition to any available remedy.

IN WITNESS WHEREOF the parties have hereunto set their hands.

By _____ By _____
　　　　　　　　Artist　　　　　　　　　　　　　　　　　Collector

8

SALES BY GALLERIES AND AGENTS

The artist will often seek professional assistance in selling work. Relationships with galleries and other agents can take numerous forms.[1] Arrangements are often oral, although the artist should insist on written agreements whenever possible. This chapter details many of the considerations involved in such agreements, but the artist should, as always, consult a lawyer for individual advice when such agreements are being negotiated.

An organization of interest to artists is the Art Dealers Association of America, Inc., 575 Madison Avenue, New York, New York 10022, which represents over one hundred of the more established galleries. The association's Activities and Membership Roster states, "Its general purpose is to promote the interests of persons and firms dealing in works of fine art, to improve the stature and status of the fine arts business and to enhance the confidence of the public in responsible fine arts dealers." Membership requires "that the prospective member-gallery shall have a good reputation in its community for honesty and integrity in its dealings with the public, museums, artists and other dealers." Unfortunately, the association has not yet evolved a code of ethics to which all galleries might refer in seeking fair guidelines for business dealings with artists.

Consignment or Sale

The usual agreements in the United States involve work consigned to a gallery which has either a limited agency to represent only that particular work or an exclusive agency to represent all the artist's work. The artist

remains owner of the work and the gallery receives a commission on sale or rental.

If agreements are informal and unwritten, questions can arise whether a work has been consigned or sold to a gallery. New York and California have both enacted statutes providing that any fine art left with an art gallery or dealer is held on consignment in trust for the artist.[2] Any money from sales of such work is also held by the gallery in trust for the artist. Even if a consigned work is subsequently purchased by the gallery, the work remains trust property held for the artist until full payment has been made. Creditors of the gallery have no right to make claims against the work or funds held in trust for the artist, even if the artist's rights to the work or funds have not been protected from creditors by filings of the financing statements required under the Uniform Commercial Code.[3] Any waiver of these favorable rights by the artist will be invalid. The New York statute does allow the artist to give up his rights to have sale proceeds considered trust funds. This applies only to sales proceeds greater than $2,500 per year. The waiver must be written and, in any case, will not apply to works initially on consignment which are purchased by the gallery. The California statute requires first payment of the trust funds to the artist unless the artist agrees otherwise in writing.

Artists who live outside New York and California should take careful note of the fact their states do not have such statutes. Written consignment agreements are a necessity to protect the artist by showing the artist's ownership of the work. A simple consignment agreement, where the gallery's agency is only for the sale of a given work or works, would specify the gallery's receipt on consignment of certain works which would be listed by title, medium, size, retail selling price, and the gallery's commission percentage on each work. The agreement would also state when payment must be made to the artist and indicate that the artist remains owner of the work until title passes to a purchaser. The agreement should provide for the return of the work upon the artist's request. Also, it would be specified that the agreement was not a general agency and the artist would have no responsibility to pay commissions on works other than those consigned.

A simple consignment agreement appears on p.79, but this agreement could encompass many more aspects of the relationship between the artist and dealer.[4] The chapter will focus on agreements where the gallery represents all or most of an artist's output over a period specified in the contract. But many of the provisions relevant to such representation

Dear Sir:

You hereby confirm receipt on consignment of my art works as follows:

	TITLE	MEDIUM	SIZE	RETAIL PRICE	COMMISSION
1.					
2.					
3.					
4.					
5.					

I reserve title to the works until sale, at which time title shall pass directly to the purchaser. You shall remit to me the retail price of each work less your commission within a reasonable time after sale. This consignment applies only to works consigned under this agreement and does not make you a general agent for any works not so consigned.

At any time before sale of the works you will return the works to me immediately upon my request.

Sincerely yours,

Artist

CONSENTED AND AGREED TO:

Gallery

By: _____

agreements can be used in the simple consignment agreement as dictated by the given transaction.

The less common arrangement of outright purchase by the gallery might involve a situation where the gallery would wish to be the exclusive seller of the artist's work. Alternatively, the gallery might require either a given portion of the artist's output or a right of first refusal on all work. The gallery might also want to fix the prices at which the artist could make private sales. The outright purchase arrangement is rare, however, and this chapter will concentrate on representation agreements

where work is consigned in an ongoing relationship of representation between the artist and the gallery. A model form of artist-gallery agreement (referred to as the "model agreement") has been drafted by the Bay Area Lawyers for the Arts and appears at pp. 89–97.

Parties to the Agreement

When a gallery serves as agent for an artist, the representation agreement creates a bond of trust and an obligation of good faith dealing on the part of the gallery. Often the gallery will be required to exercise best efforts to sell the artist's work, although this clause is difficult to enforce (model agreement, Article 5). In addition to assurance of certainty that the gallery deals only for the artist's interest, the artist can also expect the gallery to maintain as confidential information about transactions executed for the artist.

The artist will be especially reassured that the gallery will live up to this fiduciary role, however, when the artist personally knows and trusts the gallery personnel. The artist might well wish to provide for termination of the agreement in the event of the death of a trusted dealer, a change of personnel, a transfer of ownership of the gallery, or even a change in the legal form of a gallery. The model agreement partially deals with this by prohibiting assignment of the agreement (Article 19). The artist might also want to be certain that the location of the gallery would remain the same and, perhaps, that all art work consigned would be kept at that location.

The gallery may in turn request certain assurances of fair dealing by the artist (model agreement, Article 4). These might be in the form of warranties that the artist is the creator of the work and has title to the work.

Scope of the Agency

The artist may choose, in a number of ways, to circumscribe the gallery's authority as agent.

The geographic extent of the agency could be limited to a single city or country instead of the entire world (model agreement, Article 1).

The duration of the contract should be limited (model agreement, Article 17), with provision made for the return of work and costs of return at

the end of the term (model agreement, Article 18). The artist should probably hesitate to enter into an agreement for more than two years, unless the contract provides the artist with a right of termination—for example, on 30 or 60 days notice (model agreement, Article 17). A shorter term could also be extended by options to renew.

The kinds of work which the agreement will cover is an important provision (model agreement, Article 2). The gallery may want to receive a commission even on work which the artist sells (model agreement, Article 7(c)). If the gallery sells only the artist's paintings, it must be resolved whether the gallery will receive commissions on the artist's sales of work in other media, such as drawings or graphics. Also, will the gallery be entitled to a percentage when the artist is commissioned for a work (model agreement, Article 7(c)), gives away a work either to a family member or to a charity, or barters a work to pay dentist's or accountant's bills? The gallery may demand a right to a percentage when the artist sells work created before the agency relationship was established or after the agency terminates. One possible resolution would be to exempt a certain number of works or dollar value of sales by the artist from the requirement of the gallery's commission. This approach is particularly feasible where the artist is not located closely enough to the gallery to be competitive. Or the artist might simply wish to limit the proportion of output which the gallery would have a right to demand. This raises a related issue of the gallery's right to inspect the artist's studio to see work, but, in fact, the artist would normally welcome such interest on the part of the gallery.

Few contracts will provide for all the possible contingencies discussed, yet the artist must be aware of the different limitations which can be placed upon the gallery's authority as agent.

Exhibitions

The artist will want to be guaranteed an exhibition each year (model agreement, Article 11). The dates (during the exhibition season), duration, space, and location of the exhibition should all be specified. Also, the costs of the opening, advertisements, catalogs, announcements, frames (and ownership of the frames after the exhibition), photographs of the work, shipping either to purchasers or for return to the artist, storage, and any other costs should all be detailed as either the gallery's or the artist's responsibility. The artist may demand a specific budget, especially for publicity and advertising. The artist should avoid any

situation where the gallery might later seek to place a lien on the work, perhaps refusing to return it, for costs incurred under the agreement. The artist may also wish a specific provision ensuring the confidentiality of the artist's personal mailing list. However, consent will usually have to be made to use of the artist's name, biography, and picture in the publicizing of the exhibition. The artist might also wish the gallery to use best efforts in seeking museum exhibitions for the artist. In return, the gallery might request a complimentary credit on any loans by the artist to museums or in any magazine articles displaying the artist's work.

Another important consideration in exhibitions is artistic control. The artist will wish to avoid inclusion in a group exhibition without the power to prevent inappropriate work being shown in the same exhibition (model agreement, Article 11). Also, the artist should control the choice of work and the manner of display of the work in either a solo or group exhibition. At the same time the protection of the artist's reputation may require control over the publicity and advertising relating to the exhibition. An extreme form of control would be the power to prevent any given purchaser from buying a work. Or the artist might simply insist by an appropriate clause in the representation agreement that a contract specified by the artist (such as the Projansky contract) be used for all sales (model agreement, Article 14).

Gallery's Commissions

There are two ways in which a gallery may take compensation upon the sale of consigned work. The net price method specifies an amount—for example, $1,000—which will be paid to the artist in the event of sale. The gallery may then sell the work at any price, $1,500 or $4,000, and pay the artist the $1,000 originally agreed upon. The net price method is not common, especially if the artist lacks control over the gallery's selling price, because of its possible unfairness.

The commission method, where the gallery takes a percentage of the sale price, is much more common (model agreement, Article 7). The percentage varies greatly, but 25 percent to 60 percent would be the usual limits of the range. If the gallery's commission is 50 percent, a sale of a $3,000 work will yield the artist $1,500. One risk the artist faces here is the computation of the value to be assigned a given work where a global invoice—that is, an invoice including many works—is used. If ten paint-

ings are sold for $20,000, the artist who owned one of the works may feel the value assigned that work, $1,000 or $2,000 or $3,000 is arbitrary. The artist can prevent this problem from arising by specifying a sale price in advance.

The artist whose work is expensive to construct might request that the cost of materials be subtracted from the sale price before the commission of the gallery is taken. Or the artist might request different commission rates for works done in different media. A sliding scale based on the amount of sales would be another possible commission arrangement. Also, the problem of double commissions, where one gallery consigns a work to a second gallery, must be resolved.

The right of the gallery to rent work will be determined by the agreement (model agreement, Article 10). If this is permitted, a commission rate against such rental income must be specified. Also, the agreement will then need certain additional articles detailing rental rates, copying restrictions, and, especially, insurance.[5] The representation agreement should also indicate whether the gallery will receive commissions on lecture fees, prizes, copyright royalties, or other similar income received by the artist.

Pricing

Both gallery and artist will generally wish to control prices. The gallery may wish to sell more cheaply to maintain a volume of sales, while the artist may wish to keep prices higher for the enhancement of reputation which accompanies steadily rising values for an artist's work. Usually, prices are set by consultation between the artist and the gallery (model agreement, Article 6). The agreed-upon prices may then be set forth in a schedule attached to the agreement (model agreement, consignment sheet). The agreement may well give the gallery the power to vary prices slightly—for example, 10 percent—for flexibility. Also, the agreement will have to provide for the discounts which are customarily given certain purchasers, such as museums. If the gallery has complete power to set prices, the artist should beware of sales at low prices to dummies—persons who seem to buy the work when, in reality, they are holding the work for the gallery to sell later at higher prices.

The artist may want to restrict the gallery as to the prices placed on works of the artist to be sold by the gallery for its own account or for

other galleries or collectors. Also, if the gallery has the right to sell works at auction, the artist may wish the gallery to guarantee receipt of an acceptable fair market price at auction. If the gallery sells through other galleries, the artist should require that the other galleries maintain the prices set in the agreement with the original gallery.

Accounting

The artist will want the gallery to regularly record all business transactions in books which the artist may inspect. Periodically, perhaps every three or six months, statements of account indicating sales, commissions, and proceeds due the artist should be sent out by the gallery. (model agreement, Article 13; Statement of Account). The artist will wish to receive the names and addresses of all purchasers, which most galleries will be willing to provide. If the gallery objects, a compromise might be to have a list of purchasers held by a third party so the artist will not be cut off from the work but the gallery will have its market protected.

Payments

The artist must feel confident that the gallery will meet payment obligations with reasonable promptness (model agreement, Article 8). The gallery may want corresponding assurances as to payments of commissions based on sales made by the artist. If credit is extended to a purchaser, the risk of loss should be the gallery's (model agreement, Article 8). The artist should be paid even if the purchaser defaults or, at least, have a right to the first proceeds received by the gallery from the purchaser. If the gallery has the right to accept works in payment for the artist's works sold, a fair method of valuation must be agreed upon. The respective percentages of the artist and gallery would then be applied to this valuation instead of a sales price. When work may be sold in foreign countries, the artist would be well advised to require payment in American dollars. A provision regarding losses due to delays in converting foreign currencies might also be included in the agreement.

Payments are sometimes made to artists in the form of a monthly stipend. This is an advance given by the gallery regardless of whether sales

have been made. The artist should insist that such advances are nonrefundable. Often the gallery will have the right, if the advance is nonrefundable, to purchase at year end that amount of the artist's work which will pay off the artist's debt to the gallery. The artist must be certain that the work will be purchased at fair prices, such as the prices set forth in the model agreement's consignment sheet. The gallery would receive a discount, of course, equal to its normal commission. But purchases of a substantial amount of an artist's work by a gallery can create an unfortunate tension in the relationship of trust between gallery and artist. While the gallery is an agent, bound to deal in good faith for the interest of the artist, the gallery may promote and sell its own inventory instead of those works the artist has given on consignment. The artist may find the gallery has become an alter ego, competing with the artist instead of remaining a loyal agent. But this risk will have to be balanced in each case with the advantages of the regular income provided by a monthly stipend.

Copyright

The artist should require the gallery reserve all copyrights to the artist upon sale and also take steps to protect the artist's copyrights (model agreement, Article 15).

Creditors of the Gallery

The statutes of both New York and California, mentioned earlier, protect the artist from claims by creditors of the gallery against works on consignment (model agreement, Article 16). Title to the work is transferred directly from the artist to any purchaser. The funds received by the gallery become trust funds and must be paid first to the artist regardless of creditors' claims.

The absence of such provisions in the laws of other states should be a warning to artists outside New York and California. The artist risks complex legal entanglements if a gallery's creditors claim rights to consigned works after the gallery has become bankrupt. For this reason, the artist should try to establish the financial stability of any gallery prior to consigning works. However, an agreement might also provide for termina-

tion in the event the gallery's financial condition becomes untenable, as shown by bankruptcy, insolvency, an assignment of assets for the benefit of creditors, a lien or attachment against the gallery not vacated within a reasonable time, or appointment of a receiver or trustee for the gallery or its assets. The gallery would be required in such circumstances to return immediately all work as well as money held for the artist. The agreement might also specify that the work and any proceeds from sales would be held in trust for the artist and not subject to the claims of creditors of the gallery.

But the Uniform Commercial Code provides that creditors have rights against consigned goods.[6] These rights can be cut off if the person consigning the goods, such as an artist, complies with certain filing provisions to gain a secured interest in the work consigned. Compliance with these provisions, however, is a problem for the artist who will find galleries rarely willing to agree to such a filing. This approach should certainly be considered, however, as the safest alternative where works of great value are being consigned. The creditor's rights are also cut off if the artist's interest as the person consigning the goods is shown by a sign hung in the gallery—a procedure hardly ever followed. Or the creditor's rights could be cut off if the artist could prove the gallery was known to its creditors as being substantially engaged in the sale of goods of others. This raises a burden of proof which can be difficult for the artist to satisfy. For artists outside New York and California, the safest course may be simply to make a close examination of the financial stability of the gallery before consigning any work.

Damage, Loss, Theft, Insurance

The Uniform Commercial Code requires return of consigned work to be at the gallery's "risk and expense." [7] This imposes a far higher standard on the gallery than a bailment would (model agreement, Article 12). The artist should still require a provision stating that the gallery is responsible for the safekeeping of the work and, in the event of loss, damage, or theft, will pay the artist as if the work had been sold. In case of damage the artist might seek either the right to compensation for any restoration done by the artist or control over restoration done by any other party.

The gallery should be required to insure the work so there will definitely be money to pay the artist in the event of loss, damage, or theft

(model agreement, Article 12). The artist should, if possible, be named as a beneficiary of the insurance policy. The insurance may not be for the retail value of the work, but must be sufficient to pay what the artist would normally receive upon sale. The artist might wish to take a separate policy to increase coverage on the work to 100 percent of retail value. Also, the work should be insured while in the artist's possession or in transit to the gallery if not covered by the gallery policy. The artist whose works could be dangerous to either persons or property may want insurance for injuries or damages caused by the work itself. The artist and gallery could agree as to the payment of premiums in such a case.

Customs

If the gallery will be selling work abroad, the artist will want to be certain the gallery complies with customs regulations. Many countries place no duty on original works of art but require a bond to be posted upon entry to the country in case the work is sold. Upon sale the bond will guarantee payment of a value added tax, but otherwise the bond is returned when the works are taken from the country. Where countries do place duties on original works, the work may have to be declared valueless and shipped without insurance to avoid paying duties.[8] In such case the artist would want the gallery to take responsibility for loss, damage, or theft of the work. The consulates of each country can provide assistance to both the gallery and the artist seeking to comply with customs regulations.

Other Provisions

The artist will have to decide whether the artist's death should terminate the agreement or whether the gallery should continue to sell the consigned work and pay the proceeds to the artist's estate. This provision will have to correspond to the plan developed for the artist's overall estate. If a crucial person at the gallery dies or the gallery goes out of business, the agreement should require an accounting, payment to the artist for all funds due, and a return of all works.

The agreement will provide for modification to be in writing (model agreement, Article 21), that a waiver of a right is not permanent and affects no other rights under the agreement, that the parties will arbitrate

disagreements (model agreement, Article 20), that if one provision of the contract is invalid the rest of the agreement will remain in effect, and that the law of a specific state will govern the agreement (model agreement, Article 22).

No agreement between an artist and a gallery is likely to contain all these possible provisions, but the artist's familiarity with the potential scope and details of such an agreement will enable the artist to forge more effectively the artist's relationship to a gallery.

Cooperative Galleries

Cooperative galleries often provide a welcome outlet for the artist who has difficulty in establishing a relationship with a commercial gallery.[9] A group of artists normally contribute funds to establish and maintain the gallery in which their own work will be shown. Some cooperative galleries have sought status as federal tax-exempt organizations by making their primary function the service of the public through educational activities such as lectures, workshops, employment information, and exhibitions of the work of both members and nonmembers without offering the work for sale. If the work of members was offered for sale, however, the cooperative gallery would probably not qualify for tax exemption. Such exemption was denied where "the cooperative gallery . . . engaged in showing and selling only the works of its own members and is a vehicle for advancing their careers and promoting the sale of their work. It serves the private purpose of its members, even though the exhibition and sale of paintings may be an educational activity in other respects." [10] But, regardless of tax status, many artists would value that promotion. It is important, however, to remember that the cooperative gallery is a legal entity separate from the artists who compose its membership. Thus, the artist should anticipate that nearly all the problems of dealing with commercial galleries can arise when the artist joins a cooperative gallery.

Agents

Photographers and illustrators may use agents for sales of work. Most illustrators' agents represent the illustrator individually in selling work and seeking assignments. Photographers can be represented individually,

but may also use a stock agency which maintains exclusive sales rights over the photographs submitted to the agency by many photographers. Conceptually, the concerns of the illustrator or photographer with respect to agents are much the same as those of the fine artist. The parties to the agreement, scope of the agency, promotion of the work, commission rates for the agent, prices, accountings, payments, rights of creditors, risks of loss or theft or damage, insurance, and responsibilities for costs incurred will all have to be considered and specified in the agreement. A good sample agreement for the photographer to consult is the Photographer-Representative Form Agreement drafted by ASMP.[11] The Society of Photographer and Artist Representatives, Inc., also has an agreement which it makes available to its member agents for their use in representing artists.

BAY AREA LAWYERS FOR THE ARTS
ARTIST-GALLERY AGREEMENT

This Agreement is made the _____ day of
_____ 197__ between:

NAME: _____
ADDRESS: _____

PHONE: _____ ("the Artist")

and

NAME: _____
ADDRESS: _____

specify legal
organization
e.g., "corporation"

PHONE: _____ ("the Gallery")
which is organized as a _____

The parties agree as follows:

Specify geograph-
ical area
e.g., "San Francisco"

1. AGENCY. The Artist appoints the Gallery his/her agent for the purpose of exhibition and sale of the consigned works of art in the following geographical area: _____

2. CONSIGNMENT. The Artist shall consign to the Gallery and the Gallery shall accept consignment of the following works of art during the term of this Agreement:

☐ All new works created by the Artist (in the following media: _____)

check
whichever
apply

☐ All works which the Gallery shall select. The Gallery shall have the first choice of all new works created by the Artist (in the following media: _____)

specify
particular
media
(if any)

☐ Not less than _____ new works per year (in the following media: _____)

☐ All new works created by the Artist excluding works reserved by the Artist for studio sales and commission sales made directly by the Artist

☐ The works described in the Consignment Sheet (Schedule A of this Agreement) and such additional works as shall be mutually agreed and described in a similar Consignment Sheet

The Artist shall not exhibit or sell any consigned work outside the Gallery without the prior written approval of the Gallery. The Artist shall be free to exhibit and sell any work not consigned to the Gallery under this Agreement.

specify Artist
or Gallery

3. DELIVERY. _____ shall be responsible for delivery of the consigned works to the Gallery. All costs of delivery (including transportation and insurance) shall be paid as follows:

(a) _____% by the Artist
(b) _____% by the Gallery.

4. TITLE & RECEIPT. The Artist warrants that he/she created and possesses unencumbered title to all works of art consigned to the Gallery under this

Agreement. Title to the consigned work shall remain in the Artist until he/she is paid in full. The Gallery acknowledges receipt of the works described in the Consignment Sheet (Schedule A of this Agreement) and shall give the Artist a similar Consignment Sheet to acknowledge receipt of all additional works consigned to the Gallery under this Agreement.

5. PROMOTION. The Gallery shall make reasonable and good faith efforts to promote the Artist and to sell the consigned works as follows: _____

specify
promotional
efforts

_____.

6. SALES PRICE. The Gallery shall sell the consigned works at the retail price mutually agreed by both parties and specified in writing in the Consignment Sheet.

specify discount
percentage (if any)

The Gallery shall have discretion to vary the agreed retail price by _____% in the case of discount sales.

7. SALES COMMISSION. The Gallery shall receive the following sales commission:

specify
1st medium

(a) _____% of the agreed retail price for selling works in the following medium: _____.

specify
2nd medium
(if any)

(b) _____% of the agreed retail price for selling works in the following medium: _____.

optional

(c) _____% of the amount paid for studio sales or commission sales made directly by the Artist.

The remainder shall be paid to the Artist. In the case of discount sales, the amount of the discount shall be deducted from the Gallery's sales commission.

8. PAYMENT.

(a) On outright sales, the Gallery shall pay the Artist's share within 30 days after the date of sale.

(b) On deferred payment sales, the Gallery shall pay the Artist's share within 90 days after the date of sale.

(c) On installment sales, the Gallery shall first apply the proceeds from sale of the work to pay the Artist's share. Payment shall be made within 30 days after the Gallery's receipt of each installment.

California
Civil Code
Sec. 1738.6(d)

As provided by California law, the Gallery shall hold the proceeds from sale of the consigned works in trust for the benefit of the Artist. The Gallery agrees to guarantee the credit of its customers, and to bear all losses due to the failure of the customer's credit.

9. APPROVAL SALES. The Gallery shall not permit any consigned work to remain in the possession of a customer for the purpose of sale on approval for a period exceeding 14 days.

10. RENTALS. The Gallery may not rent any consigned work without the prior written consent of the Artist. The rental period may not exceed _____ weeks unless a longer period is approved by the Artist. The Gallery shall receive _____% of the rental fees, and the remainder shall be paid to the Artist within 30 days after the Gallery's receipt of each rental fee.

11. EXHIBITIONS. The Gallery shall arrange, install, and publicize at least _____ solo exhibitions of the Artist's work of not less than _____ weeks duration each, and shall make reasonable efforts to arrange other solo and group exhibitions thereafter. The Artist's work may not be included in any group exhibition without his/her prior written approval. The division of financial responsibility for the costs of exhibitions and other promotional efforts shall be mutually agreed in advance, and neither party may obtain reimbursement for such costs without the prior written approval of the other party.

California
Civil Code
Sec.1738.6(c)

12. LOSS OR DAMAGE. As provided by California law, the Gallery shall be responsible for loss of or damage to the consigned work from the date of delivery to the Gallery until the date of delivery to the purchaser or repossession by the Artist. The Gallery shall insure the consigned works for the benefit of the Artist up to _____% of the agreed retail price.

13. STATEMENTS OF ACCOUNT. The Gallery shall give the Artist a Statement of Account (similar to Schedule B of this Agreement) within 15 days after the end of each calendar quarter beginning with _____

specify month and year

_____, 197__. The Statement shall include the following information:

 (1) the works sold or rented
 (2) the date, price, and terms of sale or rental
 (3) the commission due to the Gallery
 (4) the name and address of each purchaser or renter
 (5) the amount due to the Artist
 (6) the location of all unsold works (if not on the Gallery's premises).

The Gallery warrants that the Statement shall be accurate and complete in all respects. The Artist and the Gallery (or their authorized representatives) shall have the mutual right to inspect the financial records of the other party pertaining to any transaction involving the Artist's work.

optional

14. CONTRACT FOR SALE. The Gallery shall use the Artist's own contract for sale (a copy of which is appended to this Agreement) in any sale of the consigned works.

15. COPYRIGHT. The Artist reserves the common law copyright including all reproduction rights and the right to claim statutory copyright in all works consigned to the Gallery. No work may be reproduced by the Gallery without the prior written approval of the

Artist. All approved reproductions in catalogues, brochures, advertisements, and other promotional literature shall carry the following notice: © by (name of the Artist) 197__ (year of publication).

California
Civil Code
Sec.1738.6(b)

16. SECURITY. As provided by California law, the consigned works shall be held in trust for the benefit of the Artist, and shall not be subject to claim by a creditor of the Gallery. In the event of any default by the Gallery, the Artist shall have all the rights of a secured party under the Uniform Commercial Code.

17. DURATION OF AGREEMENT. This Agreement shall commence upon the date of signing and shall continue in effect until the _____ day of _____ 197__. Either party may terminate the Agreement by giving 30 days prior written notice, except that the Agreement may not be terminated for 90 days following a solo exhibition of the Artist's work in the Gallery.

specify Artist
or Gallery

18. RETURN OF WORKS. _____ shall be responsible for return of all works not sold upon termination of the Agreement. All costs of return (including transportation and insurance) shall be paid as follows:

(a) _____% by the Artist
(b) _____% by the Gallery

If the Artist fails to accept return of the works within _____ days after written request by the Gallery, the Artist shall pay reasonable storage costs.

19. NON-ASSIGNABILITY. This Agreement may not be assigned by the Gallery to another person without the prior written approval of the Artist. The Gallery shall notify the Artist in advance of any change in personnel in charge of the Gallery or of any change in ownership of the Gallery.

20. ARBITRATION. All disputes arising out of this Agreement shall be submitted to binding arbitration. The arbitrator shall be selected in the sole discretion of the Executive Director of Bay Area Lawyers for the Arts, Inc. If such arbitrator is not available, the dispute shall be submitted to arbitration in accordance with the rules of the American Arbitration Association. The arbitrator's award shall be final, and judgment may be entered upon it in any court having jurisdiction therof.

21. ENTIRE AGREEMENT. This Agreement represents the entire agreement between the Artist and the Gallery and supercedes all prior negotiations, representations and agreements whether oral or written. This Agreement may only be amended by written instrument signed by both parties.

22. GOVERNING LAW. This Agreement shall be governed by the laws of the State of California.

IN WITNESS WHEREOF the parties hereto have executed this Agreement on the day and year first above written.

_____ _____

The Artist For the Gallery

CONSIGNMENT SHEET (SCHEDULE A)

RECEIVED FROM:_____ DATE: _____

THE FOLLOWING WORKS OF ART:

	TITLE:	MEDIUM:	SIZE:	RETAIL PRICE:	MAY BE RENTED:
1.					
2.					
3.					
4.					
5.					
6.					
7.					
8.					
9.					

SIGNED BY:

_____ _____
 The Artist For the Gallery

STATEMENT OF ACCOUNT (SCHEDULE B)

ARTIST: _____ DATE: _____

ADDRESS: _____ QUARTER: _____

	TITLE:	RETAIL PRICE:	SALES COMMISSION:	DUE TO ARTIST:
1.				
2.				
3.				
4.				
5.				
6.				
7.				
8.				
9.				

NET AMOUNT DUE TO ARTIST: $_____

For the Gallery

9

VIDEO ART WORKS

The artist's ability to conceive works in new media offers a challenge for the lawyer who must innovate legally. Art on videotape, often combined with pictorial or sculptural elements, is becoming a medium used with regularity by artists. The legal problems of the video artist are for the most part the same as those of the artist using more traditional media. But the possibility of both mass reproduction and public broadcasting of video works raises additional legal dimensions.

Artist-Gallery Agreement

The agreement at pp. 107–109 is between an artist and a gallery for the sale and rental of a video work by the gallery.[1] The video artist must consider all of the issues raised in the last chapter regarding artist-gallery relations, and this agreement specifically deals with the nature and geographic scope of the agency (Article 1), the term (Article 2), the gallery's use of best efforts (Article 3), commissions for sale or rental (Article 4), statements of accounts and payment (Article 4), the quantity of work subject to the agreement (Article 5), prices (Article 7), promotion of work and the artist (Article 9), assignment (Article 10), termination (Article 11), the death of either party or cessation of business by the gallery (Article 12), arbitration (Article 13), modifications to be written (Article 14), and the laws of which state will govern the agreement (Article 15).

The agreement also contains provisions not found where works in more traditional media are being sold or rented. The artist may create a video piece with several videotapes running simultaneously or with videotape to be used in conjunction with photographs, sculptures, or paintings. The artist would not usually want the elements of such work to be exhibited separately. The agreement provides that the sale or rental must be of the entire work (Article 1). Also, the ease of video reproduction makes copyright even more important for the artist working with video than for other artists. For this reason the agreement specifies that the agency is only to sell the physical videotape cassettes and requires the gallery to protect the copyright against infringement (Articles 1 and 3). The gallery must obtain the agreement of each person who purchases or rents a copy of the work not to make further copies (Article 8). The dealer can only replace copies of the work if the purchaser returns the defective or damaged copy originally purchased (Article 5). The gallery must also seek to prevent a purchaser's broadcasting the work or charging admission (Article 8).

The ease of reproduction also bears on another important issue— whether or not to make the video work a limited edition. This decision may turn on many factors, such as the extent of the market, the price enhancement created by limiting the edition, and perhaps even the desire of the artist to maintain a tie to the traditional media where work is usually either unique or original. The agreement provides that no more than fifty copies of the work shall be created, guaranteeing originality, and in this case reserves twenty-five copies to the artist for sale outside the scope of the agreement. The artist might wish to use a signed warranty of originality like that described for photographic works at p. 54. This signature and assurance of the limited number of identical works or works derived from the entire work will reassure the collector as to value in this relatively new art medium.

The cost of creating copies from the master tape is the gallery's responsibility, but the artist keeps control of the master tape and has copyright notice on each copy in the artist's name (Article 6). This particular agreement does not reduce the adjusted gross proceeds specified in Article 4 by the gallery's cost of the copies, although the gallery might insist that such a reduction is only equitable.

If the gallery is to live up to the obligations contained in the agreement, the bill of sale or the rental agreement must conform to the terms restricting the purchaser's rights in the work. The bill of sale at pp.

110–111 therefore places many restrictions on the rights of the purchaser. The artist could also use this bill of sale with minor modifications when selling work directly to purchasers.

Broadcasting

The potentialities of videotape naturally open the possibility of far wider dissemination than art works have traditionally experienced. This potentiality has been recognized in an excellent article, "The Commissioning Contract for Video Artists," and in the contract draft with explanatory notes prepared for the Associated Councils of the Arts by their counsel, Harvey Horowitz, a member of the New York City law firm of Squadron, Gartenberg, Ellenoff & Plesent. The article and contract originally appeared in the June 1975 issue of the *Arts Advocate* and are reprinted here by permission of the Associated Councils of the Arts.

The Commissioning Contract for Video Artists
By Harvey Horowitz

The commissioning contract is standard practice in publishing, film, and commercial television, but it is relatively new for the creative video artist. It is therefore important for the video artist engaged in this field to be aware of the legal ramifications of a video commissioning contract.

In the legal sense a video artist is distinct from an employee for hire who is engaged to make a work for a fee where the finished product belongs to the employer. Video artists are those who conceive and produce their work and view the finished product as their own. They usually function simultaneously as producer, director, cameraman, technician, sound synchronizer, and editor. There is often confusion over the rights to the product of video artists—who owns it and for how long?

The guiding principle the artist should understand is that the artist originally owns the work and all rights connected to it. From that premise on, what any contract does is to exchange part of those rights for certain benefits to both sides. What this contract tries to do is to keep the give and take on an even basis so that the quid is balanced with the quo equally for both parties. It is up to the artist to make sure he is not being short-weighted. Some commissioning stations, for example, begin nego-

tiations with a pretty heavy finger on the scale, claiming that the large costs of production, advertising, etc., entitle them to most of the rights over the work. The argument may hold for the station's employees over whose work the station may have blanket rights, but not for the independent artist who already owns his package, and barters rights in exchange for guarantees of how it is to be used, compensation, and so on.

In television, including public broadcasting, contracts are commonplace. The following contract is not earthshaking, innovative, or novel in the law. It may, however, be innovative for the video artist. It is drafted in the traditional legal format and deals with the issues that matter. The artist should become familiar with the import of its language.

If we could win acceptance for a form contract tilted somewhat in favor of the artist who takes most of the risks, makes the most creative effort, and who, by rights, ought to be the one to propose "terms of agreement," we will have taken another small step forward for the economic rights of artists—a primary and continuing concern of Advocates for the Arts.

CONTRACT DRAFT

Dear _____

This letter will confirm the agreement reached between A. Artist (herein "the Artist") and Broadcasting In Education (herein "BIE").

Par 1 BIE hereby commissions the Artist to create a video work having as a working title, "The High Tower" (herein "the Work"). In connection with the producton of the work Artist shall have the right to use the production facilities of BIE in accordance with Schedule A attached hereto. The Work shall be approximately fifty minutes in length and deal with the subject of high towers. Artist agrees to consult with members of the staff of BIE at reasonable times although it is recognized that all artistic decisions with respect to the Work shall be made by Artist.

Comment: *The main thrust of the commissioning clause is to provide for the Work to be commissioned. Usually it will be unnecessary to describe the Work beyond the title and possibly the subject matter. The Artist should be able to use the facilities of the station and while he may be required to consult with station staff, it should be clear that artistic decisions will be made by the Artist. Schedule A to the agreement is intended to include the details of Artist's permitted use of the station's production facilities including such items as, hours*

and days per week a facility will be available, equipment and supplies available to artist and personnel available to Artist.

Sometimes the commissioning program involves the Artist serving as an artist-in-residence, or performing services in addition to producing the Work. Under such circumstances, the contract should be specific concerning the nature of the additional work to be performed by Artist, the amount of time Artist will be required to devote and additional compensation, if any. If the rendition of these additional services will possibly cause a time conflict for the Artist, the times and dates for the performance of these additional services should be subject to mutual agreement.

Par 2. In consideration for the rights to the Work granted to BIE hereunder, Artist shall be paid the sum of three thousand dollars as a fee for Artist's services payable as follows:

One thousand five hundred dollars upon execution of this agreement; and

One thousand five hundred dollars within 30 days of the completion of the Work or upon broadcast of the Work whichever is earlier.*

The Work shall be deemed completed upon delivery of a finished master tape to BIE. In connection with the creation of the Work, BIE will reimburse Artist for the expenses itemized on the expense schedule annexed hereto.

Comment: *Aside from the obvious fact that the amount to be paid Artist should be explicitly stated, some attention should be given to the language used to describe the method of payment. Care should be taken so that payments are related to objective events, such as selected date or delivery of a finished segment, rather than subjective criteria such as approval or acceptance of the Work. Additionally, if a payment is to be made upon the happening of an event under the control of the station, an outside date should be included in the schedule. Thus, if the last payment is to be made when the program is broadcast, the clause should read: "The final installment shall be paid Artist when the Work is broadcast, but if the Work is not broadcast by November 30, 1976, then the final installment shall be paid Artist on or before said date." If the station agrees to reimburse Artist's expenses, the Artist should be prepared to conform to a station policy on expense vouchers. Some care should be taken in the preparation of the expense schedule so as to avoid disagreements over expenses after they have been incurred.*

Par 3 All right, title and interest in and to the Work and all constituent creative and literary elements shall belong solely and exclusively to the Artist. It is

*Note: *All money amounts and time periods given are, of course, arbitrary, included for the sake of continuity, and are not intended to suggest actual rates and conditions.*

understood that the Artist may copyright the Work in Artist's name. Artist grants BIE the right to have four releases of the Work on station WBIE for a period of two years commencing with the completion of the Work. A release is defined as unlimited broadcasts of the Work in a consecutive seven-day period; such consecutive seven-day period beginning with the first day the Work is broadcast. At the end of said two year period the master tape and all copies of the Work in BIE's possession shall be delivered to Artist by BIE. All rights not specifically granted to BIE are expressly reserved to Artist.

Comment: *The language suggested confirms the principle that the Artist owns all rights to the resulting Work including the copyright. The station can be expected to argue that the Artist is an employee for hire under the copyright law and the copyright should belong to the station. When the contract provides for the Artist to retain the copyright, the Artist should as a matter of practice register the copyright to the Work. The sentence describing the grant of release rights to the station is intended as an example rather than a suggestion. One major area of discussion will be the "rights" issue. In general, the commissioning station will seek to acquire rights to distribute or broadcast the Work in the non-commercial, educational, nonsponsored or public television markets. While most persons involved in the field have some general understanding of the meaning of the foregoing terms, working out wording for appropriate definitions would be useful.*

When dealing with the "rights" question, two issues should be separated. First is the issue of who controls the rights; i.e. who can arrange for broadcasting, and the second is whether there will be a sharing of receipts from the exploitation of rights:

Rights can be granted to the station by the Artist on an exclusive or non-exclusive basis. As a starting point for discussion purposes, I will suggest the following guidelines:

(a) The Artist should not grant a license to the station to exploit or distribute the Work in a market in which the station does not actively participate. Thus, if a station has had no experience dealing with cable television, the station should not request a license in such a market. Certainly, if such a license is granted in a previously unexploited area, it should only be on a non-exclusive basis. Even though the grant of a non-exclusive license has some appeal as a compromise, the Artist would be aware that if the work has commercial value, a distributor may wish to have all the exclusive rights. Accordingly, the fact that there are non-exclusive licenses outstanding might affect the marketability of the Work. On the other hand, if the station is very active in a market, for example distribution to school systems, it might be in the interest of the Artist to have the station serve as a licensee for that market. Under such circumstances the second issue, sharing of revenues or royalties, becomes relevant.

(b) All licenses granted by the Artist should be limited as to geographic area

and as to time. There should be no reason to grant world wide rights in perpetuity to a station unless the artist views himself basically as creating the Work for the station rather than for him or herself.

(c) If the Artist expects to realize a financial return from a grant of a license, the Artist should have the right to terminate the license if certain minimum levels of income are not reached. Thus, purely by the way of example, if the Artist grants the station a seven year license to exploit the Work in the educational market, and the Artist has not received at least $3,000 by the end of the third year of the license, he should have the right to terminate the license.

(d) If the contract gives the Artist a percent of royalties received from the station's exploitation of the Work, at least three principles should be observed. First, percentages should be based on gross receipts rather than profits. From experience whenever the concept of net receipts or net profits is introduced, there is created an area of potential dispute as to what can be deducted from receipts to arrive at net profits. Second, the station should be obligated to remit the Artist's share of royalties at least semi-annually and such royalties should be accompanied by a royalty statement. Third, the Artist should have the right to inspect the books of the station at least annually for the purpose of verifying royalty statements. When royalties are involved, the Artist should at least consider requesting an advance against royalties.

(e) Theatrical, sponsored television, commercial and subsidiary rights should be held exclusively by the Artist. Some or all of these rights, of course, can be granted to the station in return for a lump-sum payment or royalty participation.

(f) All grant of rights of license clauses should end with this sentence: "all rights not specifically granted to the station are expressly reserved to the Artist."

The Artist should recognize that the fee payable under paragraph 2 and the rights granted to the station under paragraph 3 are very much negotiable matters. No general rule covering all artists can be formulated. For example, one artist might be willing to grant greater commercial rights to the station in return for a larger fee. To another artist, however, the amount of the fee could be less important compared with the rights desired to be retained.

Par 4 BIE shall not have the right to edit or excerpt from the Work except with the written consent of Artist. Notwithstanding the foregoing, BIE shall have the right to excerpt up to sixty (60) seconds of running time from the Work solely for the purpose of advertising the telecast of the Work or publicizing the activities of BIE. On all broadcasts or showings of the Work (except the up to sixty (60) seconds publicity uses referred to above) the credit and copyright notice supplied by the Artist shall be included.

Comment: *This clause limits the station's rights to edit or change the Artist's work and limits rights to excerpt except under stated circumstances. The language assumes that the Artist has included a credit and copyright notice in the Work. The station may request the Artist to include an acknowledgment among the credits recognizing the station's contributions to the creation of the Work.*

Par 5 BIE will be provided with the Master Tape of the Work which it shall hold until termination of the license granted to it in paragraph 3 above (or if more than one license has been granted, the clause should refer to the lapse of the last license). BIE agrees to take due and proper care of the Master Tape in its possession and insure its loss or damage against all causes. All insurance proceeds received on account of loss or of damage to the Master Tape shall be the property of Artist and shall be promptly transmitted to Artist when received by BIE. Artist shall receive one copy of the tape of the Work in any tape format selected by Artist. BIE agrees to use its best efforts to give Artist reasonable notice of scheduled broadcast dates of the Work.

Comment: *Custody of master tapes and duplicate tapes will largely depend on the nature and extent of rights to exploit the Work granted or reserved by the Artist. The Artist should understand that usually a station will attempt to disclaim responsibility for caring for the Master Tapes. In general, the law does not impose absolute responsibility on the station to take care of the tape. In the absence of language in the contract, the station will be held to what is described as a negligence standard; that it will be liable for loss of the Master Tape or damage to it if the station has been negligent. While the Artist through bargaining may not be able to improve upon this measure of responsibility, the Artist should not contractually relieve the station of this responsibility to adhere to the negligence standard.*

Par 6 Artist authorizes BIE to use Artist's name, likeness, and biographical material solely in connection with publicizing the broadcast of the Work or the activities of BIE. Artist shall have the right to reasonably approve all written promotional material about Artist or the Work.

Comment: *Because of right of privacy laws, the station must acquire the consent of Artist to use Artist's name, picture or likeness in connection with advertising or trade purposes. The Artist should limit this consent to use in connection with the Work or in connection with promotions for the station. It is of course desirable for the Artist to be able to approve all promotional material relating to the Artist or the Work. However, the station may not readily agree to this proposal. Under such circumstances if the Artist wants specific material in-*

cluded in promotional pieces, Artist should prepare this material beforehand and obtain the station's agreement to include this material in its promotional pieces.

Par 7 Artist represents that he is authorized to enter into this agreement; that material included in the Work is original with Artist or Artist has obtained permission to include the material in the Work or such permission is not required; that the Work does not violate or infringe upon the rights of others, including but not limited to copyright and right of privacy; and that the Work is not defamatory. Artist agrees to indemnify BIE against any damages, liabilities and expenses arising out of Artist's breach of the foregoing representations.

Comment: *Artist should expect to represent to the station that the Work and material contained in the Work are not defamatory, do not infringe upon any copyrights and will in general not violate rights of others. The language of the indemnity or hold harmless clause should be examined closely. The Artist should not be liable to the station unless there has been an actual breach of the representations as distinguished from merely a "claimed" breach of the representations. Some hold harmless clauses are worded so that if someone claims the Work is, for example, defamatory the station is permitted to settle the claim and charge the settlement to the Artist. It is this latter circumstance that is to be avoided. Consideration should also be given to obtaining insurance coverage for the Work against defamation, copyright and right to privacy claims. Stations usually have a form of this so-called "errors and omissions" insurance. Also at least one artist has suggested that stations should be required as a preliminary matter to have its attorney view the Work to determine the probability of defamation or right of privacy claims. Based upon the advice of its attorney, the station would determine whether or not to broadcast the Work. If it elects to broadcast the Work it would then assume the risks of such lawsuits. The rationale for such argument is that a station usually has an existing relationship with a lawyer and, as between the station and the Artist, is in a better position to evaluate the possibility of such litigation and be guided accordingly. This point is being raised for discussion purposes.*

Par 8 In the event BIE files for bankruptcy or relief under any state or federal insolvency laws or laws providing for the relief of debtors, or if a petition under such laws is filed against BIE, or if BIE ceases to actively engage in business, then this agreement shall automatically terminate and all rights theretofore granted to BIE shall revert to Artist. Similarly, in the event the Work has not been broadcast within one year from the date the Work is completed (as the term completed is defined in paragraph 1), then this agreement shall terminate and all rights granted to BIE shall revert to Artist. Upon termi-

nation of this agreement or expiration of the license granted to BIE under this agreement, all copies of the Work shall be delivered to Artist.

Comment: *This clause is intended to terminate the contract if the station should go bankrupt or cease business. Also, while a station usually will not agree to actually broadcast a Work, if it does not broadcast the Work by a given date, the agreement will terminate. Both of these clauses are intended to allow the Artist to find other means of exploiting the Work if the station goes out of business or, in essence, refuses or fails to broadcast the Work.*

Par 9 This agreement contains the entire understanding of the parties and may not be modified, amended or changed except by a writing signed by the parties. Except as is expressly permitted under this agreement, neither party may assign this agreement or rights accruing under this agreement without the prior written consent of the other except either party may assign rights to receive money or compensation without the other party's consent. This agreement shall be interpreted under the laws of the State of New York.

Comment: *This is the "boilerplate" or standard jargon usually included in written agreements, and should be self-explanatory. Also, as a miscellaneous matter, the Artist should be prepared to adhere to policy or "taste" standards or rules adopted by the station. Most stations have some form of policy guidelines and the Artist should obtain a copy of these guidelines before signing the contract.*

ARTIST-GALLERY AGREEMENT

Agreement dated the day of , 197 , between _____
(the "Dealer"), residing at _____
and _____(the "Artist"),
residing at _____.
WHEREAS the Artist has produced and created a work of art titled
_____ and described as a one-hour color videotape
¾" cassette showing _____

_____ _____

(the "Work"); and
WHEREAS the Artist desires to have this Work distributed by the Dealer; and
WHEREAS the Dealer wishes to undertake the distribution of said Work; and
WHEREAS the parties wish to have said distribution performed subject to the mutual obligations, covenants, and conditions herein.

NOW, THEREFORE, in consideration of the foregoing premises and the mutual covenants hereinafter set forth and other valuable considerations the parties hereto agree as follows:

1. Artist hereby grants to the Dealer the exclusive right to sell or lease the Work in the United States of America for the term of this agreement. The exclusive right granted hereby includes only the limited license to sell or lease the physical videotape cassettes representing single copies of the Work recorded thereon. In no event shall there be a sale or leasing consisting of less than the entirety of the Work as described above.

2. The term of this agreement shall be for a period of two (2) years, commencing as of the date set forth above.

3. Dealer agrees to give best efforts to promote the sale and leasing of the Work and to protect the Work from copyright infringement or illicit copying or distribution by others.

4. Dealer agrees to pay Artist for the rights granted hereby royalties in an amount equal to the following percentages of Dealer's adjusted gross proceeds from the Work:

 (a) For the sale of copies of the Work by
 Dealer . 50%
 (b) For all leasing proceeds . 50%

For the purpose of this provision, "Dealer's adjusted gross proceeds from the Work" shall mean all revenues derived by Dealer from the sale or leasing of the Work after deducting only all taxes collected by the Dealer. Dealer shall furnish Artist quarterly reports during January, April, July, and October of each year showing, for the preceding three months, and cumulatively from the commencement of this agreement, the number of copies of the Work sold by the Dealer, "Dealer's adjusted gross proceeds from the Work," and the royalties due artist. Such report shall be accompanied by payment of all royalties to Artist for the period covered by such report.

5. It is understood that only fifty (50) copies of the Work shall be made, of which the Dealer shall have the right to sell twenty-five (25) of the said copies. The Dealer shall also have the right to request additional copies of the Work for leasing, subject to the consent of the Artist. Artist agrees that the Dealer may contract with purchasers or lessees of the Work to replace worn, defective, or mutilated copies of the Work and, further, that Artist shall be entitled to no royalty in the event of such replacement. Dealer agrees that no copy of the Work alleged to be worn, defective, or mutilated will be replaced unless said copy is returned to the Dealer for destruction by the purchaser or lessee.

6. All copies of the Work shall be made at Dealer's cost from the master tape. It is understood that the master tape will remain the Artist's property and in his control, provided that it shall be used as necessary to make copies of the Work for sale or leasing under the terms of this agreement. All copyright and other literary property rights in the Work for the entire term of

the copyright and any renewal thereof shall belong exclusively to the Artist. The master tape of the Work and each copy thereof shall bear a copyright notice in Artist's name.

7. The retail selling price of each copy of the Work shall be _____. It is agreed that Dealer may, in the exercise of reasonable business discretion, increase or reduce the price charged for any copy of the Work by ten percent (10%) in order to further the sales of the Work and the realization of returns from the exploitation of the Work. Dealer shall periodically consult with Artist concerning Dealer's marketing program and pricing policies with respect to the Work.

8. Dealer shall not sell or lease any copy of the Work unless the purchaser or lessee agrees, in writing, that under no circumstance shall any further copies of the Work be made by the purchaser or lessee and that the purchaser or lessee shall neither broadcast their copy of the Work nor permit the charging of admission to view the Work.

9. Artist agrees that Dealer shall have the right to list the Work, with appropriate descriptive material, in any catalog which Dealer publishes or maintains. Artist further agrees that Dealer may use and authorize others to use Artist's name, likeness, and biographical material for the purpose of publicizing and promoting sales or leasing of the Work pursuant to this agreement.

10. Dealer agrees that neither this agreement nor any rights granted Dealer hereunder may be assigned without the prior written consent of the Artist. The Artist may freely assign this agreement, either in whole or in part.

11. This agreement shall automatically be renewed for successive periods of one year, each renewal commencing on the expiration date set forth above unless canceled by sixty (60) days written notice given by either party prior to the expiration of the term of this agreement or any renewal thereof.

12. This agreement shall be binding upon the parties and their respective heirs, successors, and assigns.

13. Dealer and Artist agree to arbitrate any claim, dispute, or controversy arising out of or in connection with this agreement, or any breach thereof, before an agreed-upon arbitrator, or, if no arbitrator can be agreed upon, before the American Arbitration Association, under its rules.

14. The agreement constitutes the entire agreement of the parties and may not be changed except by an agreement in writing signed by both parties.

15. This agreement shall be construed under the laws of the State of New York applicable to agreements made and to be performed solely within such State.

IN WITNESS WHEREOF, the parties have signed this agreement as of the date set forth above.

_____ _____
Artist Dealer

BILL OF SALE

Date:

Sold to: _____(Name)
_____(Address)

Artist:

Title:

Medium:

Length:

Description:

Price:

It is hereby acknowledged and agreed that the copy of the videotape listed above is being purchased solely for noncommercial use and that the acquisition of this copy is subject to the following conditions:

1. All copyrights and other rights of reproduction or commercial exploitation, including the right to make copies of the videotape, are reserved to the gallery.

2. The purchaser agrees not to make or permit others to make any copies of this videotape; not to broadcast or charge admission fees to any showings of the copy in any place; not to utilize the copy in advertisements in any media or utilize the copy commercially in any way; not to make photographs or reproductions from the copy.

3. The purchaser agrees not to show the videotape to others, other than in its entirety and with sound, if any.

4. The purchaser agrees not to sell or transfer this copy to anyone unless the person acquiring the copy agrees to be bound by the provisions of this agreement. The purchaser further agrees to notify the seller of any such transfer and to furnish the gallery with the name and address of the new owner.

5. The purchaser agrees not to rent or lend the copy to others or to permit others to use the copy in violation of the terms of this agreement.

6. The purchaser agrees that the rights given by this agreement shall also run in favor of the artist who is the author of the videotape and to the present and future holders of the copyrights thereon.

7. The gallery agrees to replace the copy of the videotape upon the purchaser's return of the copy purchased. The cost of replacement shall be the gallery's if the copy is defective and the purchaser's if the copy has been damaged in use.

The gallery acknowledges receipt of the purchase price set forth above and the purchaser acknowledges receipt of the copy of the videotape.

_____ _____
Purchaser Gallery

10

FINE PRINTS

Fine prints have offered an opportunity for persons of moderate means
to enjoy original art. The growing enthusiasm for fine prints has been
remarkable. To avoid sharp selling practices as a wider public began to
purchase fine prints, the Print Council of America, a group of experts,
sought in 1961 to create standards for the sale of fine prints.[1] However,
the failure of private efforts to eliminate such practices as passing off
photomechanical reproductions as fine prints finally necessitated preven-
tive legislation in California, Illinois, and New York. In addition to hav-
ing familiarity with this legislation, the artist must also be able to
negotiate the contracts necessary for the publication of fine prints.

Originality

The Print Council's standards promulgated in 1961 sought to ensure
that the artist would have sufficient involvement in the creative process
to guarantee orginality. The Print Council provided: "An original print
is a work of art, the general requirements of which are: 1. The artist
alone has created the master image in or upon the plate, stone, wood
block or other material, for the purpose of creating the print. 2. The print
is made from the said material, by the artist or pursuant to his directions.
3. The finished print is approved by the artist."

These definitions applied to the processes and techniques of modern
printmaking: relief processes, incised processes, lithography, and stencil
processes. The Print Council contrasted original prints made pursuant to

these requirements with each of the following: photomechanical and similar reproductions; printmaking processes where the artist took little part in creating the print except to sign it; and editions portrayed as limited when in fact they were unlimited.

The Print Council made recommendations for both the dealer and the artist to ensure the integrity of fine prints. Dealers were advised, "Catalog descriptions of prints should include all pertinent and significant information available with respect to such matters as collaboration on plate, signature or numbering by others than the artist, processes used and who used them, condition of print (such as cut margin or restoration), states, size of edition and number of impression, signature, date of execution, date of impression, cancellation of plate." This information, at the purchaser's request, was to be entered on the invoice. The dealer was also to assist the public in distinguishing between a reproduction and an original print. These proposals were excellent, but naturally had little effect on those dealers who were already engaged in what were generally considered unethical trade practices.

The artist was advised to give maximum participation to the creative process and to indicate the degree of participation on the print. The artist was to sign a reproduction only if the fact it was a reproduction was clearly shown. The Print Council advised uniform procedures for numbering limited editions. When an edition was completed, the artist was to either destroy or cancel the plate or other image to ensure the limited nature of the edition.

But the Print Council could not have fully anticipated the growth which would occur in fine prints after 1961. Regulation by law, rather than privately formulated standards, became more and more a necessity.

California Legislation

In 1971 California became the first state to enact legislation regulating the sale of fine prints.[2] The statute starts by defining fine print, plate, artist, signed and unsigned, and impression. Next, the statute limits its applications to fine prints printed after July 1, 1971, and selling for more than $25 unframed or $40 framed. Any catalog, prospectus, or circular offering fine prints for sale—or any invoice for the sale of a fine print— must set forth the following informational details:

(a) The name of the artist and the year when printed.

(b) Exclusive of trial proofs, whether the edition is being offered as a limited edition, and, if so:

(1) The authorized maximum number of signed or numbered impressions, or both, in the edition.

(2) The authorized maximum number of unsigned or unnumbered impressions, or both, in the edition.

(3) The authorized maximum number of artist's, publisher's, printer's or other proofs, if any, outside of the regular edition; and

(4) The total size of the edition.

(c) Whether the plate has been destroyed, effaced, altered, defaced or canceled after the current edition.

(d) If there were any prior states of the same impression, the total number of states and a designation of the state to which the subject print relates.

(e) If there were any prior or later editions from the same plate, the series number of the subject edition and the total size of all other editions.

(f) Whether the edition is a posthumous edition or restrike and, if so, whether the plate has been reworked.

(g) The name of the workshop, if any, where the edition was printed.

This information isn't necessary if the print is stated to be a reproduction, unless the reproduction is signed or numbered or limited, in which case all the informational details must be provided. If the seller doesn't know all the informational details, the seller can specifically and categorically disclaim any such knowledge and be relieved of providing the information.

Action for a violation must be commenced within one year of discovery of the violation and, in any event, no later than three years after the date of sale. The recovery itself is limited to the cost of the print plus interest if the violation was innocent and three times that amount if the violation was willful.

California Reform Proposals

It might seem surprising that soon after the regulation of print sales a strong impetus should develop to reform that legislation. However,

several aspects of the California law were criticized.[3] Fine print was defined as including, "but not limited to, an engraving, etching, wood-cut, lithograph or serigraph." But photographs, sculptures, and other art assemblages appeared to offer the same opportunities for sharp trade practices. Next, the exact medium in which the print was made and the exact extent of the artist's involvement were suggested as necessary additions to the list of items contained in the informational details. Also, reformers felt the seller should have to state specifically whether or not the print is signed. Finally, reformers believed that violations should be misdemeanors punishable by fine or imprisonment, that purchasers bringing private suits should be able to recover attorney's fees and costs, that every invoice should state the remedies available to purchasers in the event of any violation, and that prints regardless of the date of creation should be regulated upon sale. This type of criticism brought about a proposal in 1975 to reform the law, which, although defeated, will be reintroduced.[4]

Illinois Legislation

Illinois in 1972 became the next state to create legislation to regulate fine print sales.[5] The Illinois bill followed the pattern of the California legislation. The law applies only to prints selling at wholesale or retail for more than $50 unframed or $60 framed. The law does not apply to fine prints which were printed before July 1, 1972, the effective date of the law. The informational details required to be given are nearly identical to those required in California. The seller can disclaim knowledge or admit a print is a reproduction in order to avoid providing the informational details. The penalties and time to bring action for violations are the same as under the California law. However, the Illinois legislation provides that "any person violating this Act is guilty of a misdemeanor and shall, upon conviction thereof, be fined not more than $1,000. Proof that no person has been misled or deceived or otherwise damaged by any violation of this Act shall not constitute a defense in any prosecution under this Act." That is a far more rigorous deterrent than exists at present under the law in California.

New York Legislation

New York finally enacted legislation in 1975 to prevent deceptive acts in the sale of fine prints and posters.[6] The legislation took a different structure, however, from that previously enacted by California and Illinois. The New York law defines a fine print as "an impression produced by a printing method in more than one copy from an image or design created by an artist and includes impressions produced by or from such printing methods as engraving, etching, woodcut, lithography, serigraphy and similar printing methods." *Artist* and *plate* are defined. *Signed print* is defined as "a fine print which has been signed by the artist's own hand, and not by any mechanical means of reproduction, after it has been printed." The law applies to all prints sold after January 1, 1976, regardless of when printed.

The law provides that no fine print shall be described in writing as signed unless the print meets the law's definition of signed. Also, it is unlawful to sell prints altered from the image originally on the plate, unless such alteration is conspicuously disclosed. A purchaser does not have to show a knowing violation of the law to recover, but the seller can prove lack of knowledge as a defense. The purchaser is entitled to have the transaction rescinded and is not stopped from seeking any other damages which can be recovered. The seller who acts unlawfully is guilty of a violation which is punishable by up to fifteen days imprisonment.

Federal Legislation

A federal bill to create the "Art Collector's Protection Act of 1972" would have required disclosures in the sale of certain fine prints and reproductions.[7] However, the bill was defeated and does not appear likely to be proposed again at this time.

Contracts for Fine Prints

Contracts for fine prints can vary greatly with the particular situation of the artist. First, the fine prints must be printed. The artist may undertake this, either personally or by contracting with a printer, and then

either sell the fine prints directly to purchasers or enter into a distribution agreement with a gallery. Alternatively, the gallery, as a publisher, may agree with the artist for the creation of one or more editions of fine prints, which the gallery would finance and distribute.

If the artist must use a printer, the artist should ensure that the printer's work will satisfy the artist. The best way to accomplish this is to specify materials and methods for the printing as well as to require the artist's approval at various stages of the printing process. Once the artist has the fine prints, sales can be made either directly to purchasers or through a gallery. If sales are made directly, the artist should review Chapter 7 on sales of art works, since the same considerations apply. If a gallery is to act as the artist's agent, the artist should consult Chapter 8 as to sales by galleries.

The gallery might, however, act as publisher as well as distributor of the edition or editions of fine prints, as in the sample agreement shown at p. 121. Now the gallery is paying the costs of producing the fine prints and will want certain concessions from the artist. The degree to which the artist meets the gallery's demands will of course depend on the bargaining strength of the two parties.

The gallery's most extreme demand would be to own all rights in the fine prints. This would include ownership of the fine prints, ownership of the plate or other image used for the printing, and ownership of the copyright. The artist would receive a flat fee and artist's proofs but would not receive income from the sales of the fine prints by the gallery.

The artist should bargain for an arrangement whereby the artist owns the prints which are held by the gallery on consignment. Because the gallery has paid the costs of making the prints, however, the gallery might demand that these costs be deducted from sales receipts prior to any payments to the artist. If the gallery and the artist split sales receipts on an equal basis, the artist would receive 50 percent of sales receipts after subtraction of production costs. The artist might not agree to the subtraction of such costs or might demand a higher percentage than 50 percent. Any advance of money to the artist against future receipts from sales should be stated to be nonrefundable.

Both the gallery and the artist will want to agree regarding the size limits of each edition, the number of prints to be kept by the artist, the number to be consigned to the gallery, and whether the prints will be signed. The artist should usually seek a short term for the contract, perhaps one year, with a provision for the equal division of all unsold

prints consigned to the gallery at the end of the contract's term. If the gallery defaults under the contract, all the prints should be returned to the artist. The artist should remain the owner of all prints, and title should pass directly from the artist to any purchaser.

The price at which the gallery will sell the prints should be specified, but the artist should resist any effort to set the same price for sales of the prints owned by the artist. If the contract will cover more than one edition, a schedule can be annexed at the end of the contract to provide for additional creations. The artist should, however, remain free to create competing prints without offering the gallery any option rights to such prints. If the gallery insists on such exclusivity, of course, the artist may have to make concessions in this regard.

The artist should be willing to warrant the originality of the prints. By the same token, the artist should have full artistic control over production. If the gallery is to choose the printer, the artist should insist on the right to approve the gallery's choice. The artist should not agree to any provisions subjecting the prints to the approval or satisfaction of the gallery. The artist should retain the copyright, and copyright notice in the artist's name should be placed on the prints. The printer should be required to give the artist certification of the cancellation of the plate or other image.

The remaining considerations in sales of prints through galleries are basically the same as with sales of any art work. Provision must be made for periodic accountings and payments, inspection of the gallery's books, insurance, responsibility for loss, termination, and the other terms fully discussed in Chapter 8.

Print Documentation

The artist will desire—and may be required by state law—to provide documentation regarding the process by which the prints were created. The excellent Print Documentation given by Gemini G.E.L. is shown at pp. 119–120. The Gemini Print Terminology appears on the back of the print documentation form. This form, when properly completed, satisfies the disclosure of informational details required under the present California law discussed at pp. 113–114. It is published here by permission of Gemini G.E.L., Los Angeles.

GEMINI G.E.L. PRINT DOCUMENTATION

Print No. JJ73-708

8365 Melrose Avenue
Los Angeles California 90069
213 651-0513

Ⓘ

Artist __Jasper Johns__
Title __Four Panels from Untitled 1972 (Grays and__
__Black)__
Period of collaboration __October 1973 to May 1975__
Right to Print date __March 19, 1975__
Cancellation date __May 15, 1975__
Date signed __May 15, 1975__
Medium __5 color, 4-part lithograph__
Size: H __41"__ W __32"__ Edge: __deckle__
Signature location __each of 4 panels, bottom margin__
Processing and proofing __Dan Freeman, Serge Lozingot,__
__Charly Ritt, Jim Webb__
Edition printing __D. Freeman, S. Lozingot, C. Ritt,__
__J. Webb, assisted by A. Zepeda, B. Thomason__
Collaboration and supervision __Charly Ritt and Jim Webb__

Printing Sequence	Process or Printing Element	Additional Information
1 transparent lt. gray	aluminum plate	
2 transparent lt. gray	" "	
3 transparent med. gray	" "	(Panel A/D only)
4 transparent dark gray	" "	
5 black	" "	
6 transparent gray	" "	
7		
8		
9		
10		
11		
12		

* Printer's Proofs signed PP II, PP III, PP IV

	No.	Paper				
Edition	20	John Koller HMP Gray (handmade)				
Artist's Proofs	7	"	"	"	"	"
Trial Proofs						
Color Trial Proofs						
Right to Print Proof	1	"	"	"	"	"
* Printer's Proof II	3	"	"	"	"	"
Gemini Impressions	2	"	"	"	"	"
Cancellation Proof	2	Roll Rives				
Other Proofs OK JJ	1	John Koller HMP Gray (handmade)				
Elements in Black	42	Roll Rives				

(Panel A: 2 sets of 6, signed 1/2,2/2; Panels B-D: 2 sets of 5,
signed 1/2,2/2; each element printed
singly)

We declare the above information is correct:

Artist _[signature]_

Gemini G.E.L. _[signature: B. Felsen]_

Date __14 Aug 75__

Date __august 8, 1975__

GEMINI PRINT TERMINOLOGY

Right to Print

The first impression achieved in the proofing period which meets the esthetic and technical approval of the artist and Gemini. Each print of the *Edition* must be identical to this standard.

Edition

The body of prints identical to the *Right to Print* proof. Two numbers are used in the signing procedure: the upper one is numbered consecutively beginning with 1 and indicates the number of that print within the *Edition;* the lower number indicates the total number of prints in the *Edition.*

Printer's Proof II

A proof pulled for the printer of the *Edition.*

Artist's Proof

A proof of good quality which closely matches or equals the standards of the *Edition* prints.

Trial Proof

Generally, a proof which varies from the *Edition* in imagery, printing sequence, has added or deleted elements, or in some way the printing has differed from the *Edition.*

Color Trial Proof

Generally, these proofs have the same printing elements as those in the *Edition,* but there may be a sequence which differs, or has been added or deleted as in the *Trial Proof,* or there may simply be a color variance. Both a *Trial Proof* and *Color Trial Proof* may have been pulled at any time during the proofing period or while the *Edition* is being printed. They are signed if the artist feels they have a desirable quality of uniqueness which gives them special merit. Occasionally, there is an overlap in intent between the *Trial Proof* and the *Color Trial Proof.*

Working Proof

A print which has at least one printing element and upon which the artist has added work by hand.

Progressive Proof

A series of proofs primarily intended to illustrate the development of the image of the finished print. One set of *Progressives* shows each color or element singly. The other set shows the actual development of the completed print as each color or element is added, one by one.

State

The result of an artist developing a variance in a previously resolved print resulting in a complete *Edition* with accompanying proofs. The variance may involve a change in color, elements or printing sequence.

Gemini Impressions

Prints identical to the *Edition* pulled for exhibition purposes.

Cancellation Proof

To assure that no further proofs can be pulled from the printing element after the *Edition* has been printed, the printing element is cancelled by either the artist or printer. In the case of the lithograph, the printed image is fully inked and then defaced by the use of a sharp instrument or a stone hone. In the case of the screen print, a chemical substance is added to the stencil to effect the *Cancellation* mark, thereby preventing future use of that image. In both cases, one impression is pulled of the defaced element to document the act. This impression is signed and dated by the artist. When a print has more than one color, the most complicated and involved color plate is chosen for cancellation. The *Cancellation Proof* may or may not have the complete color printings. If the artist decides to print a particular image in an additional *State,* the *Cancellation Proof* would be pulled after all *States* have been printed.

Signing Procedure

At the completion of the printing of the *Edition* and its proofs, the approved prints are then signed and numbered by the artist. In some cases, the artist may also inscribe the title and the date.

Chop

Each signed print bears an embossed, dry stamped or printed form of the Gemini *Chop.* It is generally placed adjacent to the artist's signature and is accompanied by a copyright mark. Each *Edition* and its accompanying proofs has its own identifying number which is inscribed in pencil on the reverse side of the print adjacent to the *Chop.*

Print Contract with Gallery

Dear Artist:

This letter is to be the agreement between you and Pisces Gallery regarding the publication of a suite of six of your woodcuts of fish in paper size 9½″ × 13″. The works selected are as follows: sunfish, trout, eel, bass, carp, and whale. You will create one hundred (100) impressions of each woodcut, which are to be signed and numbered accordingly by you. You may print ten (10) additional proofs for your personal use, and these are to be signed as artist's proofs. You will affix copyright notice in your name to all prints and all copyrights and rights of reproduction shall be retained by you upon sales to purchasers. You will provide Pisces Gallery with certification of the cancellation of the blocks after completion of the printing.

Pisces Gallery shall be solely responsible for and pay all costs of the printing. Pisces Gallery will prepare the title page, descriptive material, and justification page.

Nonrefundable advances of $1,000 shall be paid to you upon delivery of each one hundred (100) prints. The minimum selling price of each suite shall be $500. Pisces Gallery will exercise best efforts to sell the suites and shall receive 50 percent of all sales revenues as its commission. The balance due you, after subtraction of any advances paid to you, shall be remitted on the first day of each month along with an accounting showing the sale price and number of prints sold and the inventory of prints remaining. Title to all work shall remain in you and pass directly to purchasers. Pisces Gallery will insure all work for at least the minimum sale price and any insurance proceeds shall be equally divided.

The term of this agreement shall be one (1) year. After one (1) year, this agreement shall continue unless terminated upon either party giving sixty (60) days written notice of termination to the other party. Upon termination the inventory remaining shall be equally divided between Pisces Gallery and you. Your share shall be promptly delivered to you by Pisces Gallery. If, however, termination is based upon a breach or default by Pisces Gallery under this agreement, all inventory remaining shall be promptly delivered to you. You agree to sign such papers as may be necessary to effectuate this agreement.

Kindly return one copy of this letter with your signature below.

Sincerely yours,

John Smith
President, Pisces Gallery

CONSENTED AND AGREED TO:

Artist

11

PUBLISHING

An artist's involvement in publishing can come in a number of ways, such as a book of photographs, illustrations for a text, a design for a book jacket, or reproductions of fine art works printed as a book. Since few publishing houses have contracts specifically designed for artists, the artist will either not be offered a written contract or will be faced with signing a contract designed for writers, which often seems irrelevant to the artist's situation.

This chapter examines the standard clauses in the author's book contract to determine how each of the provisions should be negotiated.[1] The Graphic Artists for Self-Preservation (GASP) have developed a proposed prototype book contract or purchase order which is now under review by both GASP and publishing representatives. It is presented at p. 131 as an example of what the artist might negotiate. Also, the Authors Guild, Inc., has published the Authors Guild Trade Book Contract and ASMP has published a Standard Photographers Book Agreement, both of which recommended terms the author or artist should seek.[2] After the discussion of book contracts, the special features of magazine, syndication, and commercial exploitation contracts are considered separately.

However, the complexity of all these contracts makes the advice of an agent or lawyer almost a necessity, if the artist is to feel certain of having negotiated a fair agreement.

Grants of Rights

After setting out names of the parties and the date, a book contract will detail the rights granted by the artist to the publisher. Some contracts provide for "all rights" to be given the publisher, while the ASMP contract licenses only "one-time, non-exclusive" rights in the English language throughout the world. "All rights" would be the transfer of all the rights possessed by the artist to the publisher. This would mean the publisher—and no one else—could exploit the works as a book or in any other medium without any limitation as to either territory or time. If, for example, the publisher wished to exploit the work on tee shirts, as posters, as jewelry, or as dolls, the artist would not have any right to prevent such uses. Artists who create designs for book covers frequently find that the design is subsequently used for advertising or paperbacks without the artist being entitled to additional payments.

The grant of rights can be limited as to uses which can be made of the art work, the time during which the work can be used in book form, and the territory in which the book can be sold. For example, the Authors Guild contract conveys exclusive English language book publication rights during the first term of the United States copyright for the United States, its territories, Canada, and the Philippines. The rights not conveyed in the grant of rights provision, however, might still be conveyed as subsidiary rights.

Subsidiary Rights

Subsidiary rights cover many of the uses not permitted by the grants of rights, such as abridgments, anthologies, book clubs, reprints by another publisher, first and second serializations (which are magazine rights before and after book publication), syndication, advertising, novelty uses, translation and foreign language publications, motion pictures, dramatic, radio, television, and mechanical rendition or recording uses. The definitions of these rights can vary in different contracts.

The publisher usually has the exclusive power to dispose of the subsidiary rights. The division of income between publisher and artist is specified as to each subsidiary right. However, the Authors Guild makes the general distinction that only publishing rights should be granted in a

publishing contract. Therefore, the Authors Guild would recommend against granting any control over, or benefits from, nonpublishing subsidiary rights, such as stage, record, radio, motion picture, television, and audiovisual rights. The artist might particularly seek to reserve all rights to advertising and novelty uses. For each subsidiary right, the artist should consider demanding the power either to control the right or to veto exercises of the right by the publisher. At the least, however, the artist should receive copies of any licenses for subsidiary rights granted by the publisher.

Reservation of Rights

The grant of rights and the subsidiary rights provisions will normally cover all the conceivable uses of the artist's work. However, the artist should anticipate unthought of, even uninvented, uses. This is done by insisting on a simple clause stating, "All rights not specifically granted to the publisher are reserved to the artist."

Delivery of Manuscript

The contract will probably require the artist to deliver, on or before a specified date, art work in "content and form satisfactory to the publisher." The artist should at least have the word "reasonably" inserted before "satisfactory." If the publisher has seen either completed work or work in progress, the provision should be modified to indicate such work was satisfactory. Also, the artist should have a grace period for illness and similar eventualities which may cause the work to be delivered late.

The contract may require the artist to deliver a manuscript consisting of more than just art work. The artist may be responsible for the title page, preface or foreword, table of contents, index, charts, all permissions (including payments for such permissions), and a bibliography. If the artist does not supply these materials, the publisher will normally have the right to pay for them and deduct the cost from the artist's royalties.

Royalties

The artist may sell art work for a flat fee, in which case no royalties would be payable. However, royalties permit the artist to share in the success of the book and are usually desirable. The artist receives a royalty for each copy sold, with the royalty rate often increasing with the number of copies sold. Royalty rates vary widely, although ASMP suggests 5 to 12 percent as a reasonable range. The artist should really seek expert advice from more experienced artists or agents when trying to determine whether an offered royalty is fair.

Fairness, however, is not based only on the royalty percentages. The way in which the royalty is defined is very important. Basically, the royalty should always be a percentage based on the publisher's retail list price, the price at which the book will be sold to the public. If the royalty is based on a net price—that is the price after discounts to wholesalers and book stores—the royalties will be far lower than if based on retail list price. The royalty should not be a specific amount, such as one dollar per copy, because the publisher invariably has the power to determine the selling price of the book.

Royalties will often be reduced for copies sold in digest form, in a foreign language edition, at a discount, directly by the publisher due to the publisher's advertising, and in other circumstances which are listed in each contract. The artist must consider whether each reduction is fair because of the significant effect reductions can have on royalties.

Advances

The advance is paid to the artist against royalties to be received in the future. The advance may be paid in full at the time of signing the contract or may be paid in equal installments at the time of signing, delivery of the manuscript, and publication. The artist should always request that the advance be nonreturnable except for failure to deliver the manuscript. Also, the artist should not permit a provision which would allow the advance under one contract to be deducted from royalties earned under a contract for a different book.

Payments, Statements of Account, Inspection of Books

Payment of royalties should be made on a periodic basis, usually quarterly or semiannually. The Authors Guild provision requires a statement of account showing the total sales to date and the number of copies sold for the period just ended, the list price, the rate for royalties, the amount of royalties, the amount of returns, and information relating to licensing income. The Authors Guild provides for the artist to examine the publisher's books and records at any time, upon the artist's written request, although most publishers will restrict this right of inspection.

Duty to Publish and Keep Work in Print

The artist should ideally require the publisher to stipulate the date when the book will be published. The Authors Guild provision requires publication within one year of delivery of the manuscript by the artist, while many other contracts specify a reasonable time or merely state that the date of publication will be at the publisher's discretion. The artist can request a provision expressly reverting all rights to the artist if the book is not published within the stipulated period of time, unless delays are of a nature which the publisher cannot avoid.

The artist should also seek to ensure that the book will be kept in print. If the publisher becomes bankrupt or insolvent or simply ceases to exploit the book by not printing copies for sale, the artist should no longer be obligated under the contract. In such an event, the artist should have the option within a certain time period (for example, sixty days) to purchase the plates, bound copies, and sheet stock at one-half or one-quarter of the publisher's cost. In order to seek a new publisher to promote the work more vigorously, the artist should receive back all rights, including copyright, which the publisher had in the work. These provisions vary from contract to contract and often require that the artist either demand that the publisher reprint the work or give notice that the work is out-of-print, as defined in the contract.

Copyright and Suits for Infringement

The copyright should be either in the artist's name or held in trust for the artist by the publisher. The publisher should be required to gain

copyright protection by use of appropriate notice whenever and wherever the work will be published. To assist in this, the artist should provide the publisher with a list of all previous publications of the work submitted for use in the book. Provision should also be made for renewal of the copyright at the end of the first term.

If the copyright is infringed, the publisher can sue the infringer but is not obliged to do so. If publisher or artist sues alone, the other party should have to cooperate. The party bringing suit would normally bear the costs and recoup them from any recovery. If both parties sue, the costs would be split as agreed in the contract. If either case, provision must be made for the division of amounts recovered in excess of costs. The artist should have exclusive power to sue for infringement of rights retained by the artist.

Warranty and Indemnity

The contract will require the artist to give an express warranty to the effect that the work does not infringe any copyright, violate any property rights, or contain any scandalous, libelous, or unlawful matter. The artist must agree to indemnify the publisher against all claims, costs, expenses, and attorney's fees. This means the artist will pay for the publisher's expenditures caused by any breach or alleged breach. The publisher will have the right to withhold the artist's royalties until any suit or threatened suit is settled.

ASMP provides the exact opposite by requiring that the publisher indemnify the artist. The artist under the ASMP provision explicitly makes no warranty. More realistic is the Authors Guild provision in which the warranty is modified by the artist's stating that the work, "to his knowledge," is neither libelous nor violative of privacy rights. The artist's liability under the Author's Guild provision is limited to the lesser of a stated amount or a percentage of the sums due the artist under the contract. Such liability exists, however, only as to final judgments for damages after all appeals have been taken, so that alleged breaches of warranty which do not result in final judgments would not make the artist liable for any of the publisher's expenditures. If the artist defends the suit, then the artist is not liable to pay the fees of lawyers retained by the publisher. Also, the Authors Guild limits the amount of royalties which can be withheld by the publisher to a stated percentage, in no event more than the damages claimed in any suit.

Artistic Control

Since the contract requires the publisher's approval of or satisfaction with the work, artistic control resides in the publisher. Few publishers, if any, would agree to the ASMP provision requiring that the book be published in a form approved by the artist. But the artist should insist on the opportunity to make any necessary changes in the work and should certainly seek the right to approve any changes in the work done by other persons. If the publisher wants major changes, often defined as changes of more than 10 percent of the work, the artist might require additional reimbursement. But the artist who chooses to change the work after the book is in production may be liable for part of the cost of such changes.

If an edition in the future is to be revised, the artist should have the opportunity to do any necessary revisions. If the artist cannot make such revisions, the cost of the revisions would be deducted from royalties due the artist. But the artist should not permit any such payments to be deducted from royalties owed the artist under other contracts with the publisher. The artist can protect against losing royalties due to revisions by requiring that no revisions be made for a specified period after the signing of the contract.

The publisher will have the power to fix the book's retail price, title, form, type, paper, and similar details. If the artist wishes to have a voice in any of these matters, an appropriate provision should be made in the contract.

Credits

The exact nature of the artist's credit should be specified, including size and placement, especially if a writer or editor has also worked on the book. If another person may revise the book in the future, the credit to be given such a reviser should be specified. The artist should remember that, without a provision for credit, the artist will receive credit only at the publisher's discretion.

Original Materials

The publisher should be required to return the original art work to the artist. The publisher will usually not agree to either insure the work or

pay if the work is damaged, although the artist might demand this if the work is of great value. The publisher should agree to try and keep the original art work in good condition for return to the artist.

Competing Works

The publisher may try to restrict the artist from creating competing works. Such a provision can prevent the artist from creating any work on the same subject as the work to be published. The artist may not be able to agree to such a provision, especially if all the artist's work is similar. The artist might, therefore, seek to have the competing-works provision limited to material directly based on the work to be published. Another approach would be to limit the time during which the restrictions on competing works would remain in force. Ideally, the artist should seek to have this provision stricken from the contract.

Options

Another common provision gives the publisher the option to publish the artist's next work. Such a provision may well be unenforceable unless the terms of the future publication are made definite. In any case, the artist should insist that the option provision be deleted from the contract. If the artist and publisher are satisfied with one another, they will want to contract for future books. If they are not satisfied, there is no reason why the artist should have to offer the next book to the publisher. If an option provision is agreed to, the artist should not give an option for more than one work and should require the publisher to make a determination with regard to that work within a reasonable time period after submission.

Free Copies

Most publication contracts will provide for the artist to receive five to ten free copies of the final book. Additionally, provision is made for the artist to purchase unlimited copies at a substantial discount, such as 40 percent, from retail list price. The artist should be certain such a provision is contained in the contract.

Assignment

ASMP provides that the artist may assign the contract without the publisher's consent, while the publisher can assign the contract only with the consent of the artist. A more common provision would require the written consent of either party to an assignment by the other. Presumably the publisher would not wish to have another artist substituted under the contract, but nothing should prevent the artist from assigning to another person money due or to become due under the contract. The publisher may also require a provision permitting assignment to a new publisher which is taking over the publisher's business.

Arbitration

The artist will generally benefit from an arbitration provision, because disputes under the contract can be quickly and easily resolved. Many contracts will provide for arbitration before the American Arbitration Association, but the artist should be satisfied as long as unbiased arbitrators will hear the dispute. The disadvantage of arbitration is that an arbitrator's adverse decision is very difficult to appeal to the courts, so the artist should feel certain the arbitration will be fairly conducted.

Other Provisions

The contract may have a provision for payment of fees due to the artist's agent. The contract will require that modifications be in writing. The state under the laws of which the contract is governed will be specified. The contract will state that heirs, legal representatives, successors, and assigns are bound by its terms. Waivers or defaults under one provision will usually be restricted so as neither to permit future waivers or defaults nor to affect obligations under other provisions of the contract.

The GASP Contract

The GASP contract or purchase order shown on p. 131 is being developed in the belief that both publishers and artists would benefit if a

GRAPHIC **ARTIST** **FOR SELF** **PRESERVATION**

G A S P

PURCHASE ORDER NO. _____ Date _____

Publisher _____ Address _____

Artist _____ Address _____

Book Title _____ Author _____

Edition: Hardcover Paperback Other _____

Fee _____

Trim Size _____

Number of Colors _____

Description of Job _____

The publisher owns exclusive reproduction rights to the total jacket design with art and/or photography for packaging, advertising, publicity, or any other means of promotion for the edition described above. Any change or alteration in the total design or illustration must be with artist's consent and approval.

The artist retains all other rights to the art work. Any further uses of the artwork (book club edition, film version, paperback edition, foreign edition) will be negotiated at the discretion of the artist.

The artist will not reproduce, give or sell reproduction rights of said artwork for any purpose unrelated to the original book.

☐ The publisher agrees to have (c) appear on the flap of the jacket with the year and the artist's name.
☐ The publisher agrees to file for copyright in the artist's name.
The artist guarantees that copyright does not infringe on any other.

The publisher will return all artwork (illustration, photography) for the artist in 30 days after the production of the jacket is completed.

SIGNED FOR THE PUBLISHER _____

SIGNED FOR ARTIST _____

fair written form were accepted in the publishing industry. It is simple and designed mainly for artists creating designs for book covers. However, it still deals with many of the terms discussed already and is valuable as a prototype which might evolve to satisfy both publishers and artists.

The purchase order number, date, and addresses start the agreement. Next, the book title and author are specified, including the nature of the edition. The fee must be written in the space provided, either a flat amount or a royalty schedule. The work is then described, including size and colors, so that the artist has guidelines as to what the publisher wishes.

The grant of rights gives the publisher exclusive rights to use the work as a book cover and for promotion of the book. All subsidiary rights, however, are reserved to the artist. This ensures that the artist will receive another fee if the design is to be used, for example, in a paperback edition. The artist, in turn, agrees not to sell any rights in the work for purposes unrelated to the original book.

Provision is made for copyright to appear in the artist's name on the flap of the jacket and for the publisher to file for copyright (if the appropriate boxes are checked). The artist warrants that the work does not infringe any other copyrighted work.

If any changes are to be made in the work, the artist's consent and approval must be obtained. The original work is returnable to the artist within thirty days of completion of the book cover.

The GASP proposal does not attempt to deal with every term a contract might contain, but it speaks with clarity to the needs of certain artists who serve the publishing industry.

Sales to Magazines

Sales to magazine publishers involve the same considerations as sales to book publishers, except that the contracts will be much simpler. The grant of rights to the magazine is again the artist's first concern. Some magazines purchase all rights (sometimes called exclusive world rights in perpetuity), which means the artist retains no rights to the work. Magazines may purchase all rights with the understanding that certain rights will be transferred back to the artist after publication. In such a case, the artist should have a written contract setting forth precisely

which rights the magazine will transfer back to the artist. A magazine purchasing all rights, even if some of the rights are held in trust to be transferred back to the artist, will protect the work under the magazine's copyright notice.

Many magazines purchase only first serial rights (sometimes called first rights), the right to be the first magazine to publish the work. After such publication, the artist is free to sell the work elsewhere. A variation of first serial rights would be first North American serial rights, whereby the artist conveys to the magazine the right to be the first publisher of the work in North America. Another grant of rights would be second serial rights: the right to publish art work which has appeared elsewhere—for example, in a book. This is sometimes more generally referred to as reprint rights: the right to publish work which has appeared elsewhere. A different grant of rights would be one-time rights: the right to use the work once but not necessarily first. Another way of expressing this could be the grant of simultaneous rights: granting the right to publish to several magazines at once. The artist should keep in mind the possibility of limiting the grant of rights with regard to exclusivity, types of uses, duration, and geographical scope. The artist who wishes can define exactly the nature of the permitted publication.

In any case, where less than all rights are granted to the magazine, the artist should request that copyright notice appear with the work in the artist's name. This will avoid the possibility that the copyright may be lost to the public domain because the magazine's copyright notice is not in the name of owner of the copyright who is the artist. The Copyright Revision Act of 1976 will end this risk of copyright loss commencing on January 1, 1978, although copyright notice in the artist's name may still be advantageous as discussed under copyright.

The artist should be certain what credit will be received for work. If any changes can be made in the work, the artist should seek the right to approve such changes. The original work should be returned to the artist. The artist will probably have to agree to a warranty provision and a deadline for delivery of the work. The artist should anticipate that the work may never be used and request a provision transferring all rights back to the artist in such event. If the magazine has paid on acceptance, the artist should require a provision stating no part of the payment need be returned if the magazine fails to use the work. If the magazine pays on publication, the artist should stipulate that a fee, known as a "kill fee," be paid in the event the magazine does not use the work within a certain

time period. The artist may require a number of free copies of the issue containing the work.

Generally, sale of art work to a magazine raises the same considerations as sale to a book publisher. The artist should consider the refinements of the book contract even when negotiating the simpler sale to a magazine.

Syndication Agreements

A syndicate gathers marketable features for distribution on a regular basis to markets, such as newspapers. Cartoon strips are commonly syndicated. The Cartoonists Guild has collected six syndication contracts in their excellent *Syndicate Survival Kit*, which describes what the artist should look for in a syndication contract. The basic considerations are again those of the book contract, but the creation of unique characters can have special implications.[3] For example, the creators of Superman sold all their rights and benefitted hardly at all from the phenomenal success of Superman as a comic strip and as a character in numerous other commercial ventures.[4]

The guild states that the artist selling greater rights (such as "all rights" instead of only "first North American rights") should receive a greater payment. But the guild strongly urges that the term be limited to no more than one or, at most, two years. This is to enable the artist either to negotiate a better contract, if the comic strip is a success, or to stop working on an unprofitable venture, if the comic strip is not popular. Since automatic renewal would defeat the purpose of a short term, the artist should refuse any such renewal provision.

The artist is normally paid in the form of a percentage of the receipts earned by the strip. But the artist should again be careful that the percentage is taken against gross receipts, not net receipts (which might also be phrased as "gross receipts less expenses"). The guild suggests 50 percent of gross receipts is usually fair payment to the artist, but indicates a minimum payment should always be specified. The guild urges the artist to reserve a fair percentage of gross receipts—75 percent, perhaps—from all subsidiary rights, particularly since book, television, radio, periodical, and novelty rights can be so valuable when cartoon characters are successful.

The guild suggests that the artist retain copyright in the work, in which case copyright notice should appear in the artist's name. The artist should require powers of consultation and approval with regard to any changes to be made in submitted material. Also, the original art work should be returned to the artist.

The guild stresses the importance of promotion for the success of a cartoon strip. The promotional plan should, ideally, be agreed upon in advance. The burden of promotional costs and the rights to use the work for promotion without additional payments should be resolved at this stage too.

The artist should have a right to periodic accountings showing the source of all receipts and the exact nature of any expenses. The artist should be able to inspect the books of the syndicate. Package deals, where several features are sold together, should be forbidden. Each feature should stand on its own merit and be paid for individually. The guild also suggests that legal fees and liabilities should be equally divided between the artist and the syndicate.

The artist must not relinquish the right to sell other creative work. The syndicate has received a license with regard to the comic strip at issue, so work too closely similar will infringe that license. But the artist should not agree even to refrain from marketing similar work because of the problem of defining what may be similar. Any option provision giving rights over future work of the artist to the syndicate should also be struck from the contract.

The guild suggests that, in the event of the artist's death, controls be present in the contract which ensure that payments for the comic strip will continue to be made to the artist's estate. One possible way to do this would be to require minimum payments to the estate after the artist's death. Another way might be to have the estate pay for a replacement artist, who would continue the comic strip.

The syndication contract raises many of the same issues as the publication contract, but the artist who is negotiating a syndication contract should consult the *Syndicate Survival Kit* for advice on each of the provisions likely to appear in such contracts.

Commercial Exploitation

Commercial exploitation may not appear to belong under the heading of publishing, but in fact the same general guidelines to negotiation are applicable. Commercial exploitation through the reproduction of art work can take the form of jewelry, tee shirts, prints, and even useful household objects (such as lamps with decorative bases). The artist who is offered an opportunity to exploit copyrighted or patented work can limit the rights licensed with regard to use, duration, and geographical scope. The artist will want to be certain that the entrepreneur seeking the license is financially stable, respected for honesty, and capable of creating and distributing quality products.

The entrepreneur would normally bear the cost of reproducing the work, possibly under a binding schedule for production. The artist would want the right to approve the quality of the product at the various stages of manufacture. Promotional budgets and approaches might be specified in advance along with channels of distribution. Appropriate copyright or patent notice, the right to artistic credit, the artist's ownership of the original work, the artist's right to free copies, and any warranties given by the artist would all be included in the contract.

The artist might be paid either a flat fee or a royalty. If a royalty is to be paid, the issue of gross and net receipts again becomes significant. The artist will want a stated percentage of the gross receipts, not the net receipts (or gross receipts less certain expenses). The artist would want the right to both periodic accountings and inspection of the entrepreneur's books.

The entrepreneur might request that the artist either refrain from creating competing works or offer an option on the artist's next commercial creation to the entrepreneur. The artist should not agree to these provisions, however, for the reasons discussed with regard to book contracts.

The contract should provide for termination in the event the entrepreneur fails to exploit the work or becomes bankrupt or insolvent. The rights would then revert to the artist who might be entitled to purchase stock on hand at the cost of the stock to the entrepreneur.

The commercial exploitation of art is merely a more general application of the principles which guide the artist in the specific exploitation of art involved in a publication contract. For the artist considering such a commercial venture, the principles discussed for book contracts will be a helpful guide.

12

LOFTS AND LEASES

Many artists find their work ideally requires a great deal of space for execution. Such space is often only reasonably available in older structures such as rural barns or buildings in urban districts zoned for commercial or manufacturing use. If the space is unfinished, the artist may have to expend substantial sums to have necessary utilities and fixtures installed. On the other hand, if this installation has been paid for by a prior tenant, the artist may have to pay for fixtures which seem neither useful nor aesthetically pleasing. Also, while the artist may wish to reside in the loft, zoning regulations may impair the right of the artist to do this and, in some cases, create an occupancy which is illegal.

Practical Considerations

The artist who is not an expert should find either a contractor or someone else with expertise to examine the building and loft areas for a determination as to whether the structure and facilities will be adequate and safe for the artist's work and, if necessary, living quarters. An artist creating large and heavy works will have to be certain doorways, hallways, elevators, and loading ramps can accommodate the completed work. An artist who needs power machinery must be certain the building is wired for such use. Heating, plumbing, and gas lines must all be adequate to the artist's needs. Finally, if the building is considered sound, the artist will arrive at a figure—perhaps thousands of dollars—necessary to put the loft into the condition the artist desires.

Ownership of Fixtures

The artist faced with such substantial fix-up costs, or perhaps a payment to the previous tenant for fixtures, is now offered a standard form lease by the landlord. A wise course is always to consult a lawyer when confronted with a legal document, and a lease is certainly no exception. The standard lease developed for lofts by the Real Estate Board of New York provides, "Tenant shall make no changes in or to the demised premises without Landlord's prior written consent." If written consent is obtained and the changes are made, the lease then provides, "All fixtures and all panelling, partitions, railings and like installations, installed in the premises at any time, either by Tenant or by Landlord in Tenant's behalf, shall become the property of Landlord and shall remain upon and be surrendered with the demised premises. . . ." The landlord's ownership of fixtures at the end of the lease term is a crucial factor with which the artist must contend when the lease is negotiated. The landlord may, in fact, permit the artist at the end of the lease term to demand a payment for the cost of fixtures from the incoming tenant. But the landlord does not have to do this. Also, if the market for lofts is not a good one, there may be no incoming tenant, and the artist may be forced to leave the loft without receiving any payments at all.

The Lease Term

The fix-up costs bear on what the use of the loft is truly costing over the lease term. The lease, for example, may provide for an annual rent of $3,600—that is, $300 per month. If the fix-up cost is $2,000, there is a substantial difference between a two-year and a five-year lease term on what can be called the "real rent"—the total monthly or yearly cost to the artist as tenant. If the lease term is two years, the $2,000 of fix-up costs increase the rent by $1,000 each year. The real rent is $4,600 per year, not the $3,600 per year which appears in the lease. But if the lease term is five years, the $2,000 of fix-up costs only increase the rent by $400 each year, making the real rent just $4,000 per year.

The artist benefits from a longer lease term because the fix-up costs can be enjoyed over a longer period. The artist may, therefore, seek a longer lease term, perhaps five years instead of two years. If the landlord agrees, the artist has the advantage of a rent fixed for a longer term, as

well as a longer period to enjoy the fix-up costs. The disadvantage is that the artist may wish to move before the end of the longer lease term without being responsible for rent to the end of the term.

Options to Renew

A good alternative to simply requesting a longer lease term is to request, in the lease, an option to renew. Thus, the initial lease term could be two years, but the artist might have the option to renew the lease for another three-year term. This gives the artist the advantage of five years to benefit from the fix-up costs, but the opportunity to leave sooner if need be. A disadvantage of asking for an option to renew might occur if the landlord decides the option itself is valuable and insists that the rent during the renewal term be at an increased rate. Whether the option to renew is worth a certain rent increase is a decision the artist has to make on a case-by-case basis. It's also worth noting that when an artist moves into a building scheduled for destruction, renewal options to extend the lease term to the actual destruction are a reasonable request and can be of great benefit if the destruction is delayed for any reason.

Right to Terminate

An alternative, even more flexible than an option to renew, is a right to terminate. The artist might, for example, demand the right to terminate the lease upon one month's written notice to the landlord. Often this right can only be exercised after part of the lease term, perhaps six months or a year, has elapsed. In this way the artist can take a long lease term while retaining the power to leave at will without liability for additional rent.

Right to Sublet or Assign

A desirable lease clause, particularly important where a longer lease term is obtained, is the tenant's right to sublet. A typical lease provision reads, "Tenant . . . shall not . . . underlet, or suffer or permit the demised premises or any part thereof to be used by others, without the prior written consent of Landlord in each instance." This lease prohibi-

tion on underlets or sublets is absolute and the landlord need not justify his refusal to accept a proposed subtenant. The artist should negotiate for the right to sublet, since such a right will make the artist certain of being able to have the fix-up costs reimbursed as long as a new tenant can be found who desires the loft. A typical compromise sublet clause would require the landlord's consent for any sublet but provide that the landlord would not unreasonably withhold that consent. If the proposed subtenant will pay the rent and use the loft properly, the landlord will not be able, arbitrarily, to refuse the subletting. When a loft is sublet, the subtenant pays the rent to the tenant, who in turn pays the landlord. A simpler method—with the landlord's consent—is to have the artist assign the lease to the new tenant. The artist will still usually be liable for the rent if the new tenant defaults, but the rent payments will go directly from the new tenant to the landlord.

The risk of a sublet or assignment clause is that the artist only has the right to find another tenant as a replacement. If another tenant can't be found, the artist will remain responsible for the rent. Where the lease has an option to renew, of course, the artist's responsibility for rent ends with the initial lease term and only continues for the renewal period if the artist renews the lease. The right to terminate would also protect the artist as to additional rent. Ideally, in order to have maximum flexibility, the artist should seek either an option to renew or a right to terminate, as well as a right to sublet or assign.

Hidden Lease Costs

The artist should be aware that the lease may contain costs other than rent. For example, the artist will usually be responsible for making all nonstructural repairs in the loft. The artist must be certain who will pay for electricity, air conditioning, and even water. The lease may provide for escalations of the artist's rent in proportion to increases in the landlord's real estate taxes or other expenses, such as that for heating fuel. Indeed, the lease may even contain a cost-of-living clause which increases the rent automatically to keep up with inflation. If the artist cannot negotiate these clauses out of the lease, a current cost for the landlord on each item should definitely be specified in the lease to establish an objective basis upon which future increases can be calculated. But the artist should try to include a maximum cost beyond which there can be no in-

creases. In each of these cases the artist must attempt to approximate costs, perhaps by inquiring of the landlord and other tenants as to past increases or by relying on an expert's opinion, so these costs can be added into the calculation of real rent.

Zoning

Before considering the lease clause regulating the uses of the loft, a background description of zoning laws, which may render illegal the residence of artists in their lofts, is necessary. In New York City, for example, artists often took up residence in areas which were zoned for manufacturing in order to benefit from the industrial lofts, which had good floor space and high ceilings. Recognition of these illegal tenancies brought a liberalization of the zoning laws which, starting in 1964, allowed persons certified as artists by the city's Building Department to reside in up to two lofts in buildings which met certain maximum size and safety requirements.[1] However, once certified as an artist for these A.I.R. (Artist-in-Residence) lofts, the artist still has to obtain an additional certification from the Building Department that the loft is habitable.

Many artists resisted this certification process and continued living as illegal loft tenants. In Soho, where there was a concentration of illegal loft tenancies, the Soho Artists Association led the campaign which resulted, in 1971, in the creation of legal loft zones in Soho, subject again to certain limitations such as a maximum loft size. Artists, however, still must be certified as artists, but now by the city's Cultural Affairs Department. Once certification is obtained for the artist, the building must be violation-free in order for a certificate of occupancy to be obtained from the Building Department, a process which can be difficult and expensive. In 1976, legal loft zones were created in Noho and Tribeca.[2]

In Soho, the result of these restrictions and the growing glamor of living in an artists' colony, or ghetto, has been two types of illegal tenancies. Artists often ignore the procedure to be certified as artists and avoid facing the costly removal of violations for certification of the building. On the other hand, nonartists have moved into the area and caused a dramatic increase in loft rents, an increase many artists cannot afford.[3] This aspect of the Soho experience has to be weighed carefully as legal loft living is extended into other areas of New York City and as zoning is

considered in other cities across the country. The permissive attitude of the Building Department toward such illegal tenancies has been crucial to the viability of Soho.

The Use Clause

An important lease clause is that specifying what use will be made of the loft by the artist. For example, this clause might provide, "Tenant shall use and occupy the demised premises for an artist's studio and for no other purpose." It is generally best for the artist to have as much latitude under this clause as possible. For example, a better clause for the artist would be, "Tenant shall use and occupy the demised premises for an artist's studio, residence, and gallery."

But the artist who chooses to live illegally in a loft, perhaps even without the landlord's knowledge, cannot expect the landlord to agree to a lease clause permitting use as a residence. At the least, however, the artist should not accept a use clause specifying that no living in the loft will be permitted, such as "artist's studio, no living." Such a clause will place the artist clearly in breach of the lease and subject to eviction by the landlord.

Violations

The lease will also provide that the tenant must not use the loft in violation of the building's certificate of occupancy and that the tenant must act promptly to end any violations arising from the artist's use or occupancy of the loft. This sounds ominous but—in New York City, for example, where enforcement by the Building Department has been generally lenient—may in fact not create a problem. If a violation is found, the artist at least has the opportunity under these lease provisions to correct the conditions causing the violations before the landlord can seek eviction. The artist should avoid any clauses which might provide for automatic termination of the lease if violations are not corrected within a limited time period, such as ten days.

Cooperative Buildings

Some artists may be offered the opportunity to purchase a loft from a cooperative which owns the building. In such a case the determination by experts as to the adequacy of both the building and loft for the artist is even more important than in the usual rental situation. Cooperatives sometimes lure potential purchasers by concealing the extent of repairs and renovations which will be necessary after the building becomes a cooperative. Once the repairs are completed, the maintenance costs—basically the carrying costs of the building each individual owner must bear—take an upward bound and make ownership of the loft far less attractive than it originally appeared. Also, in New York City at least, cooperatives for artists in Soho have come into existence without complying with the New York attorney general's registration requirements, which are designed to prevent frauds by requiring extensive disclosures.[4] The artist should be particularly cautious when considering the purchase of a loft in a cooperative building.

13

INCOME TAXATION

The artist's professional income—for example, from sales of work, commissions, copyright royalties, and wages—is taxed as ordinary income by the federal government and by the state and city where the artist lives, if such state or city has an income tax. The business expenses of being an artist, however, are deductible and reduce the income which will be taxed. Both income—as gross receipts—and expenses are entered on Schedule C, *Profit or (Loss) from Business or Profession*, which is attached to Form 1040. A sample Schedule C is reproduced at pp. 154–155.

Although they are not the same as an income tax, the artist should also check whether any state and city sales taxes may have to be collected on art works. If such taxes must be collected, the artist may be entitled to a resale number which permits the purchase of materials and supplies without payment of any sales tax. The artist must also determine whether either a state or local unincorporated business tax, such as New York City has, must be paid in addition to the personal income tax. These taxes vary with each state and city, so guidance must be obtained in the artist's own locality.

General guides to federal taxation are IRS Publication 17, *Your Federal Income Tax*, for individuals and IRS Publication 334, *Tax Guide for Small Businesses*, for businesses. These and the other IRS publications mentioned in the income tax chapters can all be obtained free of charge from any IRS office. The artist should keep in mind, however, that these publications represent the views of the IRS and are sometimes inconsistent with precedents already established by the courts.

144

Record Keeping

All income and expenses arising from the profession of being an artist should be promptly recorded in a ledger regularly used for that purpose. The entries should give specific information as to dates, sources, purposes, and other relevant data, all supported by checks, bills, and receipts whenever possible. It is advisable to maintain business checking and savings accounts through which all professional income and expenses are channeled separate from the artist's personal accounts. IRS Publications 552, *Recordkeeping Requirements and a Guide to Tax Publications* and 583, *Recordkeeping for a Small Business*, provide details as to the "permanent, accurate and complete" records required.

Accounting Methods and Periods

Like any other taxpayer, the artist may choose either of two methods of accounting: the cash method or the accrual method. The cash method includes in income all income actually received during the tax year and deducts all expenses actually paid during the tax year. The accrual method, on the other hand, includes as income all that income which the artist has earned and has a right to receive in the tax year, even if not actually received until a later tax year, and deducts expenses when they are incurred instead of when they are paid. Since most artists operate on the simpler cash method, the chapters on income taxes will assume that the cash method is being used.[1]

Income taxes are calculated for annual accounting periods. The tax year for the vast majority of taxpayers is the calendar year: January 1st through December 31st. However, a taxpayer could use any fiscal year (for example, July 1st through June 30th). Since most artists use the calendar year as their tax year, the income tax chapters will assume the use of a calendar year.

The cash method of accounting in a few cases, however, may include income not actually received by the artist, if the income has been credited or set apart so as to be subject to the artist's control. For example, income received by a gallery acting as agent for the artist will, when received by the gallery, be taxable to the artist unless substantial limitations or restrictions exist as to how or when the gallery will pay the artist.[2]

One valuable tax-saving device for the cash basis, calendar year artist is to pay expenses in December while putting off receipt of income until the following January when a new tax year has begun. The expenses reduce income in the present tax year while the income is put off until the new tax year.

Further information on accounting methods and periods can be obtained in IRS Publication 538, *Tax Information on Accounting Periods and Methods.*

Types of Income

The artist must be aware of the different types of income.

The first distinction is between ordinary income and capital gains income. The artist realizes ordinary income from all the income-producing activities of the artist's profession. Ordinary income is taxed at the regular income tax rates, which go up as high as 70 percent. Capital gains income is realized upon the sale of capital assets, such as stocks, real estate, or silver bullion. Capital gains from assets owned more than six months are classified as long-term gains and receive preferential tax treatment (by basically being reduced to half before being taxed.)[3] The Tax Reform Act of 1976 extends the holding period necessary for long-term gains to nine months in 1977 and one year thereafter.

The substantial tax discrimination in favor of long-term capital gains as compared to ordinary income will cause the artist to wonder why an art work is not an asset which receives favorable capital gains treatment. Congress, when enacting the tax laws, specifically stated that "a copyright . . . or artistic composition . . . held by a taxpayer whose personal efforts created such property" cannot be an asset qualifying for capital gains treatment.[4] And if the artist gives an art work to someone else, that person will own the work as the artist did—as ordinary income property rather than an asset qualifying for capital gains treatment. Unfair as it may seem, if the work is sold to a collector, the collector may own the work as a capital asset and obtain the lower capital gains rate upon sale of the work, as discussed at p. 199.

Another distinction to be kept in mind is between ordinary income which is earned and that which is unearned.[5] The professional income of the artist is considered earned income, but income from stock dividends, interest, rent, and capital gains, for example, is treated as unearned income. Personal service income, which is earned income plus pension or

annuity or deferred compensation income, is never taxed at a rate of more than 50 percent. But unearned income may be taxed at a rate as high as 70 percent. As a practical matter, most artists will be concerned about earned income in such areas as retirement (discussed at pp. 158–159) and income earned abroad (discussed at pp. 162–164).

Basis

The amount of profit to an artist on the sale of work is usually the sale price less the cost of materials in the work. The cost of materials is called the "basis" of the work for tax purposes. The cash basis artist, who deducts the cost of art materials and supplies currently when purchased, must remember that such materials and supplies cannot be deducted again as the basis of the art works when sold. In other words, if the artist deducts materials and supplies currently, then the art works have a zero basis and the entire amount of the proceeds from sales will be taxable.[6] If the work is given to someone else, that person will have the same zero basis of the artist and, as mentioned earlier, realize ordinary income upon sale. The basis for a collector who purchases the work, however, will be the purchase price. The collector's gain on resale will be the difference between the price on resale and the basis. And the gain, as stated earlier, can be taxed at the favorable capital gains rates.

Grants

Grants to artists for scholarships or fellowships to further their education and training are excluded from gross income as long as the grants are not compensation for services and are not given primarily for the benefit of the grant-giving organization.[7] Amounts given to cover expenses incurred in connection with such grants (and don't use up the $300 limit mentioned below) are excludable from income if they represent expenses specifically designated under the grant and are spent for the purpose of the grant. A degree candidate has no limit on the grant amounts which may be excluded as long as teaching, research, or other employment under the grant is required for all candidates for the particular degree.

An artist who is not a degree candidate may only exclude up to $300 time the number of months to which amounts received under the grant are attributable, but for no more than a total of thirty-six months, con-

secutive or otherwise, duirng the artist's lifetime. After the thirty-six months are exhausted, the full amount of any grants and related amounts for expenses are fully includable in income. An artist who is not a degree candidate can only exclude the grants at all if the grants are paid by certain governmental, nonprofit, or international organizations. More information on the taxation of grants can be obtained in Chapter 7, "What Income Is Taxable," IRS Publication 17, *Your Federal Income Tax*.

Prizes and Awards

Prizes and awards to artists are, in most cases, taxable, even if they are given in the form of goods or services. The sole area in which tax can be avoided is when prizes and awards are given in recognition of past achievements in the field of art without application or services on the part of the artist (for example, the Pulitzer Prize or Nobel Prize). Once the artist is selected as a candidate, however, filling out application forms or appearing for an interview will not cause the prize or award to be includable in gross income.[8]

Valuation

Valuation is important when the artist realizes income in the form of goods or services. In such event, the amount included in gross income is the fair market value of the goods or services received, which is basically the price to which a buyer and a seller, dealing at arm's length, would agree. Valuation will be particularly important to the artist who gives art work in exchange for either the art work of friends or the services of professionals, such as lawyers, doctors, and dentists. Such exchanges of art works for other works or services are considered sales.[9] Since fair market value can be a factual issue, the artist should consider using the services of a professional appraiser. Such an appraisal will be helpful if the artist must make an insurance claim for work which has been damaged, lost, or destroyed. Insurance proceeds are taxable as if a sale had occurred.

Professional Expenses

Deductible business expenses are all the ordinary and necessary expenditures the artist must make professionally. Such expenses, which are recorded on Schedule C, include, for example, art materials and supplies, work space, office equipment, certain books and magazines, repairs, travel for business purposes, promotional expenses, telephone, postage, premiums for art insurance, commissions of agents, and legal and accounting fees.

Art Supplies and Other Deductions

Art materials and supplies are generally current expenses, deductible in full in the year purchased. These include all items with a useful life of less than one year, such as canvas, film, brushes, paints, paper, ink, pens, erasers, typewriter rentals, mailing envelopes, photocopying, file folders, stationery, paper clips, and similar items. Moreover, the sales tax on these and other business purchases is a deductible expense and can simply be included in the cost of the item. Postage is similarly deductible as soon as the expense is incurred. The cost of professional journals is deductible, as is the cost for books used in preparation for specific works. Dues for membership in the artist's professional organizations are deductible, as are fees to attend workshops sponsored by such organizations. Telephone bills and an answering service are deductible in full for a business telephone. If, however, use of the telephone is divided between personal and business calls, then records should be kept itemizing both long-distance and local message units expended for business purposes, and the cost of any answering service should also be prorated. Educational expenses are generally not deductible, unless the artist can establish that such expenses were incurred to maintain or improve skills required as an artist (but not to learn or qualify in a new profession). IRS Publication 508, *Tax Information on Educational Expenses,* can be consulted here.

Repairs to professional equipment are deductible in full in the year incurred. If the artist moves to a new house, the pro rata share of the moving expenses attributable to professional equipment is deductible as a business expense.

Work Space

If the artist rents work space at a location different from where the artist lives, all of the rent and expenses in connection with the work space are deductible. However, the Tax Reform Act of 1976 places limitations on business deductions which are attributable to an office or studio at home. Such deductions will be allowed if the artist uses a part of the home exclusively, and on a regular basis, as the artist's principal place of business. Even though the artist may have another profession, if the studio at home is the principal place of the business of being an artist, the business deductions may be taken. Also, the artist who maintains a separate structure used exclusively, and on a regular basis, in connection with the business of being an artist is entitled to the deductions attributable to the separate structure. Provisions less likely to apply to artists allow deductions when a portion of the home is used exclusively, and on a regular basis, as the normal place to meet with clients and customers or when the artist's business is selling art at retail and the portion of the home, even though not used on an exclusive basis, is the sole, fixed location of that business.

To determine what expenses are attributable to an office or studio, the artist must calculate how much of the total space in the home is used as work space. If a one-room apartment comprising a fifth of the area is used as work space, 20 percent of the rent is deductible. A homeowner makes the same calculation as to work space use. However, capital assets, those having a useful life of more than one year, must be. A house has a basis for depreciation (only the house land is not depreciated), which is usually its cost less its salvage value at the end of its useful life. This basis is divided by the useful life of the house to determine the amount of depreciation of the house each year. Thereafter, the percentage of the house used professionally is applied to the annual depreciation figure to reach the amount of the depreciation which is deductible for the current year. IRS Publications 529, *Other Miscellaneous Deductions*, and 534, *Tax Information on Depreciation*, are of aid in the determination of basis, salvage value, and the calculation of depreciation. These publications also describe more rapid methods of depreciation than the straight-line method which is described above, but the artist should consult an accountant to determine whether such methods can and should be used. IRS Publication 587, *Tax Information on Operating a Business in Your Home*, can also be consulted with regard to deductions for or related to work space.

The portion of expenses for utilities, insurance, and cleaning costs allocable to the work space are deductible. Repairs to maintain the house or apartment are also deductible on this pro rata basis. Property taxes and mortgage interest are deductible in full regardless of whether or not the artist's home is used for work purposes, provided the artist itemizes personal deductions on Schedule A of Form 1040. If personal deductions are not itemized on Schedule A, the portions of property taxes and mortgage interest deductible as business expenses would be entered on Schedule C.

The Tax Reform Act of 1976 also limits the amount of business expenses which may be deducted when attributable to a home office or studio. Assuming the artist qualifies to take the deductions under one of the tests described above, the deductions for work space cannot exceed the artist's gross income from art minus deductions which would be allowed whether or not connected with a business or trade (such as real estate taxes and mortgage interest, which can be itemized and deducted on Schedule A). For example, an artist earns gross income of $1,500 in a year from art, while exclusively, and on a regular basis, using one-quarter of the artist's home as the principal place of the business of being an artist. The artist owns the home, and mortgage interest is $2,000 while real estate taxes are $1,600, for a total of $3,600 of deductions which could be taken on Schedule A regardless of whether incurred in connection with a business. Other expenses, such as electricity, heat, cleaning, and depreciation, total $8,800. A one-quarter allocation would attribute $900 of the mortgage interest and real estate taxes and $2,200 of the other expenses to the artist's business. The artist's gross income of $1,500 is reduced by the $900 allocable to the mortgage interest and real estate taxes, leaving $600 as the maximum amount of expenses relating to work space which may be deducted. Since the remaining expenses, in fact, total $2,200, the artist will lose the opportunity to deduct $1,600 because the income from art was not large enough to match against the expenses. An artist who rents will make a simpler calculation, since the expenses attributable to a home office or studio will simply be subtracted from gross income from art and any excess expenses will not be deductible. This provision of the Tax Reform Act of 1976 will work a hardship on the many artists who sacrifice to pursue their art despite not earning large incomes.

Professional Equipment

The cost of professional equipment having a useful life of more than one year cannot be fully deducted in the year of purchase but must be depreciated. Again, IRS Publication 534, *Tax Information on Depreciation*, will aid in the computation of depreciation. The useful life of professional equipment will vary, but a good faith estimate based on the personal knowledge and experience of the artist (or upon the guidelines of the more complex Class Life Asset Depreciation Range System described in Publication 534) will be acceptable. The salvage value of an asset (other than a house) having a useful life of three years or more may be reduced by 10 percent of the asset's original cost for depreciation calculations, and thus a salvage value of less than 10 percent will not affect the depreciation computation at all. Bonus depreciation of 20 percent of original cost may be added to the first year depreciation of an asset (other than a house) having a useful life of at least six years—as computed in Publication 534. If an asset becomes worthless before expiration of its estimated useful life, the remaining basis is claimed as depreciation in the year of worthlessness.

Travel, Transportation, and Entertainment

Travel, transportation, and entertainment expenses for business purposes are deductible, but must meet strict record-keeping requirements. Travel expenses are the ordinary and necessary expenses, including meals, lodging, and transportation, incurred for travel overnight away from home in pursuit of professional activities. Such expenses would be deductible, for example, if the artist traveled to another city to hang a gallery show and stayed several days to complete the work. If the artist is not required to sleep or rest while away from home, transportation expenses are limited to the cost of travel (but commuting expenses are not deductible as transportation expenses). Entertainment expenses, whether business luncheons or parties or similar items, are deductible as long as the expense is incurred for the purpose of developing business. Business gifts may be made to individuals, but no deduction will be allowed for gifts to any one individual in excess of $25 during the tax year. Accurate records detailing business purpose, date, place, and cost are particularly

important for all these deductions. The artist should also get into the habit of writing these details on copies of bills or credit card charge receipts. IRS Publication 463, *Travel, Entertainment and Gift Expenses,* gives more details, including the current mileage charge should the artist own and use a car. Also, self-promotional items, such as advertising, printing business cards, or sending Christmas greetings to professional associates, are deductible expenses.

Commissions, Fees, and Salaries

Commissions paid to agents and fees paid to lawyers or accountants for business purposes are tax deductible, as are the salaries paid to typists, researchers, and others. However, the artist should try to hire people as independent contractors rather than employees, in order to avoid liability for social security, disability, and withholding tax payments. This can be done by hiring on a job-for-job basis, with each job to be completed by a deadline, preferably at a place chosen by the person hired. Record-keeping expenses and taxes will be saved, although Form 1099, *Statement for Recipients of Miscellaneous Income,* must be filed for each independent contractor paid more than $600 in one year by the artist.

Schedule C

The completion of Schedule C—by use of the guidelines in this chapter—finishes much, but not all, of the artist's tax preparations. The next chapter discusses other important tax provisions—not reflected on Schedule C—which can aid the artist or which the artist must observe.

The Schedule C on pp. 154–155 has been provided by Rubin L. Gorewitz, C.P.A., New York.

SCHEDULE C
(Form 1040)
Department of the Treasury
Internal Revenue Service

Profit or (Loss) From Business or Profession

(Sole Proprietorship)
Partnerships, Joint Ventures, etc., Must File Form 1065.
► Attach to Form 1040. ► See Instructions for Schedule C (Form 1040).

1975

Name(s) as shown on Form 1040	Social security number
Jane Artist	000 00 0000

A Principal business activity (see Schedule C Instructions) ► ...Artist...; product ► ..Paintings..

B Business name ► .. **C** Employer identification number ►

D Business address (number and street) ► ..125 Main Street.............

City, State and ZIP code ►Indian Rock, Idaho..........

C

	Yes	No
E Indicate method of accounting: (1) ☒ Cash (2) ☐ Accrual (3) ☐ Other ►		
F Were you required to file Form W–3 or Form 1096 for 1975? (see Schedule C Instructions)		X
If "Yes," where filed ►		
G Was an Employer's Quarterly Federal Tax Return, Form 941, filed for this business for any quarter in 1975?		X

H Method of inventory valuation ► ..NA.......... Was there any substantial change in the manner of determining quantities, costs, or valuations between the opening and closing inventories? (If "Yes," attach explanation) . .

Income

1 Gross receipts or sales $.......... Less: returns and allowances $.......... **Balance** ►	1	15,592	
2 Less: Cost of goods sold and/or operations (Schedule C–1, line 8)	2	2,727	
3 Gross profit	3	12,865	
4 Other income (attach schedule) . .	4		
5 Total income (add lines 3 and 4)	5	12,865	

Deductions

6 Depreciation (explain in Schedule C–3)	6	420	
7 Taxes on business and business property (explain in Schedule C–2)	7		
8 Rent on business property	8	2,400	
9 Repairs (explain in Schedule C–2)	9		
10 Salaries and wages not included on line 3, Schedule C–1 (exclude any paid to yourself) .	10		
11 Insurance	11	556	
12 Legal and professional fees	12		
13 Commissions	13	2,250	
14 Amortization (attach statement)	14		
15 (a) Pension and profit-sharing plans (see Schedule C Instructions)	15(a)		
(b) Employee benefit programs (see Schedule C Instructions)	(b)		
16 Interest on business indebtedness	16		
17 Bad debts arising from sales or services	17		
18 Depletion	18		

19 Other business expenses (specify):

(a) Advertising	75	
(b) Entertainment	157	
(c) Postage	92	
(d) Professional dues	45	
(e) Stationery	35	
(f) Telephone	341	
(g) Telephone Answering Service	120	
(h) Travel	82	
(i) Utilities	359	
(j) Miscellaneous	143	

(k) Total other business expenses (add lines 19(a) through 19(j))	19(k)	1,449	
20 Total deductions (add lines 6 through 19(k))	20	7,075	
21 Net profit or (loss) (subtract line 20 from line 5). Enter here and on Form 1040, line 28. **ALSO** enter on Schedule SE, line 5(a)	21	5,790	

SCHEDULE C–1.—Cost of Goods Sold and/or Operations (See Schedule C Instructions for Line 2)

1 Inventory at beginning of year (if different from last year's closing inventory, attach explanation) . . .	1		
2 Purchases $.......... Less: cost of items withdrawn for personal use $.......... **Balance** ►	2		
3 Cost of labor (do not include salary paid to yourself)	3	756	
4 Materials and supplies	4	1,971	
5 Other costs (attach schedule)	5		
6 Total of lines 1 through 5	6	2,727	
7 Less: Inventory at end of year	7		
8 Cost of goods sold and/or operations. Enter here and on line 2 above	8	2,727	

Schedule C (Form 1040) 1975

Page **2**

SCHEDULE C-2.—Explanation of Lines 7 and 9

Line No.	Explanation	Amount	Line No.	Explanation	Amount
		$			$

SCHEDULE C-3.—Depreciation (See Schedule C Instructions for Line 6) If you need more space, you may use Form 4562.

Note: If depreciation is computed by using the Class Life (ADR) System for assets placed in service after December 31, 1970, or the Guideline Class Life System for assets placed in service before January 1, 1971, you must file Form 4832 (Class Life (ADR) System) or Form 5006 (Guideline Class Life System). Except as otherwise expressly provided in income tax regulations sections 1.167(a)–11(b)(5)(vi) and 1.167(a)–12, the provisions of Revenue Procedures 62–21 and 65–13 are not applicable for taxable years ending after December 31, 1970. (See Publication 534.)

Check box if you made an election this taxable year to use ☐ Class Life (ADR) System and/or ☐ Guideline Class Life System.

a. Group and guideline class or description of property	b. Date acquired	c. Cost or other basis	d. Depreciation allowed or allowable in prior years	e. Method of computing depreciation	f. Life or rate	g. Depreciation for this year
1 Total additional first-year depreciation (do not include in items below) 20% of $300.00 →						60
2 Depreciation from Form 4832 . (See Note)						
3 Depreciation from Form 5006 . (above)						
4 Other depreciation:						
Buildings						
Furniture and fixtures	1/2/75	240		straight line	8	30
Transportation equipment . . .						
Machinery and other equipment .						
Other (specify)................						
Studio Improvements	1/25/73	3,300	660	straight line	10	330
5 Totals		3,540				420
6 Less amount of depreciation claimed in Schedule C–1, page 1						
7 Balance—Enter here and on page 1, line 6						420

SCHEDULE C-4.—Expense Account Information (See Schedule C Instructions for Schedule C-4)

Enter information with regard to yourself and your five highest paid employees. In determining the five highest paid employees, expense account allowances must be added to their salaries and wages. However, the information need not be submitted for any employee for whom the combined amount is less than $25,000, or for yourself if your expense account allowance plus line 21, page 1, is less than $25,000.

	Name	Expense account	Salaries and Wages
Owner			
1			
2			
3			
4			
5			

Did you claim a deduction for expenses connected with:

(1) Entertainment facility (boat, resort, ranch, etc.)? . . ☐ Yes ☐ No (3) Employees' families at conventions or meetings? . . ☐ Yes ☐ No

(2) Living accommodations (except employees on business)? ☐ Yes ☐ No (4) Employee or family vacations not reported on Form W–2? ☐ Yes ☐ No

14

INCOME TAXATION: II

The artist must also be aware of a number of other tax benefits and obligations in order to be able to make rational choices and to seek professional advice when necessary. These provisions, while not gathered neatly in one place as income and expenses are on Schedule C, are of great significance to the artist.

Income Averaging

Income averaging might be a valuable tax-saving device for the artist when there is a large increase in the artist's taxable income for one tax year as compared to the previous years. The effect of averaging, which is computed on Schedule G of Form 1040, is to treat a certain amount of the extra income realized in the current tax year as if it had actually been received over the preceding four years. Substantial savings result because of the progressive nature of the tax structure. IRS Publication 506, *Computing Your Tax Under the Income Averaging Method,* should be consulted for details.

Self-Employment Tax

The social security system of the United States creates numerous benefits for those who have contributed from their earnings to the federal social security system. It provides benefits for a person's family in the

event of death or disablement as well as providing a pension and certain medical insurance. Artists, whether employees or self-employed, are covered by the system. Since the payments for social security are not automatically withheld for a self-employed artist, as they are for one who is an employee, the self-employed artist must file, with the Form 1040, a Schedule SE, *Computation of Social Security Self-Employment Tax,* and pay the self-employment tax shown on the Schedule SE. Self-employment income is basically the net income of the artist reported on Schedule C, subject to certain adjustments. If an artist and spouse both earn self-employment income, each must file a separate Schedule SE. If an artist has more than one business, the combined earnings should be totaled on Schedule SE for purposes of calculating the self-employment tax.

Social security coverage to gain the various benefits is created by having a certain number of years during which a worker makes payments for social security. A self-employed artist must, in any case, make social security payments for each year when net self-employment income is more than $400, but when the artist does so a year of work credit is recorded for social security benefits. If a minimum number of years of work credit is established, the artist qualifies for benefits. Some benefits require the artist to be "fully insured" (that is, have at least ten years of work credit), while other benefits only require that the artist be "currently insured" (that is, have at least six quarters of coverage in the thirteen-quarter period ending when benefits are to begin). The amount of benefits is based on average yearly earnings covered by social security. Therefore, the artist benefits by paying self-employment tax each year on the maximum permissible amount of self-employment income. The maximum amount of income on which tax must be paid has been increasing constantly over the years: for example, from $14,100 in 1975 to $15,300 in 1976.

Calculation of the self-employment tax is done by first taking all income from employers from which the social security tax has already been withheld and subtracting that from the maximum amount of income on which tax must be paid to determine how much tax must be paid on the remaining self-employment income. In 1976 the social security tax rate was 7.9 percent for the self-employed, but these rates are scheduled to increase. For 1976 the maximum self-employment tax is $1,208.70, payable if the income to be taxed, as shown on Schedule SE, is $15,300 or more.

Further information as to the computation of the self-employment tax can be found in IRS Publication 533, *Information on Self-Employment*

Tax. Additional information as to the benefits available under social security to either the artist or the artist's family is available from the local office of the Social Security Administration, including pamphlets titled "Your Social Security" and "If You're Self-Employed . . . Reporting Your Income for Social Security."

Estimated Tax

Employers withhold income and social security taxes from the wages of their employees. However, the self-employed artist must pay income and social security taxes in quarterly installments computed on Form 1040-SE, *Estimated Tax Declaration Voucher*, and mailed on or before April 15, June 15, September 15, and January 15. In most cases, Form 1040-SE is required if the artist estimates that the total of income and self-employment taxes for the next tax year will exceed any withheld taxes by $100 or more. IRS Publication 505, *Tax Withholding and Declaration of Estimated Tax*, gives more detailed information regarding the estimated tax.

Retirement Plans

Keogh plans now permit a self-employed person like an artist to contribute the lesser of 15 percent of net self-employment income or $7,500 to a retirement fund and to deduct the amount of the contribution from gross income when computing income taxes. The artist will be allowed a minimum deduction of the lesser of $750 or 100 percent of self-employment income. However, the deduction is allowed in any year only if the artist places the amount to be deducted in one of the following retirement funds: a trust, annuity contracts from an insurance company, a custodial account with a bank or other person, special U.S. Government retirement bonds, or certain face-amount certificates purchased from investment companies. Even if the artist is employed by a company with a retirement program, the artist may still have a Keogh plan for self-employment income from the career in art. Originally a contribution to a Keogh plan had to be made before December 31 to be deductible in that tax year. But with an appropriate election, such a contribution can now be made before the filing date of the tax return, which is usually the

following April 15 or any extensions of the filing date, as long as the Keogh plan was in existence during the tax year for which the deduction is to be taken. Because the money contributed to a Keogh plan is deductible, there are penalties for withdrawal of monies from a plan prior to age 59½ unless the artist becomes permanently disabled. Distributions are taxed when made, and must begin no later than age 70½. The artist's tax bracket then, however, may be much lower than when contributions are made. It should be kept in mind that employees will probably have to be covered if the artist begins a Keogh plan. More information about Keogh plans can be obtained from the institutions, such as the local bank or insurance company, which administer them. Also helpful are IRS Publications 560, *Retirement Plans for Self-Employed Individuals*, and 566, *Questions and Answers on Retirement Plans for the Self-Employed.*

Separate from the Keogh plan, the artist can begin an Individual Retirement Account. This account is available to persons who do not have a Keogh plan and whose employers do not provide any retirement plan. By creation of such an account, the artist may contribute into a retirement fund up to $1,500 per year (or only 15 percent of wages and professional fees, if that is less than $1,500). A married artist with a non-working spouse may be able to contribute $1,750 to benefit both spouses. The amount of the contribution is a deduction from gross income. Again the funds contributed must be taken out of the artist's hands and placed in a trust, a custodial account with a bank or other person, annuity contracts with a life insurance company, or special U.S. Government retirement bonds. The payment, to be deductible, must be made not more than forty-five days after December 31 of the tax year in which the deduction will be taken. More information can be obtained from the institutions administering Individual Retirement Accounts, as well as IRS Publication 590, *Tax Information on Individual Retirement Savings Programs.*

Keogh plan contributions are claimed on Form 1040, line 40a, and Individual Retirement Account contributions are claimed on Form 1040, line 40b. The artist should consult with the Keogh plan or Individual Retirement Account administrator to determine what additional forms may have to be filed.

Investment Credit

Apart from depreciation, another significant tax consideration for the artist's equipment (but not applicable to buildings) is the investment tax credit. This gives a tax reduction equal to 7 percent of the investment in new or used (if used, only to the amount of $50,000) depreciable property. The amount of the credit hinges on the length of the asset's useful life, and the useful life for purposes of computing the investment credit must be the same as the useful life for depreciation purposes. The basis for depreciation is not, however, reduced by the amount of the investment credit. To get the full 7 percent, the asset must have an expected useful life of seven years or more. The 7 percent credit is only allowed on two-thirds of the investment if the useful life is five to seven years, and on one-third of the investment if the useful life is three to five years. No investment credit is available for assets having useful lives of less than three years. Form 3468, *Computation of Investment Credit*, is used for the computation and sets forth some limitations on such credit. Early disposition of the asset causes recapture of part of the investment credit on Form 4255. The final entry from Form 3468 is made on Form 1040, line 29.

The Tax Reduction Act of 1975 increased the investment tax credit to 10 percent (and, in the case of used property, increased the permissible amount to $100,000), but only for equipment placed in use after January 22, 1975. The Tax Reform Act of 1976 extended these increases through 1980. IRS Publication 572, *Tax Information on the Investment Credit*, contains additional information regarding the investment credit.

Child and Disabled Dependent Care

The Tax Reform Act of 1976 changed the deduction for child or disabled dependent care into a tax credit. The amount of the credit is 20 percent of the employment-related expenses which an artist pays in order to be gainfully employed. Basically, this credit is available to the artist who maintains a household including either a child under age fifteen or a disabled dependent or spouse for the care of whom it is necessary to hire someone so the artist can gainfully pursue employment, self-employment, or the search for employment. IRS Publication 503, *Child*

Care and Disabled Dependent Care, describes in greater detail the availability of and limitations on this credit.

Contributions

Contributions to qualified organizations are deductible if personal deductions are itemized on Schedule A. Since the artist's own art works, and any gifts of works by other artists, have a tax basis of zero (if the artist is on a cash basis) or the cost of materials (if the artist is on an accrual basis), the artist's deduction is limited to such basis. Numerous bills have been proposed to rectify this inequitable treatment, and perhaps the artist will soon be able to deduct either part or all of the fair market value of contributed works.[1] The rule, of course, is otherwise for the collector— an artist, for example, who purchases work or exchanges work with other artists. The deductions for a collector's contributions are discussed at p. 200.

Bad Debts

A common error is the belief that if an artist (on the cash basis) sells a work for $1,000, and the purchaser never pays, the artist can take a bad debt deduction. The artist cannot, since the $1,000 purchase price has never been received and included in income. As stated in Publication 334, *Tax Guide for Small Businesses,* "Worthless debts arising from sales, professional services rendered . . . and similar items of income will not be allowed as bad debt deductions unless the income from those items has been included in gross income in the return for the year for which the deduction is claimed or for a previous year."

A cash basis taxpayer can, however, gain a tax benefit from either business or nonbusiness bad debts of the proper kind. In almost all cases, the artist's bad debts will be nonbusiness. For example, if the artist makes a loan to a friend who never repays the loan, the amount of the loan will be a nonbusiness bad debt. The loan cannot be a gift, however, and must be legally enforceable against the borrower. The nonbusiness bad debt deduction is taken in the year the debt becomes worthless. It is reported as a short-term capital loss on Schedule D.

Net Operating Losses

The artist who experiences a business loss as determined on Schedule C will carry the loss to Form 1040, where it is eventually subtracted from gross income in the calculations to reach taxable income. However, if the loss is large enough to wipe out other taxable income for the year, the excess loss can first be carried back to reduce taxable income in previous taxable years and then carried forward to reduce taxable income in future taxable years. This is quite likely to happen when a professional artist is changing over from being employed to devoting all working time to art. The result is that the artist will be entitled to a tax refund (if taxable income in previous years is reduced) or will save on taxes in future years. IRS Publication 536, *Losses from Operating a Business*, describes the net operating loss, but the artist will probably need an accountant's help for the computation of a net operating loss.

American Artists Living Abroad

American citizens, whether or not they live in the United States, are taxable by the United States government on all of their income from anywhere in the world. However, a tax benefit for many American citizens living abroad has been the exclusion from American taxable income of either $20,000 or $25,000 of earned income from foreign sources. The Tax Reform Act of 1976 reduces the exclusion to $15,000 for taxable years beginning after December 31, 1975. The exclusion can result in substantial tax benefits where the tax rates of the foreign country—such as Ireland, where a qualified artist can live tax free—are lower than the tax rates in the United States.

Publication 54, *Tax Guide for U.S. Citizens Abroad*, generally explains the guidelines for eligibility for these exclusions. The basic requirements are either a one-year residence or a physical presence in a foreign country and earned income created from work done in the foreign country. Residence is a flexible concept based on the circumstances of each individual. While the residence must be uninterrupted (for example, by owning or renting a home continually), remaining abroad for all of the taxable year in question isn't necessary. Brief trips to the United States do not affect the tax status as a resident abroad. However, the length of each visit and the total time spent in the United States must be

watched carefully. Physical presence requires the taxpayer to be present in a foreign country or countries for at least 510 days during a period of eighteen consecutive months. Regardless of which test is met, the income to be excluded must be received no later than the year after the year in which the work was performed which generated the income.

Assuming the artist met either the residence or physical presence test, the requirement that the income to be excluded had to be earned income often proved fatal to the artist's attempt to benefit from the exclusion. The reason for this was the definition, still found in Publication 54, of most of the income of an artist as unearned:

> Income of an Artist. If you are an artist and you sell your pictures wherever possible, without prior contract, order, commission or commitment from the purchaser, your income from this source does not qualify as earned income. Therefore, such income does not qualify for exclusion. This is true even if you are a U.S. citizen and a bona fide resident of a foreign country in which you paint or draw your pictures.

Since most artists work independently, this definition made the larger part of income received by artists unearned income which was not eligible for the exclusion from United States taxable income.

This unjust situation has been substantially rectified, however, by a case involving the painter, Mark Tobey, while he was a resident of Switzerland. In *Tobey* v. *Commissioner*[2] the issue before the tax court was whether Mark Tobey, all of whose "works were executed . . . without prior commission, contract, order, or any such prior arrangement," had earned income such that he could avail himself of the $25,000 exclusion from United States taxable income. The court, noting that *earned* generally implies a product of one's own work, reasoned:

> The concept of the artist as not "earning" his income for the purposes of Section 911 would place him in an unfavorable light. For the most part, the present day artist is a hard-working, trained, career-oriented individual. His education, whether acquired formally or through personal practice, growth and experience, is often costly and exacting. He has keen competition from many other artists who must create and sell their works to survive. To avoid discriminatory treatment, we perceive no sound reasons for treating income earned by the personal efforts, skill and creativity of a Tobey

or a Picasso any differently from the income earned by a confidence man, a brain surgeon, a movie star or, for that matter, a tax attorney.

This rationale necessarily led to the conclusion that Tobey's income was earned. Unfortunately, this decision can be relied upon only with the following warning. The Internal Revenue Service has not acquiesced in *Tobey* v. *Commissioner,* which means the service reserves the right to challenge each artist claiming the exclusion. This procedure may ultimately bring the different United States Circuit Courts into conflict, thus creating the groundwork for a definitive determination by the Supreme Court. Keeping this in mind, however, *Tobey* v. *Commissioner* is at present persuasive as to the artist's income being earned regardless of whether the income is derived from contractual commitments or independent sales.

Each artist hoping to benefit from the exclusion for income earned abroad must, of course, consult with a lawyer or an accountant to determine the effect of the foregoing legal provisions on each unique situation. Artists already living abroad should also inquire at their American consulate to determine whether any treaty regarding taxation between the United States and the country in which they live might affect their tax status. Then, noting the refusal of the Internal Revenue Service to acquiesce in *Tobey* v. *Commissioner,* artists satisfying either the residence or physical presence test may legitimately claim the benefits of the exclusion for earned income created during their stay abroad.

The artist living abroad should also consider whether any income taxes paid to a foreign government may be taken as either a deduction or a tax credit. However, the Tax Reform Act of 1976 provides that no credit or deduction will be allowed on foreign income taxes paid on earned income excluded from United States taxation. IRS Publication 514, *Foreign Tax Credit for U.S. Citizens and Resident Aliens,* explains these provisions further.

Foreign Artists in the United States

Foreign artists who are residents in the United States are generally taxed the same as United States citizens. Foreign artists who are not residents in the United States are taxed on income from sources in the United States under special rules. A foreigner who is merely visiting or

whose stay is limited by immigration laws will usually be considered a nonresident. A foreigner who intends, at least temporarily, to establish a home in the United States and has a visa permitting permanent residence will probably be considered a resident. IRS Publication 519, *United States Tax Guide for Aliens,* should be consulted by foreign artists for a more extensive discussion of their tax status.

Forms of Doing Business

Depending on the success of the artist, various forms of doing business might be considered. There may be both business and tax advantages to conducting the artist's business in the form of a corporation or partnership, but there may be disadvantages as well.[3]

Generally, the nontax advantages of incorporation are limited liability for the stockholders, centralized management, access to capital, transferability of ownership, and continuity of the business. For the artist, the most important of these nontax advantages will probably be limited liability. This means that a judgment in a lawsuit can affect only the assets of the corporation, not the personal assets of the artist. Limited liability can be quite significant where the work locale, machinery, chemicals, or even art work are potentially hazardous. The attribute of limited liability applies to the two types of corporations which exist—the regular corporation and the Subchapter S corporation. The tax treatment, however, differs significantly between the two types of corporations.

The Tax Reduction Act of 1975 and the Tax Reform Act of 1976 have temporarily lowered the tax rates for regular corporations, so that net corporate income is taxed at 20 percent to $25,000, 22 percent from $25,000 to $50,000, and 48 percent over $50,000. Usually the tax on the corporation can be substantially avoided by the payment of a salary to the artist, which creates a deduction for the corporation. Such an arrangement can effectively average the artist's income from year to year. The Subchapter S corporation is not taxed at all, but the income is credited directly to the accounts of the stockholders and they are taxed as individuals. Both types of corporations permit the artist to take certain business deductions which would not be possible as an individual proprietor. Thus, it is a deductible business expense for either type of corporation to maintain $50,000 worth of life insurance as well as medical insurance for the artist. However, while the regular corporation may

deduct more for a pension plan than a contributor to a Keogh plan, the Subchapter S corporation may only create a retirement plan based on the same limitations as a Keogh plan would have. Some of the disadvantages of incorporation are additional record keeping, meetings, and paper work, as well as significant expenses both for the initial incorporation and for any ultimate dissolution.

A partnership is an agreement between two or more persons to join together as co-owners of a business in pursuit of profit. Partnerships are not subject to the income tax, but the individual partners are taxable on their share of the partnership income. Partners are personally liable for obligations incurred on behalf of the partnership by any of the partners. A partnership offers to the artist an opportunity to combine with investors under an agreement in which the investors may gain tax advantages by being allocated a greater share of partnership losses. A variation of the usual partnership is the "limited partnership," in which passive investors have limited liability (but the artist, running the business actively, is still personally liable). Another variation is the "joint venture," which can be described simply as a partnership created for a single business venture.

The artist contemplating doing business as either a corporation or partnership should consult a lawyer for advice based on the artist's unique needs.

Gifts

The artist can avoid paying income taxes by giving away the artist's creations. Both art works and copyrights can be transferred by gift to family members or others whom the artist may wish to benefit. The art work and copyright on the work can be transferred separately from one another if the artist chooses. The artist could keep the work and transfer the copyright, transfer the copyright and keep the work, or transfer both the work and the copyright. If the person who receives the gift is in a lower tax bracket than the artist, tax savings will result upon sale by the person who received the gift. Gifts over certain amounts, however, are subject to the gift tax. The making of gifts and the gift tax are discussed at pp. 184–186, but careful planning is a necessity if gifts are to be effectively used in tax planning.

15

THE HOBBY LOSS CHALLENGE

Often the artist sufficiently dedicated to pursue an art career despite year after year of losses on Schedule C will face a curious challenge from the IRS: that the losses incurred by the artist cannot be deducted for tax purposes because the artist was only pursuing a hobby and did not have the profit motive necessary to quality the art career as a business or trade.[1] A hobbyist in any field may deduct the expenses of the hobby only up to the amount of income produced by the hobby. For example, if a hobbyist makes $500 in a year on the sale of art, only up to $500 in expenses can be deducted. On the other hand, an artist actively engaged in the business or trade of being an artist—one who pursues art with a profit motive—may deduct all ordinary and necessary business expenses, even if such expenses far exceed income from art activities for the year.

A Test: Two Years out of Five

But how can an artist determine whether the requisite profit motive is present to avoid being characterized as a hobbyist by the IRS? At the outset, there is an important threshold test in favor of the taxpayer.[2] This test, which was introduced in the Tax Reform Act of 1969, provides a presumption that an artist is engaged in a business or trade—and hence is not a hobbyist—if a net profit is created by the activity in question during two of the five consecutive years ending with the taxable year at issue. Thus, many artists who have good and bad years need not fear a

hobby loss challenge to a loss in one of the bad years. Also, if a hobby loss problem is anticipated, artists on the cash basis may be able to create profitable years by regulating the time of receipt of income and the time of incurrence of expenses. For example, instead of having five years of small losses, an artist is far better off having two years where a small profit is earned and three years where larger than usual losses are incurred.

Profit Motive: The Nine Factors

But even if an artist does not have two profitable years in the last five years of art activity, the contention by the IRS that the artist is a hobbyist can still be overcome if the artist can show a profit motive. The Regulations to the Internal Revenue Code specifically provide for an objective standard to determine profit motive based on all the facts and circumstances surrounding the activity. Therefore, statements by the artist as to profit motive are given little weight. But the chance of making a profit can be quite unlikely, as long as the artist actually intends to be profitable.

The regulations set forth nine factors used to determine profit motive.[3] Since every artist is capable, in varying degrees, of pursuing art in a manner which will be considered a trade or business, these factors can create an instructive model. The objective factors are considered in their totality, so that all the circumstances surrounding the activity will determine the result in a given case. Although most of the factors are important, no single factor will determine the result of a case. The nine factors follow.

1. *Manner in which the taxpayer carries on the activity.* The artist should keep accurate records of all business activities, especially receipts and expenses.

2. *The expertise of the taxpayer or his advisors.* Study is one indication of expertise, but equally important is professional acceptance as shown by gallery exhibitions, encouragement by agents or dealers, the winning of prizes, professional memberships, or critical recognition in articles or books. Use of professional equipment and techniques can also be important. The appointment to a teaching position, if the appointment is based at least in part on professional art ability, further demonstrates expertise.

3. *The time and effort expended by the taxpayer in carrying on the activity.* The activity doesn't have to absorb all of the artist's time, but a failure to work at all is not consistent with having a profit motive. Ex-

actly what is sufficient time has never been spelled out, but on one occasion the court found four hours a day acceptable. It is helpful if the art activity is the only occupation of the artist, but employment in another field does not negate the presence of a profit motive with respect to art.

4. *Expectation that assets used in activity may appreciate in value.* This factor has yet to be applied to the arts, although artists of course expect that their art will increase in value.

5. *The success of the taxpayer in carrying on other similar or dissimilar activities.* Previous critical or financial success in art, despite an intervening slack period, is helpful.

6. *The taxpayer's history of income or losses with respect to the activity.* Increasing income each year from the art activity is very positive. On the other hand, losses don't imply a lack of a profit motive, unless such losses continue over a lengthy time period during which income is being received from nonart sources and a large imbalance exists between art-related income and expenses. Ironically, the change of profession to a nonart activity after an unprofitable art career would also show that a profit motive had existed in the pursuit of the art activity.

7. *The amount of occasional profits, if any, which are earned.* Here the amount of profits is compared to the amount of expenses, but this factor is only important where the taxpayer is sufficiently wealthy to gain tax benefits from disproportionate expenses without feeling any financial strain from the amount of the expenses.

8. *The financial status of the taxpayer.* Wealth and independent income are unfavorable to having a profit motive, while the need for income from the art activity and the lack of funds to support a hobby would tend to indicate the presence of a profit motive.

9. *Elements of personal pleasure or recreation.* This has little application, since the pursuit of an art career is as painstaking and rigorous as any occupation. However, where travel is involved, the artist should be fully prepared to justify the necessity of such travel in furtherance of the art activity.

Two Cases

To give perspective to these nine factors, a look at two hobby loss cases will be helpful. In the first case the tax court found the artist a hobbyist; in the second case, a professional artist. These cases should serve

as models for the artist, as well as illustrating the approach of the tax court to hobby loss cases.

Case I: The Hobbyist

Johanna K. W. Hailman was a prominent social leader in Pittsburgh, Pennsylvania.[4] Born in 1870, she had painted from an early age—mainly portraits and flowers—and by the time of her death in 1958 had completed 500 to 600 paintings. She owned a large estate and received substantial income from investments and a trust established by her deceased husband. On her estate she had a fully equipped and heated four-room studio located about 150 feet from her main house. During her winters in Florida she maintained a room in her residence for her studio. She was recognized as a leading artist in western Pennsylvania and had good standing throughout the United States. She had shown her work in the First International Exhibition at Carnegie Institute in 1896 and, apparently, exhibited at all the subsequent International Exhibitions at Carnegie Institute through 1955.

Between 1920 and 1949 she sold about 50 paintings, but made no sales from 1949 to 1954. She did not use a dealer or agent, but offered her paintings for sale at various exhibitions in Pittsburgh and other places. In the 1950s the prices for her paintings were in a range between $700 and $1,500, and she refused to accept offers she felt would be inadequate to maintain her prestige as an artist. From 1936 to 1954 her income from painting amounted to $7,200 while her expenses incidental to making and selling paintings came to $131,140. The IRS did not allow all of these expenses, but instead adopted the practice through 1951 of permitting as a deduction the amount of $3,000 per year.

The cessation of sales in 1949 did not correspond to a cessation of expenses, which totaled $9,654 in 1952, $7,718 in 1953, and $6,457 in 1954. The IRS determined that none of the expenses in these three years should be allowed as deductions because Mrs. Hailman was not engaged in the business of being an artist.

The tax court agreed with the IRS. The court concluded that where—over a lengthy period such as 1936 to 1954—expenses are eighteen times as great as receipts from an activity and only independent wealth permits the continuance of the activity, including the setting of high prices and the retention of most of the art works, then the activity must be deter-

mined to be pursued for the pleasurable diversion provided by a hobby without the necessary profit motive to be engaged in a business or trade. The result was that no deductions for her art activities were allowed Mrs. Hailman for the years 1952, 1953, and 1954.

Case II: The Professional

Anna Maria de Grazia, who painted under the name Anna Maria d'Annunzio, was born in Switzerland.[5] The granddaughter of Gabriele d'Annunzio, the famous Italian writer and military hero, she was raised in Italy where, in 1940, she became interested in painting. During World War II she served as a guide for the Allied forces, but continued her painting until 1944, when polio forced her to learn how to paint with her left hand rather than her right. In 1942 she won first prize in an exhibition by young painters in Florence and in the same year placed third in a contest open to all Italians. She did not paint from 1943 to 1947, but did paint and exhibit from 1948 to 1951. During this period she was admitted to the Italian painters' union upon the attestation of three professional artists that she was also a professional artist. In 1952 she moved to the United States, married Sebastian de Grazia, and neither painted nor exhibited until 1955, when she also became a naturalized citizen of the United States. By 1957 she had studied with artists Annigoni, Carena, and Kokoschka, and had been recognized by having her self-portrait and biographical background appear in a book on Italian painting from 1850 to 1950.

She resumed her painting in 1956 and 1957, supported by the modest income of her husband, who was a visiting professor at Princeton University. In 1957 she worked at Princeton in a rented house she felt had inadequate facilities for a studio. Finally, in May, she left to paint at the Piazza Donatello Studios in Florence, Italy, which had been built for artists and had excellent light. Her decision to go to Florence was prompted by her familiarity with the Italian art world, although she had also made several unsuccessful visits to New York in 1957 in an attempt to attach herself to an art gallery there. She painted four hours a day in 1957, devoting additional time to stretching and preparing her canvases and transacting business with art dealers and her framemaker. She had been told that a prestigious gallery in New York would require numerous paintings for a showing, and by the end of 1957 she had completed

twelve or fifteen paintings with ten more in progress. After 1957 she did exhibit successfully, having a number of solo shows in Italy as well as having her work exhibited in Princeton and New York City. In 1957 she had no receipts from her painting while her expenses were $5,769; in 1958 she had $500 in receipts while her expenses were $6,854; in 1959 she had $575 in receipts while her expenses were $5,360; and in 1960 she had $710 in receipts while her expenses were $4,968. She did not keep formal business books, but did have records relating to her receipts and expenses as an artist. The IRS challenged her deduction of $5,769 in 1957 on the ground that she had been merely pursuing a hobby or preparing to enter a business or trade, but had not been engaged in the business or trade of being an artist in that year.

The tax court, in an excellent opinion, disagreed with the IRS and concluded that she had indeed been in the business or trade of being an artist in the year 1957. The tax court considered the following as significant proof of her profit motive: She began painting in her youth and won prizes for her work; she struggled to overcome the handicap imposed by polio; she studied with recognized artists; she received recognition from the Italian painters' union and in critical publications; she had exhibitions both prior and subsequent to 1957; she worked continually and unstintingly at her painting and necessary incidental tasks; she had no other sources of income so that the losses were a financial strain; and she had constantly increasing receipts in the years after 1957. Also, the tax court rejected explicitly the argument that she had merely been preparing to enter a trade or profession, stating that the history of her art activities after 1940 rebutted any such contention. In a notable section of the decision, the court wrote, "It is well recognized that profits may not be immediately forthcoming in the creative art field. Examples are legion of the increase in value of a painter's works after he receives public acclaim. Many artists have to struggle in their early years. This does not mean that serious artists do not intend to profit from their activities. It only means that their lot is a difficult one." [6]

An Overview

Artists with wealth and independent incomes, whose art activity expenses are large relative to their receipts over a lengthy period, are most likely to be found to be pursuing a hobby. Artists who devote much time

to their art, who have the expertise to receive some recognition, and for whom the expenses of art are burdensome will probably be found to be engaged in a business or trade rather than a hobby. Especially younger artists, who are making the financial sacrifices so common to the beginning of an art career, should be considered to have a profit motive even if other employment is necessary for survival during this difficult early period.

Each case where an artist is challenged as a hobbyist requires a determination on its own facts, but an awareness on the part of the artist as to what factors are relevant should aid in preventing or, if necessary, meeting such a challenge. It is advisable to have the professional assistance of an accountant or lawyer as soon as a hobby loss issue arises on an audit. Such professional advisors can be particularly helpful in effectively presenting the factors favorable to the artist. The presence of a lawyer or accountant at the earliest conferences with the IRS can aid in bringing a hobby loss challenge to a quick and satisfactory resolution.

16

THE ARTIST'S ESTATE

Estate planning should begin during the artist's lifetime with the assistance of a lawyer and, if necessary, an accountant, a life insurance agent, and an officer of a bank's trusts and estates department. Artists, like other taxpayers, seek to dispose of their assets to the people and institutions of their choice, while reducing the amounts of income taxes during life and estate taxes at death. But artists must take special care with their estate planning because of the unique nature of art works and the manner of valuing art works at death for the purposes of determining the value of the estate on which the appropriate estate tax rate will be levied. This chapter cannot substitute for consultation and careful planning with the professional advisors mentioned above, but it can at least alert the artist to matters of importance which will make the artist a more effective participant in the process of planning the estate.

The Art Works

The art works are unique because they are the creation of the artist and possess aesthetic qualities not found in other goods which pass through an estate. The artist may wish to control the repairs, reproductions, exhibitions, and sales of the works even after death. David Smith, for example, during his life condemned a purchaser of one of Smith's painted metal sculptures who removed the paint from the sculpture after purchase. Smith branded this as willful vandalism and considered the work

a ruin which he repudiated. Yet after his death Smith could hardly prevent the well-known critic Clement Greenberg, who served under Smith's will as one of Smith's three executors, from at the least having the paint removed from certain of the sculptures.[1] A similar situation involves the iron sculptures of Julio Gonzalez which, never cast by him during his lifetime, have sometimes been cast in bronze by his heirs after his death and sold without indication the work is posthumous.[2] Many collectors and artists try to negotiate about the exhibition of works to be received by museums. This concern prompted the agreement discussed at pp. 191–192 between Hans Hofmann and the University of California regarding the exhibition and disposition of Hofmann's work to be received by the university.[3]

Mark Rothko, who kept so many of his paintings that his estate held a huge number, had executors who entered into highly controversial contracts to sell outright to the Marlborough Galleries 100 paintings for $1.8 million to be paid over twelve years and to consign to the Marlborough Galleries for twelve years another 698 paintings at a commission rate of 50 percent, which many persons considered high for works by an artist of Rothko's reputation. Both these contracts were executed only three months after Rothko's death. A complex, bitter, and costly legal struggle was begun by Rothko's heirs, joined by the New York attorney general because a substantial part of the estate had been left to the Mark Rothko Foundation, which finally resulted in the contracts being rescinded and damages of $9,252,000 being awarded against the executors, Marlborough Galleries, and the owner of Marlborough Galleries (one of the executors was liable only for the lesser amount of $6,464,880).[4]

These examples could be multiplied, but their import for the artist is that lifetime planning is a necessity if the artist has concern about the posthumous artistic and financial treatment to which the work passing in the estate will be subject.

The Will

A properly drafted will is crucial to any estate plan. A will is a written document, signed and witnessed under strictly observed formalities, which provides for the disposition of the property belonging to the maker of the will upon death. If the maker wishes to change the will, this can be done either by adding a codicil to the will or by drafting and sign-

ing a completely new will. If no will is made, property passes at death by the laws of intestacy. These laws vary from state to state, but generally provide for the property to pass to the artist's spouse and other relatives. An administrator, often a relative but sometimes not, is appointed by the court to manage the estate. The artist's failure to make a will concedes that the artist will not attempt to govern either the distribution, aesthetic standards, or financial exploitation of the work after death.

A will offers the opportunity to distribute property to specific persons. Where art works are involved, this usually is done by bequest either to specific individuals or to a class.[5] A bequest means a transfer of property under a will, while a gift is used to mean a transfer of property during the life of the person who gives the property. An example of a bequest to a specific individual would be:

> I give and bequeath to my son, JOHN ARTIST, who resides at
> _____, the oil painting created by me, titled
> _____ and dated _____, if he
> should survive me.

An example of a bequest to a class would be:

> I give and bequeath to my son, JOHN, and my daughter JUNE, and
> my daughter MARY, or the survivors or survivor of them if any
> shall predecease me, all my paintings, sculptures, and other art
> works, except such articles specifically disposed of by Paragraphs
> _____ of this Will. If they shall be unable to agree
> upon a division of the said property, my son, JOHN, shall have the
> first choice, my daughter JUNE shall have the second choice, and
> my daughter MARY shall have the third choice, the said choices to
> continue in that order so long as any of them desire to make a selec-
> tion.

Copyrights, of course, can also be willed. For example:

> I give and bequeath all my right, title, and interest in and to my
> copyrights [describe which copyrights] and any royalties therefrom
> and the right to a renewal and extension of the said copyrights in
> such works to my daughter JUNE.[6]

But the renewal right granted under the Copyright Act of 1909 cannot be willed if the artist's spouse or children are surviving, since in that case the renewal right would automatically pass to the spouse or children.[7]

Use of a will permits (1) the payment of estate taxes in such a way that each recipient will not have any taxes assessed against the work received, (2) the uninterrupted maintainance of insurance policies on the art works, and (3) the payment of storage and shipping costs so the recipient need not pay to receive the work. The estate taxes are usually paid from the residuary of the estate, the residuary being all the property not specifically distributed elsewhere in the will.

The will allows an artist to choose the executor of an estate. Since decisions of executors were the focal points of the controversies as to the alterations of David Smith's work and the sale of Mark Rothko's work, the importance of choosing suitable executors cannot be emphasized too strongly. Yet both Smith and Rothko had chosen as executors men whom the artists knew and trusted and chose in part to achieve a diversity of backgrounds. Smith chose a critic, an artist, and a lawyer. Rothko chose an anthropologist, an artist, and an accountant. Each estate had, at least in theory, the benefit of both artistic and financial insights and concerns. Yet the failure of the executors to continue dealing with the art works as the artists would have intended is a warning to every artist, regardless of the size of the estate, who seeks to plan what will become of work after death.

The College Art Association, a national organization with a membership of diverse art professionals, has issued guidelines, applicable to unethical bronze castings, which can be given a wider scope.[8] "Sculptors should leave clear and complete written instructions or put into their wills their desires with respect to the future of their works after their death or in the event of their incapacity to continue working." All artists, as well as sculptors, should take such precautions. If necessary, the artist's wishes can be written into the will to specify how the art works are to be repaired, reproduced, exhibited, and sold. This may conflict, however, with the usually desirable practice of giving to the executor the maximum powers for management of the estate. Each estate, whether large or small, will require a decision by the artist as to executors and executor's powers, based on the unique facts of the artist's own situation. At the least, however, the College Art Association states, "All heirs and executors of the sculptor's estate should be scrupulous in discharging

their responsibilities and when necessary consult with experts on such questions as those of new castings," or, it can be added, artistic questions generally.

The executor, especially for a small estate, will often be a spouse or close relative. It is important, however, to be certain that such a person will be capable of making the necessary artistic and financial decisions for the estate. Joint executors, particularly when one is an art expert and the other a financial expert, would seem well suited to run the estate. But artistic and financial decisions are often closely interwined. For example, the determination to sell bronze castings of an iron sculpture is a decision with both artistic and financial implications. The extent to which the artist may safely restrict the discretion of executors as to artistic matters may depend upon other aspects of the estate, such as whether sufficient funds are available to pay estate taxes and meet the immediate needs of the estate. Only by resolving problems such as these can the artist be certain the executors will act as the artist would have wished.

The will also provides the opportunity to anticipate and control the amount of taxes to be levied by the state and, more importantly, federal governments. If art works are scattered among a number of states—for example, on long-term museum loans or perhaps long-term gallery consignments—the estate plan can avoid the vexing problem of numerous state estate proceedings by gathering such works in the state where the artist permanently resides.[9] An artist who lives in more than one state may risk having a so-called double domicile and being taxed by more than one state, but careful planning can parry such a danger. The artist will also wish to benefit from a number of deductions, discussed below, which can substantially reduce the estate if planned for properly. But tax planning is especially necessary for the artist because art works are valued at fair market value in computing the artist's gross estate.

Trusts

Trusts are a valuable estate-planning device whereby title to property is given to a trustee to use the property or income from the property for the benefit of certain named beneficiaries. Trusts can be created by the artist during life or, at death, by will. Trusts can also be revocable—subject, that is, to dissolution by the creator of the trust—or irrevocable, in which case the creator cannot dissolve the trust. Trusts are frequently

used to skip a generation of taxes, for example, by giving the income of a trust to children for their lives and having the grandchildren receive the principal. In such case the principal would not be included in the estates of the children for purposes of estate taxation. The Tax Reform Act of 1976, however, severely restricts the effectiveness of generation-skipping trusts and other transfers for a similar purpose.

The Gross Estate

The gross estate includes the value of all the property in which the artist had an ownership interest at the time of death.[10] Gifts made within three years of death (if greater in amount than the gift exclusion discussed later in the chapter), as well as gift taxes paid on such gifts, are also added to the gross estate.

Complex rules, depending on the specific circumstances of each case, cover the additional inclusion in the gross estate of such items as life insurance proceeds, property over which the artist possessed a general power to appoint an owner, annuities, jointly held interests, and the value of property in trusts.

Valuation

The property included in the artist's gross estate is valued at fair market value as of the date of death or, if so chosen on the estate tax return, as of an alternate date six months after death.[11] Fair market value is defined in the Regulations to the Internal Revenue Code as "the price at which the property would change hands between a willing buyer and a willing seller, neither being under any compulsion to buy or to sell and both having reasonable knowledge of relevant facts."[12]

Expert appraisers are used to determine fair market value of art works. But whether an estate is large or small, the opinions of experts can exhibit surprising variations. Because of this, the Internal Revenue Service in 1968 created an Art Advisory Panel, composed of ten art experts representing museums, universities, and dealers, to determine for income, estate, and gift tax purposes whether or not privately obtained appraisals of fair market value were realistic.

Estate of David Smith[13] is an example of the extremes which are possi-

ble in appraisals of fair market value. When David Smith died at age fifty-nine in an automobile accident, he still owned 425 of his metal sculptures—many of substantial size and weight and located at Bolton Landing, New York. Smith had never had great success financially during his life. He sold only 75 works during the entire period from 1940 to his death in 1965. He insisted on maintaining high prices and the size of much of the work also limited possible buyers. In the two years after his death, sales soared and 68 works were sold for nearly $1,000,000.

Smith's executors, in attempting to determine fair market value, first estimated the retail price of each piece individually, if sold at the date of death. The total for the 425 works was $4,284,000, which the executors then discounted by 75 percent because any sale made immediately would have to be in bulk at a substantial discount. This figure was further reduced by one-third to cover commissions which would be paid to the Marlborough Galleries. The executors concluded that the fair market value of the 425 sculptures was therefore $714,000. The Internal Revenue Service, however, disagreed that any discounting should be allowed and simply placed a fair market value of $4,284,000 on the works.

The tax court considered numerous factors related to fair market value, such as the market effect of a bulk sale, Smith's growing reputation, the lack of general market acceptance of nonrepresentational sculpture, the quality of the works, sales, and prices immediately before and after death, and the inaccessibility of the 291 works located at Bolton Landing. Terming its decision "Solomon-like," the tax court found the fair market value of the 425 sculptures to be $2,700,000 as of the date of Smith's death. This is approximately the figure which would result if the values argued for by the executors and the Internal Revenue Service were added together and then divided in half. This is certainly not scientific, but the artist must prepare for these possible variations in the valuation of the gross estate when attempting to gauge what will be the amount of the estate taxes.

Taxable Estate

The gross estate is reduced by a number of important deductions to reach the taxable estate. The deductions include funeral expenses, certain administration expenses, casualty or theft losses during administration, debts and enforceable claims against the estate, mortgages and liens, the

value of property passing to a surviving spouse subject to certain limitations, the value of property passing to an orphan under twenty-one subject to certain limitations, and the value of property qualifying for a charitable deduction because of the nature of the institution to which the property is given.[14]

Proper estate planning offers the opportunity to be as certain as possible that expenses, particularly selling commissions for art works, will be deductible as administration expenses.[15]

The marital deduction provides an important tax saving. The deduction equals the greater of $250,000 or one-half of the value of the adjusted gross estate—which is the gross estate less all but the charitable and, of course, marital deductions—assuming property of that value is left to the surviving spouse. A spouse, especially a wife, is entitled in any case to a share of the deceased spouse's estate by law in most states. In New York, for example, a surviving spouse has a right to one-half of the deceased spouse's estate, but the right is reduced to one-third if there are also surviving children.[16] The value of property used for the marital deduction can satisfy these state requirements as well. But the property which goes to the surviving spouse for the marital deduction must basically pass in such a way that it will eventually be taxable in the estate of the surviving spouse. The marital deduction thus postpones estate taxes, but does not completely avoid them.

The Tax Reform Act of 1976 excludes from the gross estate the value of transfers to a minor child of the deceased, if the decedent is not survived by a spouse and the child has no known surviving parent. The maximum amount of the exclusion for each such child is $5,000 multiplied by the number of years until the child reaches twenty-one.

The charitable deduction is of particular interest to the artist, since this provides the opportunity to give art works to institutions such as museums or schools which the artist may wish to benefit. The fair market value of such donated works is deducted from the artist's gross estate. A will clause is used stating that if the institution is not of the type to which a bequest qualifying for a charitable deduction can be made, the bequest will be made to a suitable institution at the choice of the executor.[17]

The tax effect of willing a work to charity is identical to the artist's destroying the work prior to death. If the work is willed to charity, fair market value is included in the gross estate, but the same fair market value is then subtracted as a charitable deduction in determining the taxable estate. But even if the estate tax rate were as high as 70 percent,

keeping the work would still pass 30 percent of the value on to the recipients under the will. However, if the estate does not have cash available to pay the estate taxes, charitable bequests may be an excellent way to reduce the amount of the estate taxes. Also, the intangible benefits, including perpetuating the artist's reputation, may well outweigh considerations of the precise saving or loss resulting from such bequests.

Once the gross estate has been reduced by the deductions discussed above, what is left is the taxable estate.

Unified Estate and Gift Tax

The Tax Reform Act of 1976 worked a major overhaul in the systems of estate and gift taxation. It made the progressive tax, which had previously been separately applied to the fair market value of taxable gifts and the value of the taxable estate, apply to the cumulated total of taxable gifts and the taxable estate (and ended lower gift tax rates).[18] The progressive rates rise from 18 percent if the cumulated total of taxable gifts and the taxable estate is under $10,000, to 70 percent if the cumulated total is over $5,000,000. The amount of the tax on the cumulated total of the taxable gifts and taxable estate is reduced by a tax credit. The credit increases from 1977 to 1981, the applicable amount of the credit depending on the year in which the artist dies:

Year	Credit
1977	$30,000
1978	$34,000
1979	$38,000
1980	$42,500
1981	$47,000

A single artist who made taxable gifts of $70,000 and left a taxable estate of $80,000 would owe, according to the rate schedule, a unified gift and estate tax of $38,800. If the artist died in 1977, the $30,000 credit would reduce this tax owed to $8,800. If the artist should die in 1981, the $47,000 credit would make no tax payable. An artist who dies in 1981 will only pay a tax if the cumulated total of taxable gifts and the taxable estate is greater than $175,625. If the artist who dies in 1981 is married and leaves property to a spouse to take advantage of the marital deduc-

tion, no tax will be payable until the cumulated total of taxable gifts and the taxable estate exceeds $425,625 (because the minimum marital deduction is $250,000). It should be noted that the federal estate tax is reduced by either a state death tax credit or the actual state death tax, whichever is lesser.[19]

Liquidity

The tax court in *Estate of David Smith* found a fair market value of $2,700,000 for the 425 art works. As of the date of death, cash available to the estate other than from sales of sculptures amounted only to $210,647. The discrepancy between estate taxes owed—which normally must be paid within nine months of death at the time the estate return is filed[20]—and available cash can plague estates composed largely of art works.

One of the best ways to have cash available to pay estate taxes is insurance policies on the life of the artist. The proceeds of life insurance payable to the estate are included in the gross estate. So are the proceeds of policies payable, for example, to a spouse or children if the insured artist keeps any ownership or control over the policy.[21] But policies payable to a spouse or children and not owned or controlled by the artist will not be included in the artist's gross estate. If a spouse or children are the beneficiaries under both insurance policies and the will, they will naturally want to provide funds to the estate to pay estate taxes so that the art works do not have to be sold immediately at lower prices. The funds can be lent to the estate or used to purchase art work from the estate at reasonable prices. Such policies should probably be whole life insurance, rather than the less expensive term insurance which may be nonrenewable after a certain age or under certain health conditions. Also, such life insurance may sometimes best be maintained in a life insurance trust, especially where a trustee may have greater ability than the beneficiaries to manage the proceeds. This stage of estate planning requires consultation with the artist's insurance agent to determine the most advisable course with regard to maintaining such life insurance.

Another method for easing estate liquidity problems may be available to an artist's estate. The Tax Reform Act of 1976 provides that upon a showing of reasonable cause (as opposed to the prior undue hardship standard), the district director may extend the time for payment up to ten

years.[22] However, the interest on such unpaid taxes, which had been 4 percent, has been increased as of July 1, 1975, to 9 percent, with provisions for the rate in the future to reflect the current prime interest rate.[23]

The Tax Reform Act of 1976 adds a new provision which can prove helpful to the estates of artists. If more than 65 percent of the adjusted gross estate consists of an interest in a closely held business (such as being the sole proprietor engaged in the business of making and selling art), the tax can be paid in ten equal yearly installments. And, if the executor so elects, the first installment need not be paid for five years. Interest payable on the estate tax attributable to the value of the business property (up to $1,000,000) receives a special rate of 4 percent.

Gifts

After seeing the tax computations, the artist may decide that it would be advisable to own fewer art works at death. If the artist makes gifts of art works while alive, the value of the gross estate at death could be reduced. The incentive for making gifts is a yearly exclusion of $3,000 applicable to each gift recipient. If an unmarried artist in one year gave paintings with a fair market value of $10,000 each to each of three children and two friends, there would be total gifts of $50,000. The gift to each person, however, would be subject to a $3,000 exclusion. This $3,000 exclusion applies each year to each person to whom a gift is given—one person or a hundred. Thus, the $10,000 gifts to each child would be taxable only to the extent of $7,000. The total taxable amount would, therefore, be $35,000. The artist who can afford gifts should usually take advantage of the yearly exclusions.

If the artist were married rather than single, the artist and spouse could elect to treat all gifts as being made one-half from each. This has the effect of increasing to $6,000 the yearly exclusion for each gift recipient. The Tax Reform Act of 1976 also allows an artist to deduct 50 percent of the value of gifts made to a spouse from the value of gifts subject to tax (by law, up to the first $100,000 of gifts to a spouse is completely deductible, the second $100,000 is not deductible at all, and the value of any gifts in excess of $200,000 is deductible at the 50 percent rate).

Gifts must be complete and irrevocable transfers, including transfers in trust, for the benefit of another person or group. Especially if the gift of an art work is to a family member, every effort should be taken to show a gift has truly been given. This can be done by delivery of the

DEED OF GIFT

I, _____, residing at _____, being
the absolute owner of an art work titled _____, created
by _____, and described as _____,
do hereby give, assign, and transfer to _____, residing at
_____, all of my right, title, and interest in and to said art
work, absolutely and forever. It is my intention that this transfer of the above-
described art work shall constitute a gift of the same by me to _____

_____.

IN WITNESS WHEREOF, I have hereunto set my hand and seal this _____
day of _____, 197__.

Donor

Notary Public

work and execution of a deed of gift. After the gift, the artist must com-
pletely cease to exercise control over the work. If, for example, the work
is exhibited, the name of the owner should be that of the family member
who has received the work, not of the artist. If the artist retains rights,
there will not be a valid gift for tax purposes and the value of the work
given will be included in the artist's gross estate.[24] The artist also should
not serve as custodian of gifts given to minor children, since such custo-
dianship will again cause the value of the gift property to be included in
the artist's gross estate.[25]

A gift tax return must be filed in the first quarter of a calendar year in
which taxable gifts for the year exceed $25,000. If the total of taxable
gifts during the year does not exceed $25,000, only one gift tax return
need be filed at the end of the year. The failure to file a gift tax return can
result in assessments of interest, penalties, and, in some cases, even
criminal charges.

A factor which might make the artist wary of giving too many art
works as gifts is the elusiveness of financial security and the possibility
that an artist's earlier work may be more valuable than later work. Work
from the critical period which forged the artist's sensibility and perhaps
contributed to the definition of an art movement may prove far more
valuable than work done when other new movements have become pre-
dominant or the artist has developed a different style. Giorgio de Chirico

was acclaimed as a leader in the development of surrealistic art, but his later work never met with as favorable a reception. While early work he no longer owned sold for higher and higher prices, his later style was so unrewarding that he occasionally resorted to imitating his earlier work and misdating the results to his earlier period, creating what were truly self-forgeries.[26]

The artist can also make gifts to charities without having to pay a gift tax.[27] Such gifts may give the artist the opportunity to see if the charities will put the art works to suitable uses. But charitable gifts have no advantage over charitable bequests under the will in terms of saving estate taxes. After the gift of a work, the artist of course would not own the work at death and its value could not be included in the gross estate. While the value of the same work would be part of the gross estate if owned at death, a charitable bequest would reduce the gross estate by the value of the work. The taxable estate would be the same in either case.

Carry-Over Basis

Prior to the Tax Reform Act of 1976, the recipient of an art work as a gift held the work as ordinary income property and took the basis of the artist who gave the gift. But a beneficiary who received an art work under a will held the work as a capital asset with a stepped-up basis of the work's fair market value as included in the gross estate. For example, an artist in 1970 created an art work with a zero basis. If the art work were given to a daughter, the daughter would have a zero basis and receive ordinary income when she sold the work. If the sale price were $5,000, she would receive $5,000 of ordinary income. On the other hand, if the artist died in 1972 and the work were valued in the estate at $5,000, the daughter who received the work under the will would have a basis of $5,000. So if she sold the work for $5,000, she would not have to pay any tax at all. If she sold the work for $7,500, the tax would be on $2,500 at the favorable capital gains rates.

The Tax Reform Act of 1976 eliminates this discrepancy in treatment by providing for the carry-over of a decedent's basis in appreciated property to the beneficiaries who receive such property. For example, an artist creates a work in 1980 with a zero basis, leaves the work to a daughter, and dies in 1982 when the work has a fair market value of $5,000. If the daughter sells the work for $7,500, she will have to pay tax

at ordinary income rates on the whole $7,500 because the artist's basis, which was transferred to the daughter, was zero. Also, the gain is an ordinary gain, rather than a capital gain, because of the provision of the tax laws denying treatment as a capital asset to art works where the basis of the owner is determined by reference to the basis of the artist who created the work.[28]

The effect of this provision on the beneficiaries of artists is most unfair, particularly since many believe that art works should receive capital gains treatment even when sold by the artist. Small estates will benefit from a provision increasing basis to a minimum of $60,000 (allocated to the assets in proportion to their net appreciation in relation to the overall appreciation in the estate). Also, art works created before December 31, 1976, will be stepped up to their fair market value as of that date. To find the fair market value as of December 31, 1976, the number of days the art work was in existence prior to December 31, 1976, is divided by the total number of days from the work's creation until the death of the artist. This fraction is then multiplied by the fair market value of the work as of the date of death. For example, an artist owns an art work for 2,000 days prior to death, and 500 of the days are before December 31, 1976. Upon the artist's death, assume that the art work, which had a zero basis for the artist, has a fair market value of $6,000. The basis to the beneficiary who receives the art work will be $6,000 multiplied by 500/2000. The basis to the beneficiary, in other words, will be $1,500. But if the art work had been created after December 31, 1976, the general rule would apply, giving the beneficiary only the basis of the decedent, which, in this case, would be zero.

The Estate Plan

The planning of an artist's estate is a complex task often requiring the expertise of accountants, insurance agents, and bank officers, as well as that of a lawyer. But an informed artist can be a valuable initiator and contributor in creating a plan which meets both the artistic and financial estate planning needs of the artist.

17

ARTISTS AND MUSEUMS

Museums in the United States are usually controlled privately by a board of trustees and supported by tax-exempt gifts and endowments.[1] The development of museums coincided with the growth of large industrial fortunes. The patronage of the wealthy has often been critical to the creation and continued vitality of museums. Because of this, many artists feel alienated from the power structures controlling the museums. One of the goals of Artists for Economic Action, for example, is to have artists serve as museum trustees. This position is consistent with the broader interests of artists in the cultural institutions which preserve art and make it available to the public. Museums must make difficult decisions, such as whether to acquire art obtained illegally in foreign countries or whether to exhibit controversial art, and the advice of artists could be invaluable. But since the wider spectrum of issues confronting museums has been considered in other sources,[2] this chapter will focus on the artist's specific concerns when either loaning or giving art to museums.

Loans to Museums

The concerns of the artist in lending work are quite similar to the concerns when consigning work.[3] The most important assurance is that the work will be returned promptly and in good condition or, if this is not possible, that the artist will be reimbursed for any damage to the work.

If the artist simply lends work to a museum or similar exhibition without a contract, the museum or borrower will hold the work under a

bailment and will have to exercise reasonable care in keeping the work.[4] But, since neither the museum nor the artist will normally be satisfied with such an arrangement, the best method of guaranteeing satisfaction to both parties is insurance. The museum should provide wall-to-wall insurance in the amount specified by the artist as the value of the work. Wall-to-wall insurance takes effect when the work leaves the hands of the artist and lasts until the work is returned to the artist. The lending contract will usually specify that the museum will not be liable for any amount greater than the stated insurance value.

If the museum or other borrower refuses to provide insurance, the artist should either not lend the work or should insist upon a provision making the borrower absolutely liable regardless of fault in the event of loss, damage, or theft of the work.

But even wall-to-wall insurance or absolute liability may be insufficient to protect an irreplaceable work. Attacks on works in museums—Picasso's *Guernica* and Rembrandt's *Night Watch,* for example—are becoming a more frequent occurrence, despite laws penalizing such vandalism.[5] The artist might wish to have certain minimum security precautions specified in the lending contract, regardless of who would have to pay for the work if damaged.

Of course, the lending contract should also specify receipt of specific works described by title, size (and weight for sculpture), and medium. The duration of the loan—and the exact location where the works will be shown—should be included. If work can be sold from the exhibition, as is often the case, the commission rate and other relevant provisions—such as price, time of payment to the artist, and risks with regard to the purchaser's credit—should be set forth. Shipment, storage, framing, photography, restoration, and similar costs will need detailing.

Artistic control is also an important consideration. The artist's work will be exhibited—but in what manner? Publicity about the artist may accompany the exhibition. Reproductions of the works may be used in catalogs, or even sold as postcards or jewelry. The artist will wish to control all of the aesthetic aspects of lending work. Even if the copyright for the work is in the public domain, the artist can fairly demand payments for any commercial exploitation of the work by the museum. Also, protection of the artist's common law copyright (assuming statutory notice is not placed on the work) will require the museum to post signs against copying and maintain security guards to enforce the prohibition—if the artist so insists. Some remaining uncertainty as to whether a loan to a museum will be a publication under the Copyright Revision Act of 1976

would indicate that, after January 1, 1978, statutory copyright notice should be placed on the work prior to any loan.

Before sending work on loan to other states, the artist should consider whether any creditors in that state might seize the work. The United States has enacted a statute exempting from seizure works loaned from foreign countries into the United States, if certain requirements are met.[6] Following this lead, New York State has enacted a similar provision for works loaned by out-of-state exhibitors to nonprofit exhibitions in New York State.[7] But the artist with creditors should beware when loaning work in other states without such a statute.

Lastly, the artist might well demand an assurance from the museum that the work in fact will be exhibited for the time specified in the loan contract. This provision, like the others, will be subject to negotiation based on the needs of both the artist and the museum.

Gifts or Bequests to Museums

The artist, either while alive or at death, may wish to transfer works to museums and similar cultural institutions. If, however, the artist thought the museum would either deaccession (that is, sell) or never exhibit the work, the artist would hesitate. Museums, on the other hand, are reluctant to restrict their flexibility by accepting works with requirements as to exhibition or restrictions against deaccessioning.[8] The moral issues, particularly where a will asks for but does not legally require a certain course of action with regard to works, can be difficult for the museum. Or where the museum has accepted legal restrictions, the museum in changed circumstances may go to the courts to request a different use for the works than the restrictions specify.

A collection of immense value, like that now housed in the Lehman Pavilion at the Metropolitan Museum of Art in New York City, can be used to gain legal guarantees of highly favorable treatment from the museum. Most artists, of course, do not have collections to rival that in the Lehman Pavilion. However, their collections might well be given intact to a smaller museum or cultural institution which would be willing to make concessions in order to receive the work. In this connection, the agreement between Hans Hofmann and the regents of the University of California makes an interesting study.[9]

The Hans Hofmann Agreement

In 1963 Hans Hofmann made an agreement with the regents of the University of California whereby he would donate certain works to the University of California as a permanent Hofmann Collection to be kept in a separate wing or gallery as a memorial to Hofmann and his wife, Maria.

Hofmann initially transferred an undivided one-half interest in twenty works to the university, and agreed to transfer the same interest in another twenty works of his choosing before December 1, 1968. An agent of Hofmann's selection was appointed with the power to sell those works and raise $250,000 for the university before that date. If, by the later of December 1, 1968, or Hofmann's death, $250,000 had not been raised for the university from the sale of the forty paintings, Hoffman's estate would pay the balance.

The university in return agreed to expend $250,000 to build and complete the separate wing or gallery for the Hofmann Collection by December 1, 1968. If the wing or gallery were destroyed, the university would be obliged to rebuild it only to the extent of insurance proceeds.

The Hofmann Collection was then specified to consist of thirty-five additional paintings, ten of which were listed in the agreement and twenty-five of which were to be transferred or bequeathed by Hofmann. The university had the power to accept works transferred and to select from all Hofmann's paintings if the balance of the paintings were bequeathed.

The university agreed to substantial restrictions over what could be done with the works composing the Hofmann Collection. The Hofmann Collection, or a part of the collection, along with other works by Hofmann the university might have, would be primarily exhibited in a separate wing or gallery. Until December 1, 1993, work by persons other than Hofmann could be shown only if the Hofmann Collection were temporarily exhibited at another museum or gallery. After December 1, 1993, the university could retain the entire Hofmann Collection but would only have to exhibit the collection exclusively thirty days during each year. Alternatively, after December 1, 1993, the university could sell or exchange twenty paintings from the Hofmann Collection and use the proceeds to purchase modern art considered avant garde at that time. The remaining fifteen paintings of the Hofmann Collection would have

to be exhibited primarily in the wing or gallery. *Primarily* is defined as exhibition during a major portion of the calendar year—and not being exhibited only when loaned temporarily to another museum or gallery. Thus a balance is struck which guarantees either the collection of thirty-five paintings will be exhibited one month per year or the collection of at least fifteen paintings will be exhibited during most of the year.

The agreement between Hans Hofmann and the regents of the University of California is a good example of balancing the needs of each party. Hofmann received guarantees that the collection would be exhibited and would not be deaccessioned. The university received the paintings, a new wing or gallery, and the power to eventually either sell part of the collection or exhibit the entire collection less often. These considerations are typical and the artist giving work to any museum or cultural institution should certainly try to negotiate restrictions similar to those obtained by Hans Hofmann.

Rights of the Artist in Museum-Owned Works

The artist who gives or sells work to a museum should treat the museum like any other purchaser. If the artist wishes to retain rights in the work—such as copyright, power to control the manner of exhibition, or power to repair the work—the contract of sale should so specify. Similarly, if the artist sells the work to any purchaser, these rights must be retained at the time of sale. Otherwise, when a purchaser gives a work to a museum, the museum will own the work without restrictions. In such a situation the museum may exhibit the work with little fear of the artist being able to take successful legal action.

In the 1976 exhibition, "200 Years of American Sculpture," at the Whitney Museum in New York City, for example, both Robert Morris and Carl Andre sought to prevent the Whitney from showing certain works.[10] Morris contended the Whitney was showing a damaged work from its own collection—rather than any work submitted for the exhibition. Andre withdrew the work he had submitted on the ground that it was placed next to a bay window and a fire exit. He then sought to purchase for $25,000 the work which the Whitney substituted from its own collection for the exhibition. Andre contended that the substitute piece had been misinstalled by placing rubber under copper floor pieces. If the artists had retained rights over their works, no such controversies would have arisen.

Also, the museum will have the power of commercial exploitation over works which the museum owns, unless the artist has retained the copyright. Museums will, in any case, often pay royalties or fees for commercial exploitation, although the exact payments vary and are completely within the discretion of the museum. Standards for payments to artists for exploitation of museum-owned works have been proposed by the Association of Art Museum Directors.[11]

18

THE ARTIST AS COLLECTOR

The artist often becomes—through trades, gifts, and purchases—a collector of work by other artists. While the collector will often have to know the legal and practical considerations relevant to artists, certain problems are unique to collectors. The following discussion highlights some of these unique areas so that artists who collect will know when legal advice may be helpful.

The Value of Art

Most collectors own art for the sake of enjoyment, but the value of art as a commodity cannot be ignored. During the recession in 1974, for example, a *New York Times* headline read, "Painting and Antique Markets Grow Soft As Britons Invest in Easily Portable Items."[1] Collectors had begun selling art in order to buy coins and rare jewelry, which could be more easily transported across the boundaries of countries with currency controls. The concept of art as an investment has been closely associated with the activities of auction houses such as Christie's of London and Sotheby Parke-Bernet of New York. Auctions often show the public art which has increased fantastically in value. The speculative gains to be made have brought art investment companies like Artemis and Modarco into being. Much of this investment art—for example, the Modarco collection, which is kept in storage in Geneva—leaves the public view until resold by the company.

The prices for art are so high that art thefts and forgeries have become a fact of life in the art world.[2] In 1975 a painting by Utrillo, stolen from the home of a French doctor in 1971, turned up in the collection of a Japanese collector.[3] This international movement of art extends to antiquities which are illegally excavated and exported from the countries where ancient cultures flourished. To prevent this illegal antiquities trade, the United States has signed a treaty with Mexico and passed a law affecting numerous Latin American countries, but has yet to ratify the UNESCO Convention on the Means of Prohibiting and Preventing the Illicit Import, Export, and Transfer of Cultural Property.[4] Many of the large cities of Europe now have specialized art crime squads—as does New York City. Interpol, with the assistance of the International Council of Museums, has even gone so far as to create a wanted poster of the world's Twelve Most Wanted Works of Art.

The response of collectors to this art crime has been varied. Some insure their collections, a definitive but often expensive solution. Others have fakes created which are then substituted for the real works. French collectors can avail themselves of a tower 240 feet high and 180 feet in diameter which is hidden behind the facade of a former bank and can be seen only from the top of the Eiffel Tower.[5] The security includes cameras, special keys, electronic devices, a tunnel which fills with water, and lethal gas. Another alternative is use of the International Art Registry, a New York City company which uses a grid system to isolate identifying characteristics of work and stores such characteristics in a computer memory bank. This can be an effective deterrent to art crime, since the stolen work is more readily identifiable.

Art thieves will often offer back the stolen works to the owner and demand a ransom. For example, a collector of rare Russian enamels entrusted them to a New York City storage company before leaving for Europe.[6] When he returned he found the storage company had, without checking for identification, given the enamels to another person who claimed to be a messenger for the collector. The enamels were valued at $731,000, which the storage company was liable to pay the collector if the enamels couldn't be recovered. The collector advertised that a ransom would be paid and, by paying $71,000, received back almost the entire collection. He then sued the storage company for the $71,000, having saved the company from paying the $731,000. The storage company, however, argued that perhaps no ransom had been paid since the collector refused to disclose the persons through whom he had recovered the enamels. The collector refused such disclosure because he said he had

been threatened with death. The New York Court of Appeals upheld a jury verdict for the collector despite this refusal, although the dissenters on the court argued strongly that the payment of such a ransom should be against public policy.

The crime problem is not limited to theft, but applies also to art created today by sophisticated forgers to appear to be the work of another artist. Or art of another period may be attributed to an artist rather than the school which surrounded the artist or the period generally in which the artist worked—far more subtle issues. Authentication requires experts who will often be reluctant to give opinions because of the risk of being sued for defamation of the art work if they are incorrect.[7] The most modern techniques of science are brought to bear on resolving authenticity problems, but, similarly, some forgers rely upon science as well.[8] The collector must be vigilant if art crime is to be avoided.

Purchasing Art

The collector will wish to consult pp. 52–54 to determine what warranties may be created upon the purchase of an art work. The purchaser can certainly rely upon the fact that the seller has title or the right to convey title in the art work. For example, in 1932, a couple living in Belgium purchased a work by Marc Chagall for about $150.[9] Forced to flee the German invasion in 1940, the couple found, when they returned six years later, that the painting had disappeared. In 1962 they noticed a reproduction of the painting in an art book indicating the name of the collector who had innocently purchased the work in 1955 for $4,000 from a New York City gallery. The couple sued the collector for the value of the work in 1962—$22,500—or the return of the work. Not only did the couple win, but the collector also successfully sued the gallery for his loss. The gallery, which had received only $4,000 on sale, became liable for $22,500 which could only be recouped, if at all, by bringing suit against a gallery in Paris.

Auctions have become a major force in the art market. Auctions are a process of offer and acceptance. If the auctioneer sells art with a reserve price, no offers by purchasers will be accepted which are less than the reserve price. This protects the person who has consigned art to the auctioneer from receiving too low a price. The auctioneer can, therefore, withdraw the art from the bidding at any time if the price is not satisfac-

tory. On the other hand, if the auction is without a reserve price the auctioneer must accept the highest bid made. The art cannot be withdrawn once the bidding has begun. The purchaser, regardless of whether the auction is with or without reserve, may withdraw a bid at any time prior to the fall of the hammer or other customary completion of the sale.[10]

The collector may be inclined to rely upon the representations made in an auctioneer's catalog. But the Uniform Commercial Code warranties may not be fully effective to protect the collector, particularly since most catalogs contain warranty disclaimers. Also, certain of the representations made in the catalog can be construed merely as puffing—touting a saleable item in a way which the purchaser should know not to accept at face value.

In 1962 a doctor purchased for $3,347.50 from Parke-Bernet a painting stated in the catalog to be the work of Raoul Dufy, but in fact a forgery. However, the catalog stated that Parke-Bernet disclaimed all warranties and sold any property "as is." The New York Supreme Court held for the doctor, who sought to recover what he had paid, but the appellate term reversed and held for Parke-Bernet on the rationale that authenticity was a factor in the sales price and the purchaser should satisfy himself with regard to authenticity.[11]

The New York attorney general recommended legislation to rectify this ruling. In 1968 a law passed regulating the "Creation and Negation of Express Warranties in the Sale of Works of Fine Art." [12] This covers any sale by an art merchant, which includes an auctioneer, to a purchaser who is not an art merchant, if a written instrument such as a catalog or prospectus makes representations as to authorship. Such statements as to authorship, even if not stated to be warranties, shall be considered express warranties and a basis upon which the purchaser made the purchase. For example: (1) a work stated to be by a named artist must be by such artist; (2) a work attributed to a named artist means a work of the period but not necessarily by the artist; and (3) a work of the school of the artist means a work of a pupil or close follower of the artist, but not by the artist.

An art merchant can disclaim warranties created by this law, but only if the disclaimer satisfies certain conditions. The disclaimer must be conspicuous and written separate from any statements as to authorship. It must not be general, such as a negation at the beginning of a catalog that all warranties are disclaimed, but must be specific as to the particular work. If a work is counterfeit, defined as fine art made or altered to ap-

pear to be by a certain artist when it is not, the fact of the counterfeiting must be conspicuously disclosed. Also, if a work is unqualifiedly stated to be by a given artist, such a statement cannot be disclaimed.

The effect of this New York law is to create valuable protections beyond those contained in the Uniform Commercial Code for purchasers from art merchants. Another New York law enacted in 1969 makes the falsification of a certificate of authenticity, such certificate being a written statement as to authorship by a person apparently having an expert's knowledge, punishable as a misdemeanor.[13]

The New York laws are important safeguards for collectors who may be prone to rely too much on statements contained in catalogs or certificates of authenticity. But the absence of such laws in other states, where only the Uniform Commercial Code would govern transactions, is a warning to collectors to exercise caution in the purchase of art. Also, while auctions are subject to some legal regulation, the news media do report irregular practices such as collusive bidding from time to time.[14] The auction house rules have often become complex as well, so expert advice may be a necessity for the collector entering the auction market.

Purchasing Art Abroad

The collector who purchases art abroad should be aware that many countries have enacted laws to protect artistic and archeological objects. Italy's law, for example, regulates such objects, but does not apply either to works of living artists or to works created within the last fifty years.[15] Collectors must obtain an export license from the Office of Exportation for items which come within the law. The export license will not be issued if exportation would cause great injury to the national patrimony. The collector must declare the market price of each item, which the Ministry of Education has the power to purchase at that price within two months of the application for an export license. The result is that the collector either may not be allowed to export art from Italy or may find the Ministry of Education intends to purchase the art for the stated market price. The collector must be aware that these laws, however erratically enforced, exist in most of the nations which possess an abundance of art.[16]

If the art can legally be exported from the nation where purchased, the collector must next consider whether United States customs duties will be

payable on the work to be imported. Generally, however, no duties are payable on original works of art, such as paintings, drawings, fine prints (which must be printed by hand from hand-etched, hand-drawn, or hand-engraved plates, stones, or blocks), sculptures (the original and up to ten replicas), mosaics, and works of the fine arts not fitting into the other categories (such as collages). The artist who has created work while living temporarily abroad may bring such work back to the United States without paying duties.[17]

Tax Status of the Collector

A collector may fall into three categories for tax treatment: a dealer, an investor, or a hobbyist.

One who buys and sells art works very frequently will be taxed as a dealer and will receive ordinary income from art sales, rather than the more favorable capital gains.[18] A dealer will be able to deduct all the ordinary and necessary expenses of doing business.

On the other hand, the collector may be an investor in art works, similar to a person who invests in stocks and bonds. An investor will have capital gains and losses. Ordinary and necessary expenses will be deductible if incurred for the management and preservation of the works, such as insurance and storage costs. However, the investor must own the art works primarily for profit. In one case, collectors, who kept their colleciton in their homes and derived personal use and pleasure from the collection, were found not to own the collection primarily for profit.[19] But the alternative of storing art like Modarco will hardly satisfy the collector.

The third category, the hobbyist, includes the collector who buys and keeps art works mainly for pleasure. Gains on sale will be taxed as capital gains, not ordinary income. But if a capital loss is incurred upon the sale of an art work, there must be a profit motive for the loss to be deductible.[20] A limited exception to this allows the hobbyist to deduct capital losses up to the amount of capital gains, when the losses and gains result from the same activity (the sale of art works) during the tax year.[21] Similarly, the expenses of keeping up the collection can be deducted up to the amount of income generated by the collection.

Charitable Contributions

The collector also has an advantage over the artist in the area of charitable contributions, because the collector can deduct either all or part of the fair market value of contributed works of art.[22] The Tax Reform Act of 1969, however, instituted complex limitations designed to prevent tax abuses of charitable deductions. Taxpayers may only receive a charitable deduction for donations up to a percentage of their contribution base (which is their adjusted gross income with some modifications). The charitable deduction is up to 50 percent of the contribution base if the organization receiving the donation is a church, hospital, school, museum, publicly supported religious, charitable, or similar organization, or certain limited private foundations. A charitable deduction is allowed only up to 20 percent of the contribution base if made to other exempt organizations, including the usual private foundation. The collector must verify whether the organization is exempt and, if so, whether it is a 50 percent or 20 percent organization. The purpose of these limitations is to prevent persons from reducing taxable income to zero through the use of charitable contributions.

If cash is being donated, the full amount is a deduction. If, however, art works which have increased in value are being donated, complicated rules regarding the contribution of appreciated property come into play. Basically, these rules reduce the amount which can be taken as a charitable deduction where appreciated work is contributed. Also, the amount of the deduction will be reduced if the art work which has appreciated in value will not be used for a purpose related to the exempt purpose or function of the organization which receives the donation. A lawyer or an accountant should be consulted to aid in determining the best strategy for charitable contributions where art works which have appreciated in value are involved. IRS Publications 526, *Income Tax Deductions for Contributions,* and 561, *Valuation of Donated Property,* will aid the collector who can take advantage of the deduction for contributions.

19

PUBLIC SUPPORT FOR ARTISTS

The important role of the artist in society raises the issue of what assistance society should appropriately offer to the artist. The 1975 National Report on the Arts, authored by the National Committee for Cultural Resources (the "committee") on the basis of extensive data, concluded that "interest in the arts has risen steadily over the past decade, and continues to rise. The work of the committee provides fresh evidence that both audiences and the number of arts organizations are continuing to grow in communities in every part of the nation. The American people themselves are making the strongest case for the arts."[1] A 1975 poll commissioned by the committee showed 93 percent of the public believed the arts are important to the quality of life in the community; 85 percent believed arts activities are important to the business and economies of communities; and 41 percent would be willing to pay $25 or more in additional taxes to support the arts (51 percent would be willing to pay an additional $10 in taxes for the arts). In the meantime the arts, as a growth industry, experienced an increased demand which could not be met by available revenues. This shortfall caused the committee to recommend increased support for the arts from individuals, corporations, foundations, counties, and cities. This local support—along with revenues raised from the arts—could meet 80 percent of needed budgeting. The committee proposed that the other 20 percent be comprised of 10 percent from the states and 10 percent from the federal government. Since the federal government in fact only contributed 3.5 percent of gross arts expenditures in 1974–1975, the committee would have increased the year's federal support for the National Endowment for the Arts (NEA) nearly threefold from about $74,700,000 to $209,000,000. For 1976–1977, when the NEA budget will be $82,000,000, the committee would recommend a

budget of $225,000,000. These differences in magnitude would seem to be a severe criticism of government support for the arts, yet since the early 1960s the growth of state and federal support of the arts has been extraordinary. But the failure of the NEA to approach the support levels which the federal government provided in the 1930s—mainly under the Works Progress Administration's Federal Art Project—has caused those concerned for the arts to look both home and abroad for innovative models of government support for the arts.

The NEA

The legislation creating the NEA in 1965 stated, "[T]hat the encouragement and support of national progress and scholarship in the humanities and the arts, while primarily a matter for private and local initiative, is also an appropriate matter of concern for the Federal Government . . . [and] that the practice of art and the study of the humanities requires constant dedication and devotion and that, while no government can call a great artist or scholar into existence, it is necessary and appropriate for the Federal Government to help create and sustain not only a climate encouraging freedom of thought, imagination, and inquiry, but also the material conditions facilitating the release of this creative talent." [2] Whether the NEA has created such material conditions remains a matter of debate, since most supporters of the arts contend that far more must be done to aid artists than the NEA has achieved.

NEA Funding

The budget for the NEA in 1966, the first year of operation, was $2,500,000. Over the next decade the budget continually increased to reach the level of $82,000,000 for the fiscal year beginning in October 1976. These budgets, however, had to be allocated among all the arts. Also, the amount allocated to the visual arts does not simply go to individual artists. Grants are available to individuals (further information and application forms can be obtained from the Program Information Office, National Endowment for the Arts, Washington, D.C. 20506), but grants are also given to the official arts agencies of the states and territories as well as to tax-exempt, nonprofit organizations. [3] In the 1974 fiscal year, for example, $2,335,721 was spent on the Visual Arts Program, which "provides individual assistance for painters, sculptors,

printmakers, craftsmen, art critics, and photographers of exceptional talent; for the commissioning and placement of art works in public spaces; for short-term residencies of artists, critics, craftsmen, and photographers in educational and cultural institutions; and for a variety of flexible programs. . . ." [4] Other funds would filter down to individual visual artists through allocations for programs such as the Federal-State Partnership, which received $10,558,296 to stimulate the arts in the states. The Museum Program, which includes among various purposes the "purchase of works by living American artists," received $9,050,907 for fiscal 1974. [5]

Fiscal 1975 brought a significant increase in the funding of the Visual Arts Program. $3,198,753 was allocated among the various programs as shown on the following chart. [6]

FISCAL 1975—VISUAL ARTS PROGRAM OF THE NATIONAL ENDOWMENT FOR THE ARTS

Works of Art in Public Places	682,076
	50,000*
Visual Arts in the Performing Arts	59,718
Artists, Critics, Photographers,	
and Craftsmen in Residence	163,720
	24,000*
Exhibition Aid	
Photography	150,277
Crafts	112,047
Photography Publications	35,000
Fellowships	
Visual Artists	595,000
Printmaking and Drawing	75,000
Photographers	250,000
Craftsmen	235,000
Art Critics	92,000
Workshops	
Visual Arts	363,035
Crafts	78,595
Master Craftsmen Apprenticeships	57,000
Crafts Special Projects	12,500
Services to the Field	138,285
General Programs	25,000
TOTAL	$3,124,753
	74,000*
GRAND TOTAL	$3,198,753

*Fiscal 1976 grants funded in fiscal year 1975.

State and Local Support

The first state arts council was created in 1902, but by 1960 only six such councils were in being. However, the period since 1960, when the New York State Council on the Arts was created, has seen the creation of an arts council in every state and territory, as the list of such councils at pp. 215–219 indicates.[7] During the ten years from 1965 to 1975, the appropriations of states in support of the arts increased from $1,700,000 to $55,000,000.[8] At the same time some localities are becoming increasingly aware of the value of arts programs. In 1974, at the Forty-Second Annual Conference of Mayors, a resolution was passed providing guidelines for treatment of the arts, including: "That city governments recognize the arts as an essential service, equal in importance to other essential services, and help to make the arts available to all their citizens. . . ."[9]

One innovative step in this direction has been supplied by localities requiring a percentage—usually 1 percent or 2 percent—of construction funds for government buildings to be used for art.[10] Philadelphia initiated the first "1 percent for art" program in 1959. Baltimore followed this lead in 1964. San Francisco in 1965 enacted even more comprehensive legislation giving its arts commission control over design for all public buildings—whether or not publicly financed. Both Miami and Miami Beach became beneficiaries of a similar program under legislation enacted by Dade County, Florida, in 1974. The states of Washington, Oregon, California, and Hawaii have also initiated such programs, and the federal General Services Administration in 1972 reinitiated a policy of spending .5 percent of construction budgets on art.

Another source of support for some visual artists is the not fully tested Comprehensive Employment and Training Act (CETA), which provides federal funds to innovative state and local programs designed to either train the unemployed or create work for the unemployed.[11] Since the programs are developed by localities, the exact effect of CETA on the visual arts is unclear, but additional support of any magnitude at least offers promising prospects.

The Artist in the Great Depression

One model for public support of artists was created in the 1930s, when the Great Depression made the precarious profession of the artist even

more untenable. The federal government, as part of the overall effort to create work, funded a number of extensive arts projects.[12] The first program, created under the treasury department, was the Public Works of Art Project which lasted from December 1933 to June 1934, and employed about 3,700 artists without a rigid relief test. The cost was $1,312,000. The next program, also under the treasury department, was the Section of Painting and Sculpture which obtained art work by competitions for new federal buildings. It began in October 1934, and lasted until 1943, awarding approximately 1,400 contracts and costing about $2,571,000. The third program, the Treasury Relief Art Project under the treasury department, started in July 1935, and lasted until 1939. The cost was $833,784 and 446 persons were employed—about 75 percent of whom had been on relief.

The final and most important project was the Works Progress Administration's Federal Art Project (WPA) which began in August 1935, and lasted until June 1943. The WPA employed more than 5,000 artists at one point, subject to the WPA rules for relief, and had a total cost of $35,000,000. Some of the results of the WPA were: (1) Over 2,250 murals for public buildings were painted; (2) 13,000 pieces of sculpture were completed; (3) 85,000 paintings—of more than 100,000 produced—went on permanent loan to public institutions; (4) 239,727 prints were created from 12,581 original designs; (5) 500,000 photographs were made; and (6) art centers were organized in 103 communities.[13]

The nearly $40,000,000 of federal support spent in the 1930s on the visual arts is of a different magnitude from the support which the NEA can now generate. But the WPA suffered from political turmoil, mainly challenges of Communist domination, which even caused some to doubt the artistic accomplishments and importance of the WPA. The NEA has never experienced similar political criticism, and perhaps with increased funding could use the WPA "as a model for the years ahead, for the artists and the public of tomorrow . . . for never in the history of any land has so much cultural progress been achieved in so brief a time as in the New Deal years." [14]

The need for a model—whether it be the NEA with the threefold budgetary increase proposed by the National Committee for Cultural Resources or the WPA as it existed in the 1930s—suggests the value of looking abroad to where other countries have created their own systems to support and encourage the arts and the artist. Some of these countries—the Netherlands, Ireland, and Japan—are presented as examples. Comparisons of the actual costs of supporting the arts between countries

would have little value, but the nature and variety of the programs as possible models are certainly of interest.

The Netherlands

The Netherlands has a scheme which is typical of many European countries.[15] A Ministry of Cultural Affairs, Recreation and Social Welfare deals with matters relating to the visual arts and architecture. The ministry actually purchases and commissions art works in order to encourage artists and increase public ownership of representative works.

The ministry is aided here by advisory committees in sculpture, graphic arts, drawing, the applied arts, and architecture. Works acquired by the government are placed in the Registry of State-Owned Works of Art, not in state museums and art galleries. This national institution is a repository used in the dissemination of these works to museums and galleries to supplement exhibitions or collections as well as for display by the ministry in public or other buildings. The works in the registry are available for display not only in the Netherlands, but also abroad. The registry creates a unique cultural heritage in the hands of the government rather than museums.

The ministry regularly commissions artists to do woodcuts, etchings, or lithographs which are distributed free of charge to schools in the Netherlands. Similarly, on the Delta Project, artists are commissioned to work in relationship to industrial projects which are going on under government sponsorship in the Netherlands. The works created go to schools, museums, and galleries.

A system of subsidized art sales has operated since 1960 at public exhibitions having a minimum of forty art works by at least ten artists, subject to approval by the ministry. The subsidy gives a private buyer a 25 percent reduction—which the ministry pays to the exhibitor—on the price of the art work. Restrictions are a requirement that the buyer be of Dutch nationality, that the sales prices be within a specific range, and that the buyer agrees to keep the work for at least five years.

The ministry does not subsidize exhibitions in the Netherlands, but provides subsidies for other organizations which would subsidize exhibitions. Museums and galleries, of course, have additional budgets independent of such subsidies. The ministry does arrange certain international exhibitions abroad and chooses appropriate works by use of a special commissioner.

Individual artists are eligible for grants to pursue their art. Travel grants are also available for artists to encourage innovation. Those artists over sixty-five who have devoted valuable services to art in the Netherlands are eligible for a state stipend.

The Government Buildings Department uses 1½ percent of the costs of new government buildings for murals, stained-glass windows, mural sculptures, wall hangings, graffiti, mosaics, and the like. A similar 1 percent provision applies to schools and other educational buildings funded in part or in whole by the state.

A Provident Fund exists under the Ministry of Social Affairs and Public Health and provides that unemployed artists are entitled to as much as six times the artist's contributions to the fund—but for no more than thirteen weeks in any year. Contributions are made through artists' associations affiliated with the fund, so the result is a form of voluntary unemployment insurance. Each contribution is matched 310 percent by the government and 200 percent by the municipalities in which the member artist resides.

Also, the municipalities will—upon finding financial need on the part of an artist who is over twenty-five years of age—either seek suitable work for the artist or purchase one or more of the artist's works. The municipality provides 25 percent of the funding and the Ministry of Social Affairs and Public Health provides the rest. The works of art are divided between municipalities and the government on that prorated basis. Works passing to the ministry go into the Registry of State-Owned Works of Art and works passing to the municipalities go to local museums or galleries.

Ireland

In 1969 the government of Ireland enacted an unprecedented law designed to give tax relief to artists, composers, and writers within the boundaries of Ireland. The minister of finance, in presenting the legislation to the Dail Eireann, stated, "The purpose of this relief is . . . to help create a sympathetic environment here in which the arts can flourish by encouraging artists and writers to live and work in this country. This is something completely new in this country and, indeed, so far as I am aware, in the world. . . . I am convinced that we are right in making this attempt to improve our cultural and artistic environment and I am encouraged by the welcome given from all sides both at home and abroad

to the principle of the scheme. I am hopeful that it will achieve its purpose."

The legislation completely frees the artist, regardless of nationality, from any tax obligation to Ireland with respect to income derived from art.[16] The main requirement for application is that the artist be resident in Ireland for tax purposes. Simply explained, this requires the artist to rent or purchase a home in Ireland and work at that home during a substantial part of the year. However, while the residence must be uninterrupted, an artist does not necessarily have to be in Ireland for the entire year. Brief trips back to the United States, for example, would not affect an artist's tax status as a resident of Ireland. Every United States artist should remember, however, that the United States reserves the right to tax its citizens anywhere in the world, so consult pp. 162–164 for the United States tax effect of living abroad.

Once an artist is resident in Ireland, there are two methods to qualify for tax relief. An established artist, who has produced "a work or works generally recognized as having cultural or artistic merit," would use Artists Application Form 1. A less established artist would use Artists Application Form 2 for the exemption of a particular work "having cultural or artistic merit." In both cases the determination of "cultural or artistic merit" is made by the Irish revenue commissioners after consultation, if necessary, with experts in the field. Once an artist qualifies under either Artists Application Form 1 or Form 2, all future works by the artist in the same category will be exempt from Irish tax. The offices of the revenue commissioners are in Room 5, Cross Block, Dublin Castle, Dublin 2, Ireland. For the artist exempt from Irish tax, the sole Irish tax requirement is that a tax return showing no tax due be prepared and filed with the revenue commissioners in Dublin.

By early 1976, however, only about 500 persons had qualified to live tax free in Ireland. This was true despite the ease of application, absence of excessive tax paper work, and high percentage of applicants approved by the revenue commissioners. Of those who qualified, about 22 percent were painters and 6 percent sculptors, while 69 percent were writers and 3 percent composers. The assistance to the individual artist who comes to Ireland is certainly valuable, but Ireland's hope to create a new Byzantium has yet to be realized.

Japan

Japan has a unique approach whereby an organization or an individual artist can be registered as a "Living National Treasure." [17] Legislation in 1955 created the National Commission for Protection of Cultural Properties, which, by 1967, had designated fifty-seven persons and seven organizations as living national treasures for their role in aiding and continuing the culture and arts of Japan. Fields where living national treasures have been designated include ceramic art, dyeing and weaving, lacquered ware, metalwork, special dolls, Noh and Kabuki acting, Bunraku puppets, music, dance, singing, and so on. The living national treasures receive a stipend in order to be able to improve their special artistic talent while training students to perpetuate their art form.

Proposed United States Legislation

A plethora of proposals to aid artists were introduced in 1975 during the first session of the Ninety-fourth Congress. H.R. 8563 and H.R. 9527 would have provided that $20,000,000 be allocated to the National Endowment for the Arts to employ unemployed painters, musicians, actors, writers, and other artists during any fiscal year in which the national rate of unemployment exceeded 6.5 percent. H.R. 585, H.R. 6829, and H.R. 7091 would have allowed artists and other creative persons to donate their work to museums and other suitable organizations with a charitable deduction of fair market value instead of just the cost of materials. S. 1435, a variant of those three bills, would have permitted such charitable deductions to the extent of 75 percent of the fair market value of donated work, but such a deduction would not be allowed to be greater than income derived from art. H.R. 3999 would have allowed collectors who purchase American art created after 1945 a $10,000 tax deduction if that amount of work were purchased from a professional artist or the artist's agent. Any excess purchases could be carried over as deductions for a period of nine years. Proposals were also discussed to introduce an American version of the European *droit de suite*. [18] Finally, H.R. 8274 would have permitted each taxpayer to make a donation to the National Endowment for the Arts by either designating a portion of a tax overpayment for such use or including a contribution with the tax

return. The advantage of such a proposal would be the ease with which the contributions could be made. A significant proposal was made in the first session of the Ninety-third Congress but not introduced in the Ninety-fourth Congress. H.R. 696 would have made the proceeds from sales of art works capital gains income, subject to the favorable capital gains tax rates, instead of ordinary income. It is hoped these bills will be reconsidered in the future.

A Proposal

The legislative initiatives offer evidence of the concern felt for the status of the artist. The intangible contribution of the artist to society is seldom matched by comparable tangible benefits returned to the artist. While society rewards its favorites well, the struggling artist is often forgotten. The unemployed artist and the economically marginal artist should be the primary beneficiaries of any legislation intended to improve the artist's status.

Unemployment benefits and projects for artists are certainly a fruitful approach. But for those artists who struggle to maintain a precarious financial equilibrium, a form of tax incentive such as that proposed by Michael Pantaleoni, former executive director of the Volunteer Lawyers for the Arts in New York City, should be seriously considered.[19] He suggests that artists who earn less than $10,000 per year be entitled to a reduced rate of tax, as long as their income is from sales of their art work. This favorable treatment could be eliminated to the extent the artist received income over $10,000 from either art or nonart sources. The cost of such a program to aid artists might be surprisingly little, since the arts provide a substantial stimulus to the economies of communities.[20] Incentives for business are common enough, and society's recognition and support of the artist can immeasurably enhance the future.

APPENDIXES

Artists Groups

American Institute of Graphic Artists (AIGA), 1059 Third Avenue, New York, New York 10021. Founded in 1914 as a formal, cooperative organization to recognize creative workers in graphic arts. It incorporates broad-range programs for artists, designers, and craftsmen in all classifications: books, print, learning kits, direct and space ads, TV, sales promotion, album covers, packages, labels, periodicals, environmental graphics, plus municipal and other government design industry assignments. AIGA gives shows, publishes journals, runs clinics and plant tours, and awards its "Distinguished Medal" each year.

Anyart: Contemporary Arts Center, 250 Water Street, Warren, Rhode Island 02885. Cooperative gallery offering workshops, a journal, and a cataloged slide registry. No gallery fees or commissions charged.

Art Coordinating Council for the Area (ACCA), Meramec Community College, 11333 Big Bend Boulevard, Kirkwood, Missouri 63122. Workshops, lectures, and a newsletter for artists.

Art Directors Club, Inc., 488 Madison Avenue, New York, New York 10022. Founded in 1920, "to promote and elevate the profession of Art Directing." Provides professional services, conducts educational programs, publishes and exhibits, and seeks to elevate professional standards through active participation in the Joint Ethics Committee.

Artists Equity Association (AEA), 2813 Albemarle Street, N.W., Washington, D.C. 20008. Newsletter, information kits and service, insurance. Has local chapters.

Artists Equity Association of New York, 1780 Broadway, New York, New York 10019. Newsletter, code of ethics, contracts, insurance.

The Artists Guild, 25 West 36th Street, New York, New York 10018. Founded in 1920 by a small corps of illustrators to combat a malpractice of business

ethics, the group helped establish the right of an artist to free-lance. A partner with the ADC and SI in creating The Joint Ethics Committee, has programs that have included an apprentice division for art school graduates, an "Artist of the Year" award, and an annual exhibition of fine and commercial art. Membership includes fine and commercial artists.

Artists Rights Association (ARA), 27 West 15th Street, New York, New York 10011. Promotes artists rights, mainly through the Artist's Reserved Rights Transfer and Sale Agreement.

Artists Rights Today, Inc. (ART, Inc.), c/o Rubin L. Gorewitz, 250 West 57th Street, New York, New York 10019. Seeks legislation beneficial to artists.

Artists for Economic Action (AFEA), 10930 Le Conte Avenue, Los Angeles, California 90024. Works for the economic betterment of artists through media coverage, legislative changes, artist representation on arts councils and museum boards, and professional services for artists.

Association of Artist-Run Galleries (AARG), 431 West Broadway, New York, New York 10012. Central association of cooperative galleries.

Association of Independent Video and Filmmakers, Inc. (AIVF), 75 Horatio Street, New York, New York 10014. Works through the combined effort of the membership to provide practical, informational, and moral support for independent video and filmmakers.

Boston Visual Artists Union (BVAU), 3 Center Plaza, Boston, Massachusetts 02108. Large membership, newsletter, gallery, insurance, other professional services.

Chicago Artists Coalition, 6627 Glenwood, Chicago, Illinois 60626. Slide registry, newsletter, ethics committee.

Cartoonists Guild, Inc., 156 West 72nd Street, New York, New York 10023. Founded in 1967 as a national organization of professional cartoonists. Some of the main services provided members are: a bimonthly newsletter, confidential market information and bulletins, panel discussions and workshops with follow-up written reports available to members who cannot attend, availability of a membership disability insurance plan, aid in problems of payment and recovery of cartoons from publications, a copy of the guild-developed "Cartoonists and Media Joint Code of Professional Practices and Ethics," and participation in an ongoing program to upgrade the standards in the field.

Foundation for the Community of Artists, 220 Fifth Avenue, New York, New York 10001. Publishes *Art Workers News,* seeks the economic betterment of artists, offers insurance.

Graphic Artist for Self-Preservation (GASP), c/o Robert Anthony Advertising, 156 East 52nd Street, New York, New York 10022. Mainly seeks acceptance by publishers of a fair book contract or purchase order for use with book jacket designers.

Graphic Artists Guild (GAG), 30 East 20th Street, New York, New York 10010. Seeks to correct abuses to which graphic artists are subjected and to gain recognition for graphic arts as a profession with all that such status

entails. First formed in 1967 in Detroit, that chapter was awarded the power to negotiate with the National Labor Relations Board (NLRB). The New York chapter was formed in 1971. Programs include bimonthly meetings and newsletter and Blue Cross and Blue Shield for members. The group just published *Pricing and Ethical Guidelines* and is involved with guiding people in more than twenty working disciplines. Just began its first annual exhibition.

Illustrators Guild (IG), 30 East 20th Street, New York, New York 10010. Purposes of this national professional organization: establishing of ethical and financial standards and raising consciousness among illustrators. IG is interested in becoming a collective bargaining organization for illustrators to affect pricing structures for the business "corresponding to the times." Major concerns are ownership of original materials and residual rights. It also offers members legal help and has just completed its own code of ethics, geared especially to illustrators.

Kansas City Artists Coalition (KCAC), 1507 N. 63 Place, Kansas City, Kansas 66102. Educational business programs, newsletter, slide registry, gallery services committee.

N.A.M.E., 9 West Hubbard St., Chicago, Illinois 60610. Large cooperative gallery.

New Alliance for Artists in New York (NAANY), 220 Fifth Avenue, New York, New York 10010. A coalition of over 50 artists' organizations representing the interests of over 5,000 artists. Promotes artists' rights.

New Organization for the Visual Arts (NOVA), 1240 Huron Road Mall, Cleveland, Ohio 44115. Gallery, newsletter, educational activities, slide file.

Society of Publication Designers (SPD), 23 Park Avenue, New York, New York 10017. Began in 1964. Main purposes: to encourage and help publication designers in ways which will advance the level and efficiency of their endeavors; to increase the exposure given to the contributions of these designers, and to achieve professional recognition. Concerned with consumer publications, newspapers, business, and company publications. Activities include: annual exhibition, monthly newsletter, monthly special programs or lectures.

Society of Photographer and Artist Representatives, Inc. (SPAR), P.O. Box 845, FDR Station, New York, New York 10022. Formed in 1965, with the continuing purpose of establishing and maintaining high ethical standards in the business conduct of representatives and the creative talent they represent, and fostering productive cooperation between talent and client. This organization runs speakers' panels and seminars with buyers of talent from all fields; just completed "Standards" relations statement to clarify urgent problems and abuses; works with new reps to orient them on business, contracts, The Joint Ethics Committee, and free legal advice. Members: regular (agents), associates, out-of-town.

Society of Illustrators (SI), 128 East 63rd Street, New York, New York

10021. Begun in 1901 and dedicated to the advancement of the art of illustration and the welfare of persons in the art. Included in programs: welfare fund to help indigent members: U.S. Air Force program—yearly exhibit and tours; membership service on the U.S. Stamp Advisory Committee; annual exhibition of American illustration; annual books; lecture series. SI also serves as an official archive of illustration.

Society of Photographers in Communications (ASMP), 60 East 42nd Street, New York, New York 10036, telephone (212) 661-6450. Works in several areas to improve basic compensation and stock photo rates for members; establish basic legal precedents; preserve reusage rights; protect individuals in "fighting major battles"; provide low-cost group insurance. It publishes *Bulletin,* a monthly guide to improve financial results and a guide to business practices in the field; offers direct aid to members, backed by legal counsel; has exhibits; gives press card I.D. to members.

Upper Midwest Artists Association (UMAA), 714 Southwood Drive, Fargo, North Dakota 58102. Artists' rights, legal and financial advice, education activities, newsletter.

Organizations for the Arts

The Associated Councils of the Arts (the ACA, located at 570 Seventh Avenue, New York, New York 10018) seeks to create appropriate national priorities for the arts. The ACA is a national membership association composed of about five hundred arts agencies, most of which are state and community arts councils and commissions. ACA coordinates activities of many local regional arts organizations and sponsors conferences on matters of special interest or importance to those active in advancement of the arts. It has sponsored Advocates for the Arts, which is a national group of private citizens seeking legal and economic betterment for the arts. The ACA also publishes books and monthly newsletters related to its overall purposes.

The Business Committee for the Arts (1700 Broadway, New York, New York 10019) seeks funds for the arts from business sources and also attempts to develop new sources of funding for the arts. Some innovative funding ideas explored by the Business Committee for the Arts include lotteries for the arts, community united funding drives for the arts, matching grants, and employee matching gift programs. Awards are given to corporate donors for the sponsorship of particular arts projects, and businesses often take positive steps to encourage the arts.

The National Committee for Cultural Resources (1865 Broadway, New York, New York 10023) is devoted to formulation of a national policy which will encourage the availability and growth of the arts in the future. The membership in-

cludes not only representatives of the entire range of the arts, but also representatives of business, labor, education, and government. An important contribution of the National Committee for Cultural Resources has been their *National Report on the Arts*, an examination of the needs of arts organizations based on extensive research including polls conducted by the National Research Center of the Arts, an affiliate of Louis Harris and Associates, Inc.

State Arts Agencies

Alabama State Council on the Arts
and Humanities
M.J. Zakrzewski, Exec. Director
449 S. McDonough Street
Montgomery, Alabama 36104

Alaska State Council on the Arts
Roy H. Helms, Exec. Director
360 K Street, Suite 240
Anchorage, Alaska 99501

American Samoa Arts Council
Palauni M. Tuiasosopo, Chairman
Office of the Governor
Pago Pago,
American Samoa 96799

Arizona Commission on the Arts and
Humanities
Mrs. Louise Tester, Exec. Director
6330 North 7th Street
Phoenix, Arizona 85014

The Office of Arkansas State Arts
and Humanities
Dr. R. Sandra Perry, Exec. Director
Old State Capitol
300 West Markham
Little Rock, Arkansas 72201

California Arts Commission
Clark Mitze, Exec. Director
808 "O" Street
Sacramento, California 95814

The Colorado Council on the Arts
and Humanities
Robert N. Sheets, Exec. Director
1550 Lincoln Street, Room 205
Denver, Colorado 80203

Connecticut Commission on the Arts
Anthony S. Keller, Exec. Director
340 Capitol Avenue
Hartford, Connecticut 06106

Delaware State Arts Council
Mrs. Sophie Consagra, Exec. Director
Wilmington Tower, Room 803
1105 Market Street
Wilmington, Delaware 19801

D.C. Commission on the Arts and
the Humanities
Leroy Washington, Acting Director
1023 Munsey Building
1329 E Street, N.W.
Washington, D.C. 20004

Fine Arts Council of Florida
Mrs. Anna Price, Exec. Director
c/o Department of the State
The Capitol Building
Tallahassee, Florida 32304

Georgia Council for the Arts
John Bitterman, Exec. Director
706 Peachtree Center South Building
225 Peachtree Street, N.E.
Atlanta, Georgia 30303

Insular Arts Council of Guam
Mrs. Louis Hotaling, Director
P.O. Box EK (Univ. of Guam)
Agana, Guam 96910

Hawaii State Foundation on Culture
and the Arts
Alfred Preis, Exec. Director
250 South King Street, Room 310
Honolulu, Hawaii 96813

Idaho State Commission on Arts and
Humanities
Miss Suzanne Taylor, Exec. Director
c/o State House
Boise, Idaho 83720

Illinois Arts Council
Michele Brustin, Director
111 North Wabash Avenue,
Room 1610
Chicago, Illinois 60602

Indiana Arts Commission
Exec. Director
Union Title Building
155 East Market, Suite 614
Indianapolis, Indiana 46204

Iowa State Arts Council
Jack E. Olds, Exec. Director
State Capitol Building
Des Moines, Iowa 50319

Kansas Cultural Arts Commission
Jonathan Katz, Exec. Director
117 West 10th Street, Suite 100
Topeka, Kansas 66612

Kentucky Arts Commission
Miss Nash Cox, Exec. Director
100 W. Main Street
Frankfort, Kentucky 40601

Louisiana State Arts Council
Mrs. E. H. (Lucile) Blum, President
c/o Dept. of Education
State of Louisiana
P.O. Box 44064
Baton Rouge, Louisiana 70804

Maine State Commission on the Arts
and the Humanities
Alden C. Wilson, Director
State House
Augusta, Maine 04330

Maryland Arts Council
Kenneth Kahn, Exec. Director
15 West Mulberry
Baltimore, Maryland 21210

Massachusetts Council on the Arts
and Humanities
Miss Louis G. Tate, Exec. Director
1 Ashburton Place
Boston, Massachusetts 02108

Michigan Council for the Arts
E. Ray Scott, Exec. Director
Executive Plaza
1200 Sixth Avenue
Detroit, Michigan 48226

Minnesota State Arts Council
Stephen Sell, Exec. Director
314 Clifton Street
Minneapolis, Minnesota 55404

Mississippi Arts Commission
Lida Rogers, Exec. Director
301 North Lamar Street
P.O. Box 1341
Jackson, Mississippi 39205

Missouri State Council on the Arts
Emily Rice, Exec. Director
111 South Bemiston, Suite 410
St. Louis, Missouri 63105

Montana Arts Council
David E. Nelson, Exec. Director
235 East Pine
Missoula, Montana 59801

Nebraska Arts Council
Gerald Ness, Exec. Director
8448 West Center Road
Omaha, Nebraska 68124

Nevada State Council on the Arts
James Deere, Exec. Director
560 Mill Street
Reno, Nevada 89502

New Hampshire Commission on the
Arts
John G. Coe, Exec. Director

Phenix Hall, 40 North Main Street
Concord, New Hampshire 03301

New Jersey State Council on the Arts
Brann J. Wry, Exec. Director
27 West State Street
Trenton, New Jersey 08625

The New Mexico Arts Commission
Bernard Blas Lopez, Exec. Director
Lew Wallace Building
State Capitol
Santa Fe, New Mexico 87503

New York State Council on the Arts
Robert A. Mayer, Exec. Director
80 Centre Street
New York, New York 10013

North Carolina Arts Council
Halsy North, Exec. Director
N.C. Department of Cultural
Resources
Raleigh, North Carolina 27611

North Dakota Council on the Arts
and Humanities
Glen Scott, Program Director
Department of English
North Dakota State University
Fargo, North Dakota 58102

Ohio Arts Council
L. James Edgy, Exec. Director
50 West Broad Street, Suite 2840
Columbus, Ohio 43215

Oklahoma Arts and Humanities
Council
William Jamison, Exec. Director
2101 N. Lincoln Blvd.
Oklahoma City, Oklahoma 73105

Oregon Arts Commission
Peter deC. Hero, Exec. Director
328 Oregon Building
494 State Street
Salem, Oregon 97301

Commonwealth of Pennsylvania
Council on the Arts
Otis B. Morse, Exec. Director
2001 North Front Street
Harrisburg, Pennsylvania 17101

Institute of Puerto Rican Culture
Luis M. Rodriguez Morales, Exec.
Director
Apartado Postal 4184
San Juan, Puerto Rico 00905

Rhode Island State Council on the
Arts
Mrs. Anne Vermel, Exec. Director
4365 Post Road
East Greenwich, Rhode Island
02818

South Carolina Arts Commission
Rick George, Exec. Director
829 Richland Street
Columbia, South Carolina 29201

South Dakota State Fine Arts
Council
Mrs. Charlotte Carver,
Exec. Director
108 West 11th Street
Sioux Falls, South Dakota 57102

Tennessee Arts Commission
Norman Worrell, Exec. Director
222 Capitol Hill Building
Nashville, Tennessee 37219

Texas Commission on the Arts and
Humanities
Maurice D. Coats, Exec. Director
P.O. Box 13406, Capitol Station
Austin, Texas 78711

Utah State Division of Fine Arts
Mrs. Ruth Draper, Director
609 East South Temple Street
Salt Lake City, Utah 84102

Vermont Council on the Arts, Inc.
Ellen Lovell, Exec. Director
136 State Street
Montpelier, Vermont 05602

Virginia Commission on the Arts and
Humanities
Frank R. Dunham, Exec. Director
400 E. Grace Street
Richmond, Virginia 23219

Virgin Islands Council on the Arts
Stephen J. Bostic, Exec. Director
Caravelle Arcade
Christiansted, St. Croix
U.S. Virgin Islands 00820

Washington State Arts Commission
James L. Haseltine, Exec. Director
1151 Black Lake Boulevard
Olympia, Washington 98504

West Virginia Arts and Humanities
Council
Norman Fagan, Exec. Director
Science and Cultural Center

State Capitol Complex
Charleston, West Virginia 25305

Wisconsin Arts Board
Jerrold Rouby, Exec. Director
123 W. Washington Avenue
Madison, Wisconsin 53702

Wyoming Council on the Arts
Michael Haug, Exec. Director
200 West 25th Street
Cheyenne, Wyoming 82002

NOTES

Books listed in the Selected Bibliography are cited by title only in the notes. The form for the notes is modified from that provided in *A Uniform System of Citation* (11th ed., Cambridge: Harvard Law Review Association, 1967) in order to be accessible to the artist as well as to the lawyer. After a full citation to a source is given in the notes for a chapter, additional references to the same source in that chapter are in shortened form.

Chapter 1. ART AND LAW

1. p. 3. Reginald Stuart, "Legal Costs: Pay Now, Litigate Later," *N.Y. Times,* January 18, 1976, Section 3 (Business), p. 3.

2. p. 3. *See, e.g.,* John Brooks, "Fueling the Arts, or Exxon as a Medici," *N.Y. Times,* January 25, 1976, Section 2 (Arts and Leisure), p. 1; Business Committee for the Arts, *1776 and More Examples of How BCA Companies Supported the Arts in 1975 and 1976* (New York: Business Committee for the Arts, 1976).

Chapter 2. COPYRIGHT

1. p. 5. This chapter draws on *Nimmer on Copyright* and the materials arranged by Carl Zanger in *Current Developments in Copyright Law,* vol. 2, pp. 137 *et seq.,* to establish the basic principles of the pre-1978 copyright law. Extensive citations to authority can be found in Tad Crawford, "Copyright Reform and the Visual Artist," *Art and the Law* (February–March 1976), p. 1.

2. p. 7. *Nimmer on Copyright,* Sections 166–173, pp. 714–760.

3. p. 7. N.Y. General Business Law Article 12-E; *see,* as to the limited purpose of Article 12-E, Legislative Memorandum of the Attorney General on N.Y. General Business Law, Article 12-E, in, *Art Works: Law, Policy, Practice,* p. 198.

4. p. 7. Cal. Civil Code Section 982 (*as amended* Assembly Bill No. 1051, September 22, 1975); *see,* as to the more extensive scope of California's legislation in comparison to New York's, Hamish Sandison, "California Legislation," *Art and the Law* (December 1975), p. 2.

5. p. 8. Coventry Ware, Inc. v. Reliance Picture Frame Co., 288 F.2d 193 (2d Cir. 1961), *reversing* 186 F. Supp. 798 (S.D.N.Y. 1960), *cert. denied* 368 U.S. 818 (1961).

6. p. 8. *Compendium of Copyright Office Practices*, Section 4.3.6, II, pp. 4–39.

7. p. 8. 17 United States Code Section 19.

8. p. 9. *Id.*, Section 1.

9. p. 9. *Id.*, Section 2.

10. p. 9. *Id.*, Section 9.

11. p. 9. *Id.*, Section 24.

12. p. 9. *Id.*, Section 16.

13. p. 10. *Id.*, Section 22.

14. p. 10. *Id.*, Section 23.

15. p. 10. *Id.*, Section 9.

16. p. 11. American Tobacco Co. v. Werckmeister, 207 U.S. 284 (1970); *Nimmer on Copyright*, Section 58, pp. 224–225.

17. p. 11. Letter Edged in Black Press, Inc. v. Public Building Commission, 320 F. Supp. 1303 (N.D. Ill. 1970); *see generally* Randolph Jonakait, "Do Art Exhibitions Destroy Common Law Copyright in Works of Art?", *ASCAP Copyright Law Symposium*, Number 19 (1971), pp. 81–116; Harry Weintraub, "Exhibiting Without Copyrights: The Visual Artist's Dilemma," *Art and the Law* (January 1975), p. 1.

18. p. 11. Grandma Moses Properties, Inc. v. This Week Magazine, 117 F. Supp. 348 (S.D.N.Y. 1953); *Nimmer on Copyright*, Section 54, pp. 212–213; *cf. Art Works: Law, Policy, Practice*, pp. 199–200; *but see* Pushman v. New York Graphic Society, 287 N.Y. 302, 39 N.E.2d 249 (1942).

19. p. 11. *Nimmer on Copyright*, Section 82, p. 302.

20. p. 12. *Id.*, Section 92.1, pp. 345–348; *The Visual Artist and the Law*, p. 8; *cf.* 17 United States Code Section 24.

21. p. 12. 17 United States Code Section 209; Scherr v. Universal Match Corp., 297 F. Supp. 107 (S.D.N.Y. 1967), *aff'd* 417 F.2d 497 (2d Cir. 1969), *cert. denied* 397 U.S. 936 (1970).

22. p. 12. 17 United States Code Section 21; *see Nimmer on Copyright*, Sections 90.1, 90.11, 90.12, 90.13, 90.14, pp. 338–341.

23. p. 12. *See generally* Cambridge Research Institute, *Omnibus Copyright Revision, Comparative Analysis of the Issues* (Washington, D.C.: American Society for Information Service, 1973), p. 107; *Nimmer on Copyright*, Section 119.1, pp. 510–512.

24. p. 13. Judy Schulman, "About Copyright," *Art and the Law* (Fall, 1975), p. 4; *Nimmer on Copyright*, Sections 119.1, 119.2, pp. 510–516; *but cf.* Goodis v. United Artists Television, Inc., 425 F.2d 397 (2d Cir. 1970).

25. p. 13. 17 United States Code Section 26; *Nimmer on Copyright*, Sections 6.3, 62, pp. 11–14, 238. 1–244.

26. p. 13. Yardley v. Houghton Mifflin Co., Inc., 108 F.2d 28 (2d Cir. 1939), *cert. denied* 309 U.S. 686 (1940); Morton v. Raphael, 334 Ill. App. 399, 79 N.E.2d 522 (1948); *The Visual Artist and the Law*, p. 35.

27. p. 14. 17 United States Code Section 28.

28. p. 14. *Id.*, Section 30.

29. p. 14. *Id.*

30. p. 14. *Id.*, Sections 24, 28; *Nimmer on Copyright*, Section 115, pp. 471–479.

31. p. 14. *Nimmer on Copyright*, Section 122, p. 529.

32. p. 16. 17 United States Code Section 101(b).

33. p. 16. *Id.*

34. p. 16. *Id.*, Section 101(a), (c), (d).

35. p. 16. Mazer v. Stein, 347 U.S. 201 (1954); In re Yardley, 181 U.S.P.Q. 331 (1974).

36. p. 16. *Art Works: Law, Policy, Practice*, p. 207.

37. p. 17. *Id.*

38. p. 17. 35 United States Code Section 154.

39. p. 17. *Id.*, Section 173.

Chapter 3. THE COPYRIGHT REVISION ACT OF 1967

1. p. 18. For an extensive examination of copyright revision, *see* Tad Crawford, "Copyright Reform and the Visual Artist," *Art and the Law* (February–March 1976), p. 1; Hamish Sandison, "Copyright Revision Bill's Impact on the Visual Artist," *Art and the Law* (September–October, 1976), p. 1.

Chapter 4. RIGHTS OF THE ARTIST

1. p. 30. Berne Convention for the Protection of Literary and Artistic Works, June 26, 1948 (Brussels), Art. 6 *bis* (1), in, *Nimmer on Copyright*, Appendix O, p. 1020; *compare* the more recently adopted text of the Berne Convention, July 10, 1974 (Paris), Art. 6 *bis* (1), in, *Nimmer on Copyright*, Appendix P, pp. 1037–1038.

2. p. 30. Wladimir Duchemin, "Le Droit de Suite," *Revue Internationale du Droit d'Auteur* (April 1974), pp. 6–8.

3. p. 30. The private contract is the Projansky contract discussed at pp. 61–67. The federal legislation for an art proceeds right is reportedly being prepared by Representative Drinan. *See also* Rubin L. Gorewitz, "Royalties For Artists: A Practical Proposal," *American Artist* (January 1975), p. 28; Jerry Cohen, "The Evolving Law of Artists: The Search for an American Law of Personality," *Art and the Law* (December 1974), p. 1.

4. p. 30. *See generally,* as to moral rights under French law, Raymond Sarraute, "Current Theory of the Moral Rights of Authors and Artists Under French Law," *American Journal of Comparative Law,* vol. 16 (1968), p. 465, in, *Art Works: Law, Policy, Practice,* pp. 29–66.

5. p. 32, "Toward Artistic Integrity: Implementing Moral Right Through Extension of Existing American Legal Doctrines," *Georgetown Law Journal,* vol. 60 (1972), pp. 1539, 1540, n.5, which indicates that other moral rights under classical French theory allow prevention of excessive criticism of a work or other violations of an artist's reputation.

6. p. 32. *The Visual Artist and the Law,* pp. 40–41.

7. p. 33. Duchemin, "Le Droit de Suite," p. 4. This article is the source for much of the discussion of the French *droit de suite.*

8. p. 33. *Id.,* pp. 26–28; *cf.* Bonnie Burnham, *The Art Crisis* (New York: St. Martin's Press, 1975), pp. 39–40.

9. p. 33. *Art Works: Law, Policy, Practice,* p. 285, adopts the view expressed in Rita Hauser, "The French Droit de Suite: The Problem of Protection for the Underprivileged Artist under the Copyright Law," *ASCAP Copyright Law Symposium,* Number 11 (1962), p. 1, that the *droit de suite* is payable to an United States artist under the assimilative principle of the Universal Copyright Convention. However, Wladimir Duchemin, the secretary general of S.P.A.D.E.M., stated in a letter to the author dated January 19, 1976, that United States artists have no right to the *droit de suite* in France because "in your country the *droit de suite* isn't yet recognized."

10. p. 33. Duchemin, "Le Droit de Suite," p. 20.

11. p. 33. James M. Treece, "American Law Analogues of the Author's 'Moral Rights,'" *American Journal of Comparative Law,* vol. 16 (1968), pp. 487–506, in, *Art Works: Law, Policy, Practice,* pp. 53–66, and "Toward Artistic Integrity: Implementing Moral Right Through Extension of Existing American Legal Doctrines," *Georgetown Law Journal,* pp. 1539–1562, are the main sources for the discussion of American doctrines which approximate moral rights.

12. p. 34. Shaw v. Time-Life Records, 38 N.Y. 2d 201 (1975).

13. p. 34. Fisher v. Star Co., 231 N.Y. 414, 433, 132 N.E. 133, 139, *cert. denied* 257 U.S. 654 (1921).

14. p. 35. Vargas v. Esquire, Inc., 164 F.2d 522 (7th Cir. 1947).

15. p. 35. Crimi v. Rutgers Presbyterian Church, 194 Misc. 570, 89 N.Y.S.2d 813 (Sup. Ct 1974); *compare* Meliodon v. Philadelphia School District, 328 Pa.457, 195 A. 905 (1938).

16. p. 35. *See Warren's Forms of Agreements,* vol. 2, Sections 65, 66 for general information on trademarks and trade names, as well as forms for grants, licenses, and assignments.

17. p. 36. *See, e.g., California Jurisprudence 2d,* vol. 40, *Privacy,* Section 11, p. 11; Booth v. Curtis Publishing Company, 15 App. Div. 2d 343, *aff'd* 11

N.Y.2d 907 (1962); Pavesich v. New England Mutual Life Insurance Co., 122 Ga. 190, 50 S.E. 68 (1905).

18. p. 36. Neyland v. Home Pattern Co., 65 F.2d 363 (2d Cir.), *cert. denied* 290 U.S. 661 (1933).

19. p. 36. Geisel v. Poynter Products, Inc., 295 F. Supp. 331 (D.C. N.Y. 1969).

20. p. 37. *Black's Law Dictionary* (4th ed., St. Paul, Minn.: West Publishing Company, 1951), pp. 505, 1060, 1559.

21. p. 37. *Corpus Juris Secundum*, vol. 53, *Libel and Slander*, Section 134(c), pp. 221-222; Fisher v. The Washington Post Co., 212 A.2d 335 (D.C. App. 1965); Fitzgerald v. Hopkins, 70 Wash.2d 924, 425 P.2d 920 (1967).

22. p. 37. *See* Haelan Laboratories v. Topps Chewing Gum, 202 F.2d 866 (2d Cir.), *cert. denied* 346 U.S. 816 (1953); Uhlaender v. Henricksen, 316 F. Supp. 1277, 1278-79 (D. Minn. 1970); "Transfer of the Right of Publicity," *U.C.L.A. Law Review*, vol. 22 (1975), pp. 1103-1128.

23. p. 38. Cal. Civil Code Section 986.

Chapter 5. THE CONTENT OF ART WORKS

1. p. 40. *The Visual Artist and the Law*, pp. 50-51.

2. p. 40. *Corpus Juris Secundum*, vol. 53, *Libel and Slander*, Section 137, pp. 223-227.

3. p. 40. *Id.*, Section 148, pp. 231-232. This liability is stated to be, "in full, without apportionment."

4. p. 41. *The Visual Artist and the Law*, p. 55; *see*, as to photography, Harold F. Birnbaum, "Libel by Lens," *American Bar Association Journal*, vol. 52 (1966), pp. 837-839.

5. p. 41. Cassidy v. Daily Mirror Newspapers, Ltd., (1929) 2 K.B. 331, C.A.

6. p. 41. New York Times v. Sullivan, 376 U.S. 254 (1964).

7. p. 41. Firestone v. Time, Inc., 44 U.S.L.W.4263 (U.S. March 2, 1976).

8. p. 41. Gertz v. Robert Welch, Inc., 418 U.S. 323 (1974).

9. p. 41. *Corpus Juris Secundum*, vol. 53, *Libel and Slander*, Sections 74-76, 260, pp. 124-127, 372-375.

10. p. 42. Galella v. Onassis, 487 F.2d 986, 992 (2d Cir. 1973).

11. p. 42. Man v. Warner Brothers, Inc., 317 F. Supp. 50 (S.D.N.Y. 1970); *cf.* Meeropol v. Nizer, 381 F. Supp. 29 (S.D.N.Y. 1974).

12. p. 43. *ASMP Guide: Business Practices in Photography: 1973*, p. 17.

13. p. 43. Miller v. United States, 413 U.S. 22, 24 (1973).

14. p. 45. *See generally The Visual Artist and the Law*, pp. 54-55.

15. p. 45. Roaden v. Kentucky, 413 U.S. 496 (1973); *see also The Visual Artist and the Law*, pp. 51-52.

16. p. 46. 18 United States Code Section 700; for a state statute, *see* N.Y. General Business Law Section 136(a) which was held partially unconstitutional in Long Island Vietnam Moratorium Committee v. Cahn, 437 F.2d 344 (2d Cir. 1970), *aff'd* 418 U.S. 906 (1974).

17. p. 46. U.S. *ex rel.* Radich v. Criminal Court of City of New York, 385 F. Supp. 165, 168 (S.D.N.Y. 1974).

18. p. 46. *Id.*, pp. 174–184; Spence v. Washington, 418 U.S. 405 (1974).

19. p. 47. 18 United States Code Section 475.

20. p. 47. *Id.*, Section 333.

21. p. 47. *Id.*, Section 489; *cf.* U.S. v. Roussoupulous, 95 F. 977 (D.C. Min. 1899).

22. p. 47. 18 United States Code Section 504; Senate Report No. 2446, 1968 *U.S. Cong. and Adm. News*, p. 2310 (85th Cong. 2d Sess.).

Chapter 6. CONTRACTS: AN INTRODUCTION

1. p. 48. General principles of contract law are drawn from sources such as the *Restatement of Contracts* (1932) and the multivolume treatises *Corbin on Contracts* (196) and *Williston on Contracts* (1957, 1975 Supp.). A good single-volume text is John Calamari and Joseph Perillo, *The Law of Contracts* (1970). An article specifically dealing with some of the contractual problems of the artist is Robert L. Myers, "A Few Things You Never Asked about Contracts that You Probably Should Know," *Art Law: Domestic and International*, pp. 7–20.

2. p. 48. *Cf.* National Historic Shrines Foundation, Inc., v. Dali, 4 U.C.C. Rep. Serv. 71 (N.Y. 1967); Yardley v. Houghton Mifflin Co., Inc., 108 F.2d 28 (2d Cir. 1939), *cert. denied*, 309 U.S. 686 (1940). *Art Works: Law, Policy, Practice*, p. 468, includes a portrait as a personal services contract which, if this characterization is accurate, would apparently not be within Uniform Commercial Code Section 2–201(3)(a) relating to specially manufactured goods.

3. p. 49. *But see* Uniform Commercial Code Sections 2-204(3), 2-305, under which a contract may be formed despite the absence of a material term such as price.

4. p. 49. *Compare* Zaleski v. Clark, 44 Conn. 218 (1876); Pennington v. Howland, 21 R.I. 65 (1898); *see* Calamari and Perillo, *The Law of Contracts*, Section 153.

5. p. 49. Myers, "A Few Things You Never Asked about Contracts that You Probably Should Know," p. 13.

6. p. 50. N.Y. General Obligations Law Section 1-202; Cal. Civil Code Section 25.

7. p. 51. 19 United States Code Section 2091 *et seq.* (Supp. 1974).

8. p. 51. Uniform Commercial Code Section 2-201.

9. p. 52. *Id.*, Section 2-204(1); *see also* Douglas K. Newell, "The Merchant of Article 2," *Valparaiso University Law Review*, vol. 7 (1973), pp. 307–344.

10. p. 52. Joseph Perillo, "The Statute of Frauds in the Light of the Functions and Dysfunctions of Form," *Fordham Law Review*, vol. 43, pp. 77–79 (1974); N.Y. General Obligations Law Section 5-701.

11. p. 53. Uniform Commercial Code Section 2-312.

12. p. 53. *Id.*, Section 2-315. If the artist were considered a merchant with respect to the goods sold, Uniform Commercial Code Section 2-314 would also apply.

13. p. 53. Uniform Commercial Code Section 2-313.

14. p. 54. This form of warranty, although developed by the author at the request of an artist, is, in fact, necessitated to a substantial degree, as is shown by the similarity of this warranty to that found in Alvin S. Lane, "How the Bar Can Assist the Art Community," *Record of Association of the Bar*, vol. 20 (1965), p. 168, in, *Art Works: Law, Policy, Practice*, p. 1032.

15. p. 54. La Rue v. Groezinger, 84 Cal. 281, 24 p. 42 (1890).

16. p. 54. *Id.; American Jurisprudence 2d*, vol. 6, *Assignments*, Section 19, p. 200.

17. p. 55. Brockhurst v. Ryan, 2 Misc.2d 747, 146 N.Y.S. 2d 386 (Sup. Ct. 1955).

18. p. 55. *American Artist Business Letter* (Supplement, September 1974).

19. p. 56. Uniform Commercial Code Section 2-509.

20. p. 56. Deitch v. Shamash, 56 Misc.2d 875, 290 N.Y.S.2d 137 (Civ. Ct. 1968); *but see* Robert J. Nordstrom, *Handbook of the Law of Sales*, Section 134 (1970).

21. p. 56. Brockhurst v. Ryan, 2 Misc.2d 747, 753, 146 N.Y.S.2d 386, 392 (Sup. Ct. 1955).

22. p. 57. Wagner-Larscheid Co. v. Fairview Mausoleum Co., 190 Wis.357, 362, 208 N.W.241, 242 (1926). For an interesting dispute involving the substantial performance issue, *see* Carl Baldwin, "Notes on an Awning," *Art News* (October 1975), p. 83.

23. p. 57. *See Corpus Juris Secundum*, vol. 17A, *Contracts*, Section 334, p. 311; Section 511, p. 831.

24. p. 57. Annotation, "Specific Performance of Contracts for Services," 135 *A.L.R.* 279, 289–290 (1941).

25. p. 57. For a curious case where a party seeking specific performance did not succeed, *see* Youssoupoff v. Widener, 246 N.Y. 174, 158 N.E.64 (1927).

26. p. 58. *Compare* N.Y. Civil Practice Law and Rules Section 213(2) with Uniform Commercial Code Section 2-725; *see Art Works: Law, Policy, Practice*, pp. 465–472.

27. p. 58. The issue arises whether all of the artist's bailments are for mutual benefit or whether certain bailments would either be for the sole benefit of the

bailor or the sole benefit of the bailee. If the bailment is for the sole benefit of the bailor, the bailee will only be liable for gross negligence. If the bailment is for the sole benefit of the bailee, the bailee can be liable even though reasonable care is taken with the goods. A bailment for mutual benefit will usually be found where the bailee takes possession of the goods as an incident to the bailee's business, even if no consideration is received. *American Jurisprudence 2d*, vol. 8. *Bailments*, Section 10, pp. 914–915. *See generally* Colburn v. Washington Art Association, 80 Wash. 662, 141 p. 1153 (1914); Gardini v. Museum of City of New York, 173 Misc. 791, 19 N.Y.S.2d 96 (City Ct. N.Y. Co. 1940); Prince v. Alabama State Fair, 106 Ala. 340, 17 So. 449 (1894).

28. p. 58. *Photography: What's the Law?*, pp. 98–101; *see, e.g.*, Rhoades, Inc. v. United Air Lines, Inc., 224 F. Supp. 341 (W.D. Pa. 1963).

29. p. 58. *Photography: What's the Law?*, pp. 102–105.

30. p. 58. Robert M. Cavallo, "Protecting Your Work: Delivery Memo Form," *ASMP Journal of Photography in Communications* (January 1976), pp. 14–15. The Delivery Memo and an Invoice appear in *Photography: What's the Law?*, pp. 105–109.

Chapter 7. SALES OF ART WORKS

1. p. 65. Sylvia Hochfield, "Artists Rights: Pros and Cons," *Art News* (May 1975), p. 6.

2. p. 67. The Jurrist contract appears in *Law and the Arts*, pp. 40–42.

3. p. 69. *See generally American Jurisprudence 2d*, vol. 17, *Contracts*, Section 413, pp. 864–866. For a case where the artist died leaving work in progress, *see* Matter of Buccini v. Paterno Construction Company, 253 N.Y. 256 (1930).

4. p. 73. Corliss v. E. W. Walker Co., 64 F.280 (C.C.D. Mass. 1894); *Photography: What's the Law?*, p. 11.

5. p. 73. *American Artist Business Letter* (February 1976), p. 5.

Chapter 8. SALES BY GALLERIES AND AGENTS

1. p. 77. A number of helpful sources exist in this area, including the Model Form of Artist-Gallery Agreement with Explanatory Annotations developed by the Lawyers for the Arts Committee, Young Lawyers Section, Philadelphia Bar Association, 423 City Hall Annex, Philadelphia, PA. 19107; the Artist-Dealer Form of Contract available from Artists Equity Association; *The Visual Artist and the Law*, pp. 15–26; *Art Works: Law, Policy, Practice*, pp. 473–526; and *American Artist Business Letter* (December 1974), p. 5.

2. p. 78. N.Y. General Business Law Section 219-a; Cal. Civil Code Sections 1738–1738.9.

3. p. 78. Uniform Commercial Code Section 2-326; *see Art Works: Law, Policy, Practice*, p. 495.

4. p. 78. *Compare* this agreement with that in *Art Works: Law, Policy, Practice*, p. 493, which states that "a security interest in, the Painting (and any proceeds thereof) is reserved in me until sale. . . . In the event of any default by you, I shall have all the rights of a secured party under the Uniform Commercial Code."

5. p. 83. *See Art Works: Law, Policy, Practice*, p. 519, for the Consignment and Rental Agreement used by the Art Lending Service of the Museum of Modern Art.

6. p. 86. Uniform Commercial Code Section 2-326; *see Art Works: Law, Policy, Practice*, p. 495.

7. p. 86. Uniform Commercial Code Section 2-327; *see Art Works: Law, Policy, Practice*, p. 496; *contra, The Visual Artist and the Law*, p. 28.

8. p. 87. *The Visual Artist and the Law*, p. 28.

9. p. 88. The practical aspects of a cooperative gallery are discussed in Betty Chamberlain, "How to Set Up a Cooperative Gallery," *American Artist* (January 1974), p. 28; *see*, for the history of a particular cooperative, "The Art Co-op of Berkeley," *Art Workers News* (March 1975), p. 6.

10. p. 88. Rev. Rul. 71-395, 1971—2 Cum. Bull. 228; Rev. Rul. 76-152, I.R.B. 1976-17, 19; *see* "The Tax-Exempt Co-op," *American Artist Business Letter* (November 1974), p. 4, for an innovative proposal by Rubin L. Gorewitz whereby artists would be paid to teach with funds raised by the cooperative gallery through sales of work contributed to the gallery.

11. p. 89. *ASMP Guide: Business Practices in Photography: 1973;* pp. 35–39; *see also Photography: What's the Law?*, pp. 110–118.

Chapter 9. VIDEO ART WORKS

1. p. 98. The artist-gallery video agreement and bill of sale in this chapter should be compared with those in *Current Developments in Copyright Law*, vol. 2, pp. 231–238.

Chapter 10. FINE PRINTS

1. p. 112. Print Council of America, "What Is an Original Print?", (1961), in, *Art Works: Law, Policy, Practice*, pp. 441–446.

2. p. 113. Cal. Civil Code Sections 1740–1745.

3. p. 115. Robert E. Duffy, Jr., "Disclosure Requirements in Connection with the Sale of Fine Art Prints," *California State Bar Journal*, vol. 48 (1973), pp. 528–534, 605–609.

4. p. 115. Assembly Bill No. 1054 (1975). This bill was debated by June Wayne and Hamish Sandison, "On Print Disclosure Legislation," *American Artist* (April 1976), pp. 58–59.

5. p. 115. Ill. Annotated Statutes, Chapter 121½ (Smith-Hurd).

6. p. 116. N.Y. General Business Law, Article 12-H.

7. p. 116. H.R. 15968, 92d Cong., 2d. Sess. (1972).

Chapter 11. PUBLISHING

1. p. 122. Three excellent articles dealing with standard contracts for writers are Irwin Karp, "What the Writer Should Look for in His First Book Contract," *Writer's Yearbook* (1967), p. 27; Richard Dannay, "A Guide to the Drafting and Negotiating of Book Publication Contracts," *Bulletin of the Copyright Society of the U.S.A.*, vol. 15 (1967–68), pp. 295–311; Andrew O. Shapiro, "The Standard Author Contract: A Survey of Current Draftsmanship," *ASCAP Copyright Law Symposium*, Number 18 (1970), pp. 135–173.

2. p. 122. The Authors Guild Trade Book Contract is provided by the guild to its members. The Standard Photographers Book Agreement is in *ASMP Guide: Business Practices in Photography: 1973*, pp. 42–47.

3. p. 134. *See, e.g.*, Reginald Ray Reeves, "Superman v. Captain Marvel or, Loss of Literary Property in Comic Strips," *ASCAP Copyright Law Symposium*, no. 5 (1954), pp. 3–36.

4. p. 134. Mary Breasted, "Superman's Creators, Nearly Destitute, Invoke His Spirit," *N.Y. Times*, November 22, 1975, p. 31; Siegel v. National Periodical Publications, Inc., 364 F. Supp. 1032 (S.D.N.Y. 1973), *aff'd* 508 F.2d 909 (2d Cir. 1974).

Chapter 12. LOFTS AND LEASES

1. p. 141. An excellent historical background to the zoning changes is by Jacqueline Skiles and Laurin Raiken, "Where Do Artists Live and Work?", *Art Workers News*, December 1974–January 1975, part I, p. 1; February, 1975, part II, p. 1; *see also Housing for Artists: the New York Experience.*

2. p. 141. Zoning resolutions were approved by the Board of Estimate for Soho and Noho on April 27, 1976, as Calendar No. 7, and for Tribeca on June 11, 1976, as Calendar No. 239.

3. p. 141. Wendy Schulman, "Soho a 'Victim of Its Own Success,' " *N.Y. Times*, November 24, 1974, Section 8 (Real Estate), p. 1.

4. p. 143. *Id.*, p. 10.

Chapter 13. INCOME TAXATION

1. p. 145. Treas. Reg. Section 1.471-1 requires accrual accounting for inventories "to reflect taxable income correctly . . . in every case in which the production, purchase or sale of merchandise is an income-producing factor." The artist who produces substantial quantities of identical works, such as 500 replicas of a statue, would be characterized as a manufacturer producing merchandise and should use accrual accounting for inventories. Herrick K. Lidstone and Leonard R. Olsen, "The Individual Artist: Recordkeeping, Methods of Accounting, Income and Itemized Deductions for Federal Income Tax Purposes," (New York: Volunteer Lawyers for the Arts, 1976), pp. 12–17, even suggest that a sculptor might have to use accrual accounting for inventories if the sculptor's works required substantial costs in materials and the labor of others. However, Rubin L. Gorewitz, a New York C.P.A. who represents many artists, states that the income of artists, including sculptors, can only be correctly reflected by the use of cash basis accounting because of the obsolescence of art works as artists change styles, the possibility that even a completed work may be destroyed to use the materials in a newer work, and the unknown sales potential of any work. *See* Renato Beghe, "The Artist, the Art Market, and the Income Tax," *Tax Law Review*, vol. 29 (1974), p. 494, n. 16. This article offers an excellent treatment of the tax problems confronting artists.

2. p. 145. Beghe, "The Artist, the Art Market, and the Income Tax," pp. 503–504, n. 53, discusses this constructive receipt problem, particularly in view of N.Y. General Business Law Article 12-C making funds held by a dealer for an artist into trust funds. For a discussion of the artist's use of installment sales, *see* Lidstone and Olsen, "The Individual Artist: Recordkeeping, Methods of Accounting, Income and Itemized Deductions for Federal Income Tax Purposes," pp. 32–38.

3. p. 146. The exact calculation, of course, involves the subtraction of net short-term capital loss from net long-term capital gain prior to application of one of the alternative methods for computing the tax provided by Internal Revenue Code of 1954, Sections 1201, 1202; Treas. Reg. Section 1.1202-1.

4. p. 146. Internal Revenue Code of 1954, Section 1221(3), which continues "in whose hands the basis of such property is determined, for purposes of determining gain from a sale or exchange, in whole or in part by reference to the basis of such property in the hands of the person whose personal efforts created such property," so as to deny art works being capital assets in the hands of a donee.

5. p. 146. Beghe, "The Artist, the Art Market, and the Income Tax," pp. 495–500, discusses the different facets of earned income and the artist.

6. p. 147. Internal Revenue Code of 1954, Sections 1001, 1002, 1012.

7. p. 147. *But cf.* Rev. Rul. 74-95, 1974-1 Cum. Bull. 39–40, where teachers given awards by the National Endowment for the Arts to attend university

classes had the awards included in gross income because the grant contract provided for the United States government to be able to use and reproduce materials developed in the course of the studies. This ruling is discussed critically in Harvey Horowitz, "Tax Treatment of Artists," *Volunteer Lawyers for the Arts Newsletter,* no. 8 (June-July 1974), pp. 16–18.

8. p. 148. Internal Revenue Code of 1954, Section 74; Treas. Reg. Section 1.74-1.

9. p. 148. *Id.,* Section 1001(b).

Chapter 14. INCOME TAXATION: II

1. p. 161. H.R.585, H.R.6829, H.R.7091, 94th Cong., 1st Sess. (1975).

2. p. 163. 60 T.C. 227 (1973); *see* Renato Beghe, "The Artist, the Art Market and the Income Tax," *Tax Law Review,* vol. 29 (1974), pp. 491–524.

3. p. 165. *See* Beghe, "The Artist, the Art Market and the Income Tax," pp. 509–514, for a discussion of possible incorporation problem areas, such as the collapsible corporation, personal holding company provisions, and reallocation of income.

Chapter 15. THE HOBBY LOSS CHALLENGE

1. p. 167. This chapter is based on an unpublished article by the author. Tad Crawford and Herrick Lidstone, "Hobbies, Horses and the Struggling Artist," *Art and the Law* (Summer 1975), pp. 3–4, should be consulted for detailed citations on hobby losses.

2. p. 167. *See generally* Internal Revenue Code of 1954, Section 183.

3. p. 168. Treas. Reg. Section 1.183-2(b).

4. p. 170. Estate of Johanna K. W. Hailman, 17 T.C.M. 812 (1958).

5. p. 171. Sebastian de Grazia, 21 T.C.M. 1572 (1962).

6. p. 172. *Id.,* p. 1577.

Chapter 16. THE ARTIST'S ESTATE

1. p. 175. Judith Joseph, "Is a Smith of Another Color Still a Smith?", *Art and the Law* (December 1974), p. 5; Rosalind Krauss, "Changing the Work of David Smith," *Art in America* (September–October 1974), pp. 30–34.

2. p. 175. Alvin S. Lane, "How the Bar Can Assist the Art Community," *Record of Association of the Bar,* vol. 20, pp. 626–627, in, *Art Works: Law, Policy, Practice,* p. 1040.

3. p. 175. This agreement appears in *Art Works: Law, Policy, Practice*, pp. 1101–1106; *see also* Harry Weintraub, "Museums With Walls," *Art and the Law* (Fall 1975), p. 1.

4. p. 175. Estate of Mark Rothko, 84 Misc.2d 830, (Sur. Ct. 1975), *appeals pending.*

5. p. 176. A selection of will clauses appears in *Art Works: Law, Policy, Practice*, pp. 807–808.

6. p. 176. Harold D. Klipstein, *Drafting New York Wills: Law and Forms* (2d ed., New York: Matthew Bender & Co., 1969), Section 6.11, p. 189.

7. p. 177. 17 United States Code Section 24.

8. p. 177. College Art Association, "A Statement on Standards for Sculptural Reproduction and Preventive Measures to Combat Unethical Casting in Bronze," *Art Journal*, vol. 34, no. 1 (Fall 1974), p. 48.

9. p. 178. *Cf.* City Bank Farmers' Trust Company v. Schnader, 291 U.S. 24 (1934); *Art Works: Law, Policy, Practice*, p. 861; *see also* Internal Revenue Code of 1954, Section 2105(c), and New York Tax Law Section 960(c)(2).

10. p. 179. *See generally* Internal Revenue Code of 1954, Sections 2031–2044.

11. p. 179. *Id.*, Section 2032.

12. p. 179. Treas. Reg. Section 20.2031-1(b).

13. p. 179. 57 T.C. 650 (1972), *acquiesced in,* I.R.B. 1974-27, 8; *see generally* Diane Cochrane, "The Artist and His Estate Taxes," *American Artist* (January 1974), pp. 32–37; Leonard Sloane, "Valuing Artist's Estates: What Is Fair?", *Art News* (April 1976), pp. 91–94.

14. p. 181. Internal Revenue Code of 1954, Sections 2051–2056.

15. p. 181. *See Art Works: Law, Policy, Practice*, pp. 879–884.

16. p. 181. N.Y. Estates, Powers and Trusts Law Section 5-1.1.

17. p. 181. *See Art Works: Law, Policy, Practice*, p. 807.

18. p. 182. Internal Revenue Code of 1954, Section 2001.

19. p. 183. *Id.*, Section 2011.

20. p. 183. Treas. Reg. Sections 20.6151-1, 20.6075-1.

21. p. 183. Internal Revenue Code of 1954, Section 2042; Treas. Reg. Section 20.2042-1.

22. p. 184. Internal Revenue Code of 1954, Section 6161; Treas. Reg. Section 20.6161(a)(2).

23. p. 184. Internal Revenue Code of 1954, Section 6621.

24. p. 185. Jane C. Guynn, (CA-4), 71-1 USTC Par. 12,742, 437 F.2d 1148.

25. p. 185. Internal Revenue Code of 1954, Section 2038; Rev. Rul. 57-366, 1957-2 Cum. Bull. 618; Rev. Rul. 59-357, 1959-2 Cum. Bull. 212.

26. p. 186. *Encyclopedia of World Art*, vol. 3 (New York: McGraw-Hill, 1960), p. 578.

27. p. 186. Internal Revenue Code of 1954, Section 2522(a); Treas. Reg. Section 25.2522(a)-1(a).

28. p. 187. Internal Revenue Code of 1954, Sections 1014, 1221(c). This interpretation was given by the staff of the Joint Committee on Internal Revenue Taxation in the memorandum, dated November 29, 1976, which follows:

SUBJECT: Character of income from sale of art objects inherited from artist who created the objects.

Code section 1221(3) provides that the term "capital asset" does not include an artistic composition held by a taxpayer whose personal efforts created the property or by a taxpayer whose basis in the property is determined in reference to the basis of the taxpayer who created the property. Prior to enactment of the Tax Reform Act of 1976, this provision did not preclude capital gains treatment of sales of art work by a deceased artist's executor, heirs, or legatees.

The Tax Reform Act of 1976 provides a carryover basis rule for property acquired or passing from a decedent. Under this rule, the decedent's executor, heir, or legatee will take the same basis in property for determining gain or loss as the decedent had immediately before death, subject to certain adjustments for death taxes imposed on the unrealized appreciation. As a result of the interplay of this carryover basis rule and the definition of a capital asset, a gain realized with respect to art work by the executor, heir, or legatee of an artist will always be treated as ordinary income.

I do not recall that anyone focused on this aspect of the application of the carryover basis rule to art work in the hands of an artist's executor, heir, or legatee.

For cases indicative of the prior law, *see* Garret v. United States, 120 F. Supp. 193 (Ct. Cl. 1954); Estate of Jacques Ferber, 22 T.C. 650 (1954), *acquiesced in,* 1954-2 Cum. Bull. 4.

Chapter 17. ARTISTS AND MUSEUMS

1. p. 188. *The Visual Artist and the Law,* p. 37.

2. p. 188. *See generally Art Works: Law, Policy, Practice,* pp. 1093–1157; *Art Law: Domestic and International,* pp. 345–423; Harry Weintraub, "Museums With Walls," *Art and the Law* (Fall 1975), p. 1.

3. p. 188. Loan agreements for the Museum of Modern Art and the Whitney Museum of American Art are found in *Art Works: Law, Policy, Practice,* pp. 738–744.

4. p. 189. *Id.,* pp. 735–737.

5. p. 189. *See, e.g.,* N.Y. Education Law Section 264.

6. p. 190. 22 United States Code Section 2459.

7. p. 190. N.Y. General Business Law Section 228; *see Art Works: Law, Policy, Practice,* p. 745.

8. p. 190. *See* Weintraub, "Museums With Walls," p. 1.

9. p. 190. The agreement between Hans Hofmann and the regents of the University of California appears in *Art Works: Law, Policy, Practice*, pp. 1101–1106.

10. p. 192. *N.Y. Times*, March 31, 1976, p.43.

11. p. 193. The standards proposed by the Association of Art Museum Dealers appear in *Art Works: Law, Policy, Practice*, pp. 271–278.

Chapter 18. THE ARTIST AS COLLECTOR

1. p. 194. Terry Robards, "Painting and Antique Markets Grow Soft as Britons Invest in Easily Portable Items," *N.Y. Times*, October 26, 1974, p. 43; *see generally* Bonnie Burnham, *The Art Crisis* (New York: St. Martin's Press, 1975), pp. 191–244.

2. p. 195. Burnham, *The Art Crisis*, and Laurie Adams, *Art Cop* (New York: Dodd, Mead & Company, 1974) each treat interestingly of the art crime problem.

3. p. 195. *N.Y. Times*, December 25, 1975, p. 6.

4. p. 195. The treaty with Mexico is at 1 U.S.T. 494 T.I.A.S., Number 7088 (1971). The federal statute affecting Latin American countries is 19 U.S.C. Section 2091 *et seq.* (Supp. 1974).

5. p. 195. Andreas Freund, "A Tower in Paris Guards Art Treasures," *N.Y. Times*, April 3, 1976, p. 29.

6. p. 195. Kraut v. Morgan & Brother Manhattan Storage Co., 38 N.Y.2d 445 (1976).

7. p. 196. *See* Sperry Rand v. Hill, 356 F.2d 181 (1st Cir. 1965); Hahn v. Duveen, 133 Misc. 871 (Sup. Ct. N.Y. Co. 1929); *see generally Art Works: Law, Policy, Practice*, pp. 980–1053.

8. p. 196. Stuart J. Fleming, *Authenticity in Art* (New York: Crane, Russack & Co., Inc., 1975) gives an overview of the forensic science brought to bear on questions of authenticity.

9. p. 196. Menzel v. List, 24 N.Y.2d 91, 246 N.E.2d 742, 298 N.Y.S.2d 979 (1969); *see also Art Works: Law, Policy, Practice*, pp. 337–342, 470–472.

10. p. 197. Uniform Commercial Code Section 2-328; *see generally Art Works: Law, Policy, Practice*, pp. 355–400.

11. p. 197. Weisz v. Parke-Bernet Galleries, Inc., 67 Misc. 2d 1077, 325 N.Y.S.2d 576 (Civil Ct. N.Y. Co. 1971), *reversed*, 77 Misc.2d 80, 351 N.Y.S.2d 911 (App. Term 1st Dept. 1974).

12. p. 197. N.Y. General Business Law Article 12-D; *see* Daniel L. Martin, "Art Warranties and Certificates of Authentication or the Case of the Sterile Bull," *New York State Bar Journal*, vol. 48, no. 3 (1976), pp. 193–195.

13. p. 198. N.Y. General Business Law Article 12-F.

14. p. 198. N.Y. General Business Law Section 24; *see* Peter Hellman, "Do I Hear Two Million on the Left?" *N.Y. Times,* September 28, 1975, Section 2 (Arts and Leisure), p. 1.

15. p. 198. Law of June 1, 1939, Number 1089; *see generally Art Law: Domestic and International,* pp. 233–291; Burnham, *The Art Crisis,* pp. 89–190.

16. p. 198. *See generally* Halina Nieć, "Legislative Models of Protection of Cultural Property," *Hastings Law Journal,* vol. 27, no. 5 (1976), pp. 1089–1122.

17. p. 199. 28 F.R. 9003; 19 C.F.R. Section 10.48 *et seq.*

18. p. 199. Hollis v. United States, 121 F. Supp. 191 (N.D. Ohio 1954).

19. p. 199. Wrightsman v. United States, 28 F.2d 1316 (Ct. Cl. 1970).

20. p. 199. Internal Revenue Code of 1954, Section 165; *see* Barcus v. Commissioner, T.C. Memo. 1973-138, decided under Section 165, where an antique dealer was found not to have a profit motive.

21. p. 199. Internal Revenue Code of 1954, Section 183; as to capital gains and losses in an activity not engaged in for profit, *see* Treas. Reg. Section 1.183-1(b)(4).

22. p. 200. Internal Revenue Code of 1954, Section 170; Treas. Reg. Section 1.170; Ralph E. Lerner, "Planning the Collector's Estate," *Art Works: Law, Policy, Practice,* pp. 787–808.

Chapter 19. PUBLIC SUPPORT FOR ARTISTS

1. p. 201. The National Committee for Cultural Resources, *National Report on the Arts* (New York: The National Committee for Cultural Resources; 1975), p. 1.

2. p. 202. 20 United States Code Section 951(5), in, National Foundation on the Arts and Humanities Act of 1965, 20 United States Code Section 951 *et. seq.*

3. p. 202. *See generally* The National Endowment for the Arts, *Guide to Programs* (1975-76 ed.; Washington, D.C.: Superintendent of Documents; August, 1975), pp. 3–7, 75–82.

4. p. 203. The National Endowment for the Arts and The National Council on the Arts, *Annual Report, 1974* (Washington, D.C.: Superintendent of Documents: March, 1975), p. 104.

5. p. 203. *Id.,* p. 11.

6. p. 203. Figures provided in chart form by the Visual Arts Program of the National Endowment for the Arts with accompanying letter dated January 23, 1976.

7. p. 204. *The Visual Artist and the Law,* p. 68.

8. p. 204. *National Report on the Arts,* p. 11.

9. p. 204. *Id.,* p. 27.

10. p. 204. Dennis Green, *% for Art: New Legislation Can Integrate Art and Architecture,* ed. Brennan Rash (Denver: Western States Arts Foundation,

1976); Joyce Newman, "One Percent for Art: How Does It Work?", *American Artist* (January, 1975), pp. 33–35; Cal. Government Code Chapter 2.1 (West's Cal. Leg. Serv., 1975-1976 Reg. Sess., Chapter 513).

11. p. 204. Paul Delaney, "Manpower Program Is Helping the Arts," *N.Y. Times,* January 16, 1976, p. 1. Comprehensive Employment and Training Act, 29 United States Code Section 801 *et. seq., as amended,* Emergency Jobs and Unemployment Assistance Act of 1974, 29 United States Code Section 961 *et. seq.* (also codified in sections of 20, 29, 42 United States Code), and Emergency Jobs Program Extension Act of 1976, Pub. L. No. 94-444 (October 1, 1976).

12. p. 205. *See generally* Olin Dows, "The New Deal's Treasury Art Program: A Memoir," *The New Deal Art Projects: An Anthology of Memoirs,* ed. Francis V. O'Connor (Washington, D.C.: Smithsonian Institution Press, 1972), p. 12.

13. p. 205. *Id.,* p. 43, citing studies by Dorothy Miller for *Collier's Yearbook.*

14. p. 205. Audrey McMahon, "A General View of the WPA Federal Art Project in New York City and State," *The New Deal Art Projects: An Anthology of Memoirs,* pp. 75–76.

15. p. 206. *See generally* Kingdom of the Netherlands, *Facts and Figures,* vol. 16, *The Arts* (The Hague, Netherlands: Government Printing Office, 1970-71), pp. 26–48.

16. p. 208. Irish Finance Act of 1969, Part I, Section 2.

17. p. 209. *See generally* National Commission for Protection of Cultural Properties, *Living National Treasures of Japan* (Tokyo, Japan: Mainichi Newspapers, 1967), pp. 2–3.

18. p. 209. Diane Cochrane, "Activism in the Arts: Temporary Phenomenon or Permanent Force?", *American Artist* (January, 1976), p. 70. Representative Drinan is mentioned as the sponsor of such a bill. In a letter dated February 25, 1976, to the author, however, Representative Drinan states that a greater expectation of support from a national community of artists than he now believes to exist will be necessary for introduction of such a legislative proposal to be purposeful. An interesting model, "Art Proceeds Act," is presented in Diane B. Schulder, "Art Proceeds Act: A Study of the *Droit de Suite* and a Proposed Enactment for the United States," *Northwestern University Law Review,* vol. 61 (March-April, 1966), pp. 44–45.

19. p. 210. Michael Pantaleoni, "Comment: Priorities for Tax Law Reform," *Art and the Law* (December, 1974), p. 2; Tad Crawford, "A Proposal for the Arts," *New York Law Journal* (May 19, 1976), p. 1.

20. p. 210. *National Report on the Arts,* p. 17.

SELECTED BIBLIOGRAPHY

Books and Booklets

Abouaf, Jeffrey. *Tax and the Individual Artist.* Arts Law Guide Number 5. San Francisco: Bay Area Lawyers for the Arts, 1976.

Alexander, James, ed. *Law and the Arts.* 3rd ed. Chicago: Lawyers for the Creative Arts, 1975.

ASMP—The Society of Photographers in Communications, Inc. *ASMP Guide: Business Practices in Photography: 1973.* New York: ASMP—The Society of Photographers in Communications, Inc., 1973.

Associated Councils of the Arts, The Association of the Bar of the City of New York, and Volunteer Lawyers for the Arts. *The Visual Artist and the Law.* 1st rev. ed. New York: Praeger Publishers, 1974.

Baumgarten, Paul A., and Farber, Donald C. *Producing, Financing and Distributing Film.* New York: Drama Book Specialists, 1973.

Cartoonists Guild. *Syndicate Survival Kit.* New York: Cartoonists Guild, 1975.

Cavallo, Robert M., and Kahan, Stuart. *Photography, What's the Law?* New York: Crown Publishers, Inc., 1976.

Chernoff, George, and Sarbin, Hershel. *Photography and the Law.* 4th ed. Garden City, New York: Amphoto, 1971.

Derenberg, Walter J., and Goldberg, Morton David. *Current Developments in Copyright Law.* 2 vols. New York: Practicing Law Institute, 1975.

DuBoff, Leonard D. *Art Law: Domestic and International.* South Hackensack, New Jersey: Fred B. Rothman & Co., 1975.

Feldman, Franklin, and Weil, Stephen E. *Art Works: Law, Policy, Practice.* New York: Practicing Law Institute, 1974.

Freedman, Robert. *Basic Law for Artists.* Legal Rights Guide Number 1. San Francisco: Bay Area Lawyers for the Arts, 1975.

Graphic Artists Guild. *Pricing and Ethical Guidelines.* 2nd ed. New York: Graphic Artists Guild, 1975.

Hodes, Scott. *What Every Artist and Collector Should Know About the Law.* New York: E. P. Dutton & Co., 1974.

Holcomb, Bill, and Striggles, Ted. *Fear of Filing.* New York: Volunteer Lawyers for the Arts, 1976.

Hollander, Barnett. *The International Law of Art.* London: Bowes & Bowes, 1959.

Knoll, Alfred P., *Museums—A Gunslinger's Dream.* Legal Rights Guide Number 3. San Francisco: Bay Area Lawyers for the Arts, 1975.

Lindey, Alexander. *Entertainment, Publishing and the Arts.* 2 vols. New York: Clark Boardman Co., Ltd., 1963, Supp. 1975.

Nimmer, Melville. *Nimmer on Copyright.* 2 vols. New York: Matthew Bender, 1963, Supp. 1975.

Planning and Probating the Collector's Estate. 2d ed. New York: Practicing Law Institute, 1975.

Redfield, Emanuel. *Artists' Estates and Taxes.* New York: Artists Equity Association, 1971.

Sandison, Hamish, ed. *The Visual Artist and the Law.* San Francisco: Bay Area Lawyers for the Arts, 1975.

Sandison, Hamish, ed. *A Guide to the New California Artist-Dealer Relations Law.* San Francisco: Bay Area Lawyers for the Arts, 1975.

Volunteer Lawyers for the Arts. *Housing for Artists: the New York Experience.* New York: Volunteer Lawyers for the Arts, 1976.

Periodicals

American Artist Business Letter. New York: *American Artist,* published monthly except July and August.

Art and the Law. New York: Volunteer Lawyers for the Arts.

Art and the Law. *Hastings Law Journal.* Vol. 27, Number 5 (1976).

INDEX

ABOUT THE AUTHOR

Born in 1946, Tad Crawford grew up in the artists' colony of Woodstock, New York. Now a member of the New York Bar, he served as a judge's clerk on the New York Court of Appeals after his graduation from Columbia Law School. He writes and lectures frequently on legal matters pertaining to artists and teaches Law and the Visual Artist at the School of Visual Arts in New York City. Mr. Crawford also serves on the Board of Directors of the Foundation for the Community of Artists. He recently completed a new book, *The Writer's Legal Guide* (Hawthorn Books, 1977), and has a novel in progress. He lives in New York City with his wife Phyllis.